LEESIDE LEGENDS

LEESIDE LEGENDS

100 of Cork's Sporting Greats

JOHN COUGHLAN

EASTWOOD BOOKS

First published 2021 by Eastwood Books
Dublin, Ireland
www.eastwoodbooks.com
www.wordwellbooks.com

Reprinted 2022

2

Eastwood Books is an imprint of the Wordwell Group

Eastwood Books
The Wordwell Group
Unit 9, 78 Furze Road
Sandyford
Dublin, Ireland

ISBN:978-1-913934-22-4 (Paperback)

British Library Cataloguing in Publication Data.
A catalogue record for this book is available from the National Library of Ireland and the British Library.

*Front cover image*s: Roy Keane and Sonia O'Sulivan, courtesy of Sportsfile
Back cover images: Gemma O'Connor and John Fenton.
Typesetting and design by the Wordwell Group
Copyediting by Emer Condit
Printed in Spain by Gráficas Castuera

ACKNOWLEDGEMENTS

As one can imagine, this book has taken a lot of research and many thanks must go to all those who contributed in any way to making possible its compilation. I would like to pay tribute to the sports stars in this publication, as it was an honour to write about them and their sporting achievements. All 100 'Leeside Legends' have represented our great city with pride and honour over many years in their different sporting codes and I salute them all.

In August 2018 I lost two very special brothers, Peter and Padraig ('Paudie'), in the space of 48 hours and I would like to dedicate this book solely to them.

CONTENTS

INTRODUCTION

For hundreds of years, men and women from Cork city and county have made the headlines in their respective sports. The Rebel County has an incredible tradition of finding, developing and nurturing young men and women and helping them to become world-class sportspeople. This is a book about Cork's famous stars, their greatest achievements and most impressive feats.

Our stars are all household names, respected not just in Cork and Ireland but all over the sporting world. Christy Ring, Jack Lynch and Jimmy Barry Murphy are hurling icons, and on the football side who could forget the skills of Billy Morgan, Denis Allen and Ray Cummins? Dual legends Briege Corkery and Rena Buckley have brought great honour to this county. On the world stage, Roy Keane and Denis Irwin have done our city proud, while Sonia O'Sullivan in athletics and Jack Doyle in boxing were superstars.

Cork's tradition on the sporting fields is unquestioned and unmatched, and that's what makes this city and county so special. I'm certain that this book will create and generate some debate—not on account of the quality or authenticity of the stars included but by reason of the stars who didn't make the cut. There was one stipulation when I put this book together and that was that present-day sports stars who are still competing did not come into the equation. I'm sure that in the years ahead some other gentleman or woman will be recognising another 100 of Cork's sporting greats.

If there is one thing many of our stars have in common it is that somewhere along their way to greatness they were assisted by teachers and the many unsung, unpaid volunteers who are the lifeblood of every sport in this city and county. Volunteers are the foundation stones on which Cork sport was built and still thrives. In every code and every game there are very many men and women who selflessly devote their days and nights to clubs. Some of us may never meet our heroes, but it would be nice to remember that each time we go to a sporting event we will bump into the unsung heroes.

This collection is not meant to be definitive but rather representative of the many thousands of sporting greats who, through the clash of the ash or the wearing of the green on an international stage, have brought happiness and joy to the sporting capital of Ireland.

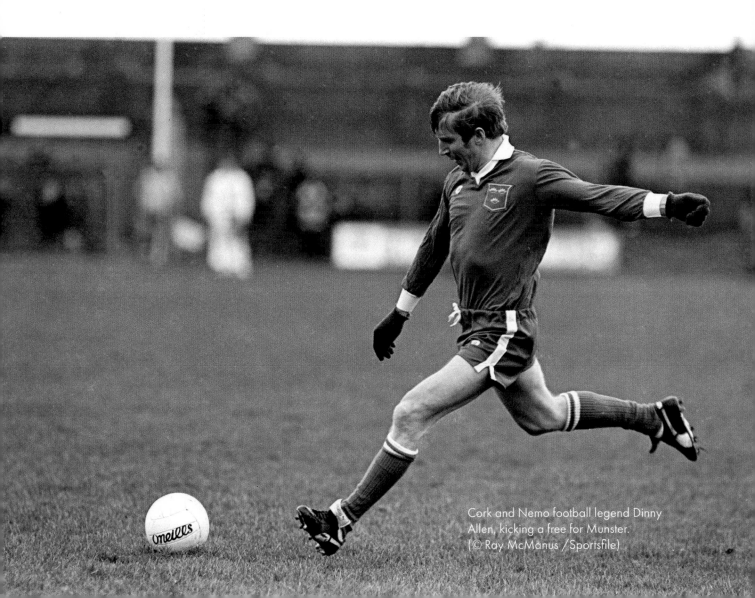

"One of the most talented Gaelic footballers ever to don the red and white jersey of Cork ... a devastating finisher and a superb opportunist."

Cork and Nemo football legend Dinny Allen, kicking a free for Munster. (© Ray McManus /Sportsfile)

DENIS ALLEN — FOOTBALL

Denis (Dinny) Allen was rated one of the most talented Gaelic footballers ever to don the red and white jersey of Cork. As a teenager, he won an U15 Munster hurling medal when Chríost Rí defeated Limerick CBS in the final. He joined Nemo Rangers in 1964 but it took six years before he achieved major success. In 1970 Nemo won the Cork County Minor double in hurling and football and, with league medals as well, Allen had clinched six winning medals, with two city division, two league and two county championships in one season. There was disappointment for the Nemo man when the Cork minor footballers lost to Kerry in the Munster final that year. He made it onto Nemo's senior team, but unfortunately they lost to Muskerry by a single point in the county final.

Another loss in the 1971 senior championship was a bitter pill to swallow, but it was put behind him a year later when Nemo were crowned champions. That win proved to be the start of a golden era for Nemo, who went on to win the championship in 1975, 1977, 1978, 1981, 1983, 1987 and 1988. The power of the Trabeg club was also illustrated at All-Ireland club level, as they won four titles in 1979, 1982, 1984 and 1989.

In 1972 Allen signed with the junior side of the local northside soccer club, St Mary's, and he regretfully recalls one incident in his sporting career.

'I helped St Mary's reach the FAI Junior Cup final against Talbot United, but I had a hurling league game with Nemo on the same day and I chose not to play with St Mary's. Mary's lost the final 3–1 and to this day I would put it down to the worst decision I made in sport.'

Allen joined Cork Hibernians in 1972 and what a move that turned out to be, as they won the FAI Cup in the same season. He had to wait until 1989 to win his first and only senior All-Ireland football medal with Cork as they completed the double, also winning the National Football League.

'That was a magical year for me to captain my county to a senior All-Ireland title, and when you think it only took me four months to win an FAI Cup medal with Cork Hibs but I had to wait nineteen years for my first and only senior All-Ireland.'

Nemo Rangers' success is the envy of many clubs in this country and Allen pinpointed the main reason for their success.

'To be honest, I think we are one happy family at our club, as we are genuine friends and that stood to us down through the years, and the elder lemons like myself enjoy giving something back to the club.'

Always a pleasure to watch, Allen was a devastating finisher and a superb opportunist.

DECLAN BARRON — FOOTBALL

Declan Barron was one of the best midfielders ever to grace a football pitch, and the bustling Bantry man was admired for his no-nonsense approach as well as his wide range of skills. Born in 1951, his footballing talents enthralled every county in Ireland. In 1972 he obtained his first success with the Bantry Blues, when they won the Cork County Junior Championship title. Three years later they were crowned Intermediate County champions. At seventeen years of age Barron broke into the inter-county squad, and in 1968 and 1969 played a major part as the Rebels won two All-Ireland minor titles. He continued to improve as he progressed through to the Cork U21 ranks and his medal haul continued to increase, with two All-Ireland wins in this grade in 1971 and 1972.

He joined the Cork senior footballers in 1971 and won the first of three Munster Championship titles that year. In 1973 he was on the team that brought the Sam Maguire back to Leeside, but when he looks back on his career he rues winning just one medal at this level.

'It is the ultimate to win an All-Ireland senior medal, and although I was happy at the time to win one, I would have loved to have a few more in my cabinet,' he said.

There was a major setback the following year, when Cork were defeated in the All-Ireland Senior Football Championship semi-final by Dublin.

'We had a great squad of players but got caught on the hop, but, to be fair, Dublin were the up-and-coming team of that time, as it is now well documented what a force they turned out to be in later years.'

Munster finals against Kerry are always memorable occasions and they were no different in Barron's day. He has great memories of the tussle in his centre-field berth against the men from the Kingdom.

'Kerry were a superb team. When you had to face players like Jack O'Shea, John O'Keeffe and Seán Walsh, you knew you were facing players of real quality,' he said. 'I have consistently said over the years that the men from the Kingdom were the hardest team in the land to beat, and if we did win it was down to sheer hard work and graft.

'In 1975, when we were expected to win, a young Kerry side surprised us with how good they really were, and I think that's the first time that people saw the team they called the best ever.'

There was no one better at fielding a high ball, and Barron is still talked about to the present day when that particular skill is discussed.

'I think it was natural for me to have this skill, and I certainly couldn't give any of the present footballers any advice, because it was a gift I was born with.'

His last success with Cork was a National League medal in 1980. Barron retired from inter-county football in 1982. With two All-Stars (1974 and 1978) to his name as well as being named on the Cork Football Team of the Millennium in 2000, he was undoubtedly a remarkable athlete.

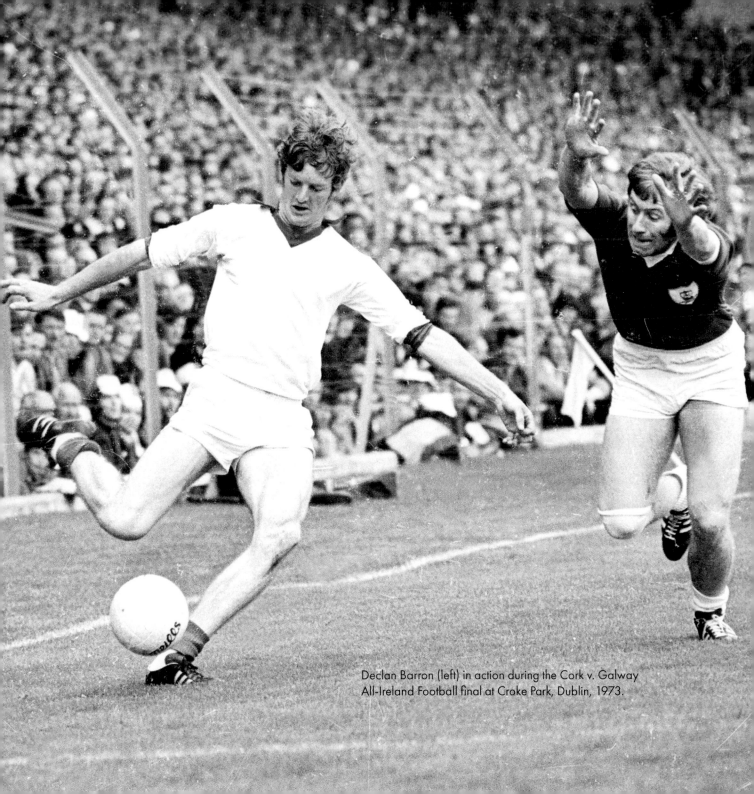

Declan Barron (left) in action during the Cork v. Galway
All-Ireland Football final at Croke Park, Dublin, 1973.

"Only the place that Christy Ring occupies in hurling rivals that of Barry in road bowling."

The legendary Mick Barry in action in his All-Ireland Championship match against Derry Kenny. (© Cummins Sports)

MICK BARRY — BOWLING

Every sport has its superstars, but few have thrown up so dominant a figure as has road bowling, in which the late Mick Barry has given us a champion supreme. You must look at the likes of Jack Nicklaus in golf, Muhammed Ali in boxing, Babe Ruth in baseball and Michael Jordan in basketball for international comparisons. In the domestic context, only the place that Christy Ring occupies in hurling rivals that of Barry in road bowling.

The last competitive score in which Barry competed was back in 1997, which in terms of longevity alone puts him in a class apart. Knowing that the end of a magnificent career spanning six decades was nigh, many old friends and admirers went to Monkstown, Co. Cork, to see Barry do battle with Liam O'Keeffe in the veteran's tournament final. It was a bright May day, a fitting setting to the finale of a wonderful career, and Barry came out on top.

Born in Waterfall in 1919, Barry took up road bowling as a seven-year-old, and for many years his determination and skill were admired on every bowling road in Cork and Armagh. He won his first All-Ireland in 1955, followed by another brace of titles in 1957 and 1962. Armagh player Danny McParland clinched the 1963 and 1964 All-Ireland titles, but a year later Barry bounced back to win another title. In his own words, it took the greatest shot of his life to deny McParland that elusive treble.

'I can remember when McParland threw the first bowl, my road guide Flor Crowley came back to me and told of the incredible shot he had taken,' Barry recalled. 'He also reminded me that he had placed £150 on me to win the first shot.'

The big crowd on the Keady Road in Armagh was stunned when Barry beat the McParland shot by 60 yards amid scenes of joy, as he went on to win the match by a sizeable margin. In 1966 he clinched another All-Ireland title and was also crowned champion in 1967, 1969, 1970, 1972, 1974 and 1975. He won thirteen Munster championships besides numerous other titles. From 1962 until 1975 he was Munster senior champion in all but three years. He twice completed the four in a row, from 1964 to 1967 and from 1969 to 1972. At the start of that phenomenal period he was 43, and 56 at the end; is there any sportsperson in any code who could emulate that?

He returned to active competition in the 1990s, winning three Munster Vintage (over-60) finals, the most famous being his 1994 win over his great rival Denis O'Donovan at Crossbarry. At 75 years of age, he covered the road in eighteen shots, better than most players could do at 25. It's certain that Barry, who passed away in December 2014, was the greatest bowler of all time. The sport is littered with his records, like putting a 16oz. bowl over the Chetwynd Viaduct or lofting Mary Anne's pub on Dublin Hill—it goes on and on. He did things that didn't seem humanly possible. More importantly, however, he did those things with a level of integrity equally supreme.

DAVE BARRY — FOOTBALL AND SOCCER

Dave Barry thrilled Cork's sporting public with his silky skills on the soccer and GAA fields in many corners of this county and country. Born in 1961, Barry hails from Pouladuff and, like many fellow southsiders, began his sporting career playing Gaelic football at Coláiste Chríost Rí. Remarkably, he played hurling and football on opposite sides of the city.

'My dad's brother Mick was a staunch member of Delany's and he signed a group of us from Pouladuff to play with the club. Our biggest success with Delany's was winning the Feile B U14 hurling championship. That was a huge achievement at that time,' said Barry.

In 1977 Barry moved back across the city to play with St Finbarr's. He made his début for Cork as a raw eighteen-year-old in a Munster Championship semi-final against Limerick in 1980. They were later beaten by Kerry at Pairc Ui Chaoimh. Barry went on to win two All-Ireland U21 medals with the Rebel County. He also won four Cork County Senior Football Championships and two All-Ireland Senior Club medals with St Finbarr's. Barry's League of Ireland career began in 1984, on a day he will never forget. 'I made my début against Dundalk at Oriel Park and I broke my leg, which was a terrible experience.'

He won his first Munster Football Championship with Cork in 1983, when they beat their old rivals Kerry, but they were subsequently defeated in the All-Ireland semi-final by Dublin. He was faced with a major dilemma in 1987 when he had to choose between soccer or Gaelic football, so he opted for soccer and wasn't considered for the Cork senior football side.

'The code of conduct, as it was known, was thrown out the following year, and Dinny Allen and I were brought back into the Cork football panel in 1988 by Billy Morgan.'

Cork reached another All-Ireland final in 1988 but were again defeated by their arch-rivals Meath. The following year was a special one for Barry, as Cork defeated Mayo to win the All-Ireland football title and he also picked up the Man of the Match award. In 1989 Cork beat Dublin 0–15 to 0–12 to win the National Football League. That year, Cork City lost out to Derry City in the FAI Cup final after a replay. The Cork footballers and hurlers achieved an All-Ireland double the following year. One of Barry's most memorable performances for Cork City was his goal in the 1–1 draw against Bayern Munich at Musgrave Park in the 1991/2 UEFA Cup.

In 1991 Barry brought his football career to an end but continued to play soccer, and in 1992 Cork City won the league title under the guidance of Noel O'Mahony. In 1996 he was appointed manager of City, following the sacking of Rob Hindmarch, and helped the team avoid relegation. There was more joy for Barry in the 1997/8 season, when he led City to FAI Cup triumph following a win over Shelbourne. The following season they finished runners-up in the league behind St Patrick's Athletic. In 2000 Barry brought the curtain down on his managerial role, ending a truly great sporting career.

"... two All-Ireland U21 medals, four Cork County Senior Football Championships and two All-Ireland Senior Club medals with St Finbarr's ...

... and a goal against Bayern Munich at Musgrave Park in the UEFA Cup."

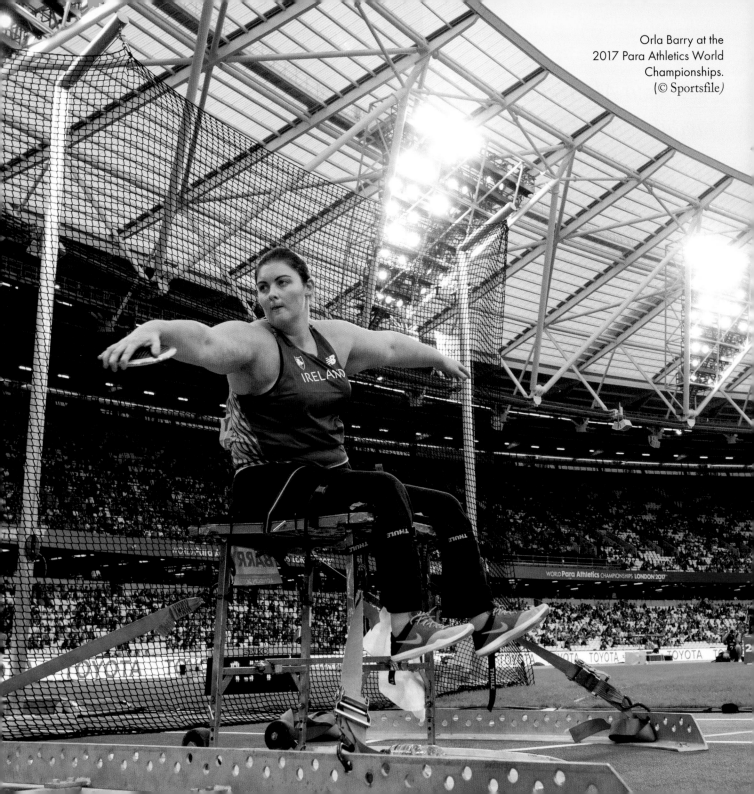

ORLA BARRY — DISCUS

Orla Barry is one of Ireland's most successful athletes and Paralympians. She won nine medals at major events in her thirteen-year career as a high-performance para-athlete in the F57 discus. She took up the sport at nine years of age after visiting an athletics track with her mother. She competed at her first Paralympics in Beijing in 2008 when she was just eighteen, a goal she'd been working towards for years. She came fifth—a brilliant achievement.

'It was a great learning experience,' she said. 'The younger you are, the less fazed you are. I didn't really know what to expect.'

She never let the expectations of others affect her, although she was always tough on herself and wanted to be the best. From a young age, Barry trained six days a week, sometimes twice a day.

At her second Games, in London in 2012, she earned the bronze medal. 'It was amazing. I'd been working towards it for four years.'

At the 2013 World Championships in Lyons she got the silver medal and broke the world record for her event. The 2014 European Championships in Swansea saw her win the silver medal, and she won another silver at the 2015 World Championships in Doha. In 2016, her best year as an athlete, she won the gold medal at the European Championships, as well as a Paralympic silver medal. Two years later she won the gold medal at the Europeans in Berlin.

'It's really different to make it to a Paralympics, never mind make the podium,' she said.

All of her wins have different meanings. 'Every competition, you're always trying to build on your distance.'

A highlight of her career is her gold medal at the European Championships in 2012. 'It was my first time winning a major championship,' she said. 'I was on the podium for every championship after that until 2018.'

Barry announced her retirement in January 2020. 'I had made so many sacrifices,' she said. 'I was really proud of what I had achieved.' She wanted to leave while she still had a love for the sport and never wanted to dread going training.

'I achieved everything that I set out to achieve when I first started competing as a fourteen-year-old girl. I have some amazing memories that I will cherish forever, and I have worked with brilliant coaches, competed alongside some incredible athletes and made some lifelong friends.'

MICHAEL BRADLEY — RUGBY

Michael Bradley will go down in Irish rugby history as one of the finest scrum-halves this country has ever produced. Honest and straight as a die, Bradley was always a very good motivator and a great team player. Despite his undoubted talent, and to the puzzlement of his many admirers, the former Cork Constitution scrum-half was unfairly made the scapegoat for many an Irish defeat during the 1980s and early 1990s.

Born in Glasheen in 1962, Bradley took up rugby while attending the Presentation Brothers College, winning a Munster Schools Junior Cup medal in 1976, followed by a Munster Senior Cup in 1980. He joined Cork Con after leaving school and the honours continued to flow as he helped them win the 1981 Munster Junior Cup. Three Munster Senior Cup wins followed in 1982, 1985 and 1989, when he captained the team at Temple Hill.

He got his first international cap at U21 level in 1982. Two years later he won his first cap with the Irish senior team, amassing a total of 40 caps from 1984 to 1995. Sadly, he was consistently targeted by the Irish media. Undaunted by this, Bradley concentrated on his game, always giving his best, and showed that he was Irish rugby's ultimate survivor. He played a starring role when Ireland won the Triple Crown in 1985. Following 22 consecutive internationals, he was dropped after the 35–3 humiliation by England in 1988. Despite one game against Wales in 1990 when he broke his ankle, Bradley was shunned by selectors for the next four years. He was recalled in 1995 but decided to call it a day after the Five Nations Championship.

'I enjoyed my international career despite the flak I had to take at times, and for me there is no better feeling than wearing the green jersey of Ireland,' said Bradley.

Winning the inaugural All-Ireland League in 1991 as a player with Cork Con and coaching them in 1999 were two major highlights for Bradley. In July 2003 he took up the coaching position with Connaught following his stint with the Irish U21 team. After stints at club level with Edinburgh and CSM Bucuresti, he is now coaching in Italy with Zebre.

He believes that Munster's success in the last few years has been good for rugby.

'The various Munster teams over the years have made the sport of rugby fashionable, as there is an unbelievable brand of supporters, not alone from Ireland but in all parts of Europe. There is little doubt the team spirit in Munster was incredible, and the supporters just love the teams because they have a special rapport that is not seen with any team in Europe.'

In typical Irish style, it took his retirement for some of his critics to accept that his qualities on the pitch far outweighed his flaws. True followers of the game were always quick to recognise the qualities that made him an invaluable member of club, provincial and national squads.

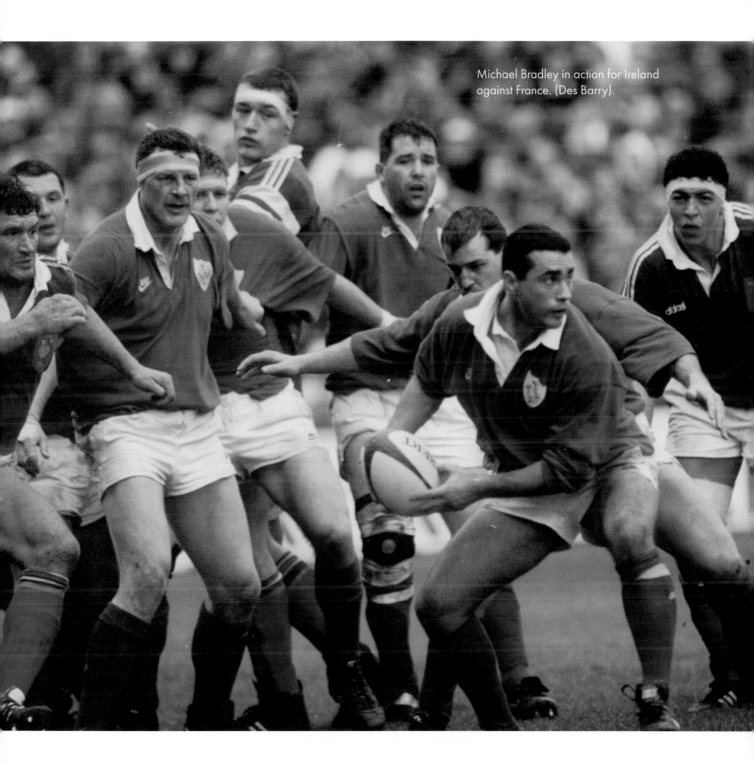

Michael Bradley in action for Ireland against France. (Des Barry).

JIMMY BRUEN — GOLF

Jimmy Bruen was one of a long list of golfers who scorned conventional wisdom and became one of the most charismatic golfers of all time. At seventeen years of age he was hailed as the greatest discovery of all time in golf. Born in Belfast in 1920 but reared in Cork, he first used a golf club when he was eleven years old while on holiday in the west of Ireland. That first encounter was to sow the seeds of a prestigious career, as shortly after that holiday his father bought him his first cut-down clubs. His famous looped swing could be seen even at that young age, as he married a natural ability with perseverance to come within a shot of the Walker Cup team within six years.

Two outstanding years in his all-too-brief career were 1937 and 1938. It all began at Easter 1937 in the Cork Scratch Cup, a major event which included Billy O'Sullivan, Redmond Simcox, J.D. McCormack and J.C. Browne. Young Bruen breezed into the final and dispatched Simcox seven and six, as the loser was only five over par for the holes, putting Bruen's score into perspective. The following month Bruen went to Sandwich to play in the St George's Gold Vase competition, which was then a 36-hole stroke-play competition. He scored a 73 and 74 and finished second in front of players such as Leonard Crowley, Joe Browne and Cecil Ewing. He was only seventeen when he played number one on the British and Irish team that won the Walker Cup against America in 1938.

In due course Bruen helped Cork to win the Irish Senior Cup and the Barton Shield at Ballybunion. The Kerry venue of Ballybunion hosted the Irish Close Championship the following week, and once again the brilliance of Bruen saw him reach the final against John Burke of Lahinch. Burke was highly fancied as an Irish international but the superb Bruen produced champagne golf and defeated him three and two. The sportswriters in Ireland and England continued to rave about the boy wonder from Cork but, sadly, the outbreak of the Second World War saw the edge go off Bruen's magic, as he became immensely successful in the insurance business.

Having virtually vanished from the golf scene, his entry for the 1946 British Amateur Championship caused quite a stir. He scored arguably his greatest achievement in the sport when he defeated American Robert Sweeney by four and three in the 36-hole final.

It was to be his last major championship success, as he simply lost his appetite for the rough and tumble of championship golf. That was never stated by Bruen, but then he never said a lot about himself. In April 1947 he suffered an injury to his wrist that was decisive in more or less putting an end to a remarkable career. In 1963 he came out of retirement when the Irish Close Championship was held in Killarney and, in a match that's still talked about today, he lost on the eighteenth in the semi-final. Bruen passed away in 1972.

DIN JOE BUCKLEY — HURLING

Din Joe Buckley of Glen Rovers was once described as fearless, unyielding and uncompromising, full of grit and tenacity, and teak-tough—an apt description of Buckley, who could play in any position in his team's line of defence. Born in 1919, he grew up in the Shandon area of Cork, where every outdoor game—hurling, rounders, handball, ball in the cap and even road bowling—was played.

Buckley began to play hurling as soon as he could walk, and his years of solid practice paid rich dividends in 1936 and 1937, when he won two County Minor Championships with the Glen. In 1937 he was also a substitute with the Cork minor hurling team that won the All-Ireland after beating Kilkenny 8–5 to 2–7. In 1937 he joined the Irish army. During the 'Emergency' period from 1941 to 1945 he played lots of sports while serving in the 31st Battalion. In 1940 Buckley had to battle hard against the legendary Mick Mackey of Limerick in the Munster final that went to a replay, with the Shannonsiders winning 3–3 to 2–4.

Buckley was part of the Cork side that won a record-breaking four in a row from 1941 to 1944. Tipperary halted the five-in-a-row bid in 1945, but Cork were back again in 1946, when Buckley won his fifth All-Ireland medal. He confessed that the 1944 All-Ireland semi-final against Galway was the greatest game he ever played in, and also pinpointed the Munster final of that year.

'Christy got the ball on the right wing about twenty yards from the sideline in the middle of the field before he soloed 60 yards before hitting an unstoppable shot.'

One player that Buckley admired in the Limerick side was Mackey, and when asked about his battle with him, he once said, 'The harder you gave it to him the more he loved it'.

Mackey simply loved the hard going, but Buckley said that the most important thing about him was that there was never any bitterness in him after the match.

Buckley captained the 1944 Glen Rovers team that defeated St Finbarr's 5–7 to 3–3 before a crowd of 34,000. In football, he won a county senior football medal with St Nick's in 1941, and he also played right half-back in the 1947 Cork senior football final against Clonakilty, which they lost 2–5 to 1–4.

Buckley retired from inter-county hurling after the 1949 championship with eight All-Ireland medals in his pocket. He will be remembered as one of a group of hurling giants whose like we will never see again in the red and white jersey.

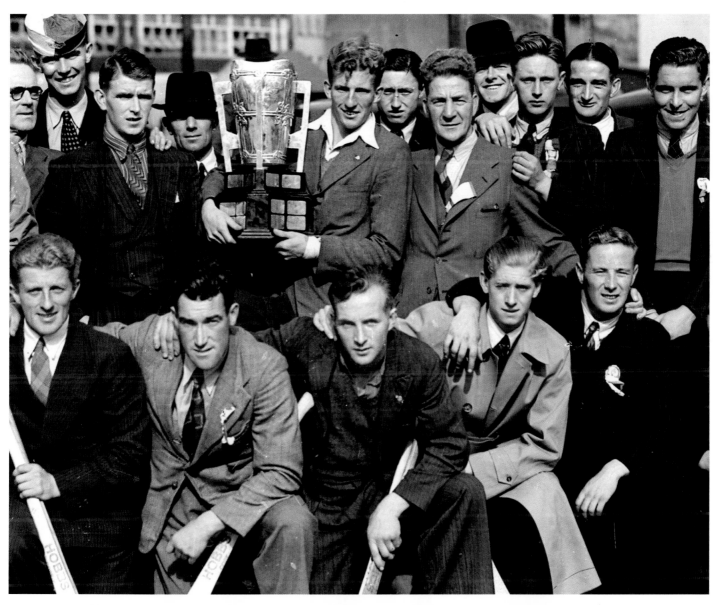

Din Joe Buckley captained Cork when they won the 1941 All-Ireland against Dublin. His brothers Jack and Con (Sonny) also played for Cork, and Con played on that victorious 1941 team. (Picture: Denis Minihane / *100 Cork Sporting Heroes*, Vol. 1.)

> *"We're honoured to have witnessed Rena Buckley's phenomenal career, and she has made this city proud."*

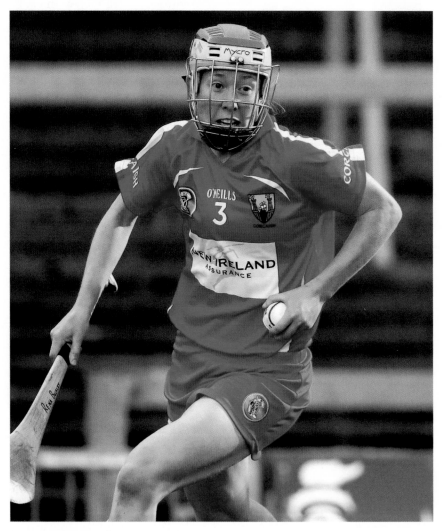

(Image © INPHO / Bryan Keane)

RENA BUCKLEY — FOOTBALL AND CAMOGIE

When the great dual players of ladies' football and camogie are documented, Rena Buckley will surely be in the top ranking as one of the greatest athletes produced on Leeside. With eighteen senior All-Ireland medals across football and camogie, she and her former team-mate Briege Corkery are the most decorated GAA players of all time.

Although there isn't a big tradition of Gaelic games in the Buckley family, she and her siblings got 'great enjoyment' out of all sports as youngsters. They were all involved in Iniscarra and Donoughmore GAA clubs, with Buckley also competing in athletics.

She had success early on with Donoughmore in 2001, when they won the County Championship.

'I was young at the time,' she recalled. 'I didn't appreciate how special it was, but I knew I was involved in something big. It contributed hugely to my development as a player.' In 2004, still a teenager, Buckley was set to appear in her first All-Ireland final with the Cork senior camogie team. In what was 'certainly a new experience', there was a press night, and a photographer from the Echo came to her school. One year later, Buckley lined out for both the senior camógs and the footballers.

The camogie players came out on top. 'It was unbelievable,' she said. 'We managed to get over the line. It was phenomenal to be a part of it, something that I wasn't expecting.' A few weeks later, the footballers also triumphed. 'We played very well on the day and got enough scores to win the game,' Buckley said.

The passing of Éamonn Ryan earlier this year was sad for all GAA people in Cork and nationwide. He had a huge influence on Buckley, and focused on developing the Cork women not just as players but also as people.

'He was a huge figure in my life. He really helped steer us all in a good direction.'

Her highlights with the footballers include that first All-Ireland win in 2005 and that 'unbelievable' 2014 ten-point comeback against Dublin. 'We nearly accepted we were going to lose,' she said. 'It's very hard to put words on it.' For camogie, the highlight was her last game with the side against Kilkenny in 2017, when she captained them to All-Ireland victory. 'It was personally special because I was captain. We weren't favourites going into the game, we barely won.'

Though her personal achievements are vast (eleven All-Stars, and joint winner of the 2015 Irish Times Sportswoman of the Year), Buckley doesn't put much stock in them. 'Those things are absolutely lovely … but sport is much bigger than personal accolades.'

Buckley takes great pride in representing Iniscarra in camogie and Donoughmore in football. In 2018 Iniscarra won the Munster Senior Club Camogie Championships and completed three back-to-back County Championship victories. In 2019 Donoughmore won their second All-Ireland Junior Club Championship.

'I get just as much enjoyment out of them as the county wins,' Buckley said. 'I'm really grateful.'

GER BURNS — HOCKEY

Ger Burns was rated one of hockey's finest defenders and his 76 international caps testify to his all-round class. He began playing hockey at Ashton Comprehensive and his talent helped the school to Munster U14, U16 and Senior Cup wins. He joined the Church of Ireland club in 1978, and by the age of twenty he had fourteen Irish caps at U21 level. Such was the standard of his performances that he got rave reviews when playing for Ireland in the U21 European World Cup in Rome in 1983.

It only took two years for the Irish senior selectors to call up Burns to their squad, but disaster struck when he broke his kneecap during a training session in Berlin. He was recalled to the team in 1987 after recovering and scored a magnificent goal against Belgium in Dublin as Ireland won 9–1. The 1989 season was a notable one for Burns, as he travelled to New Jersey in the USA for the World Cup qualifiers. After defeating Poland, the final play-off place came down to a game against Malaysia. Ireland stood up to the test and with the aid of another superb performance from Burns they won 3–1. The World Cup of 1990 was soon upon Burns and it was off to Lahore in Pakistan, where the host nation was Ireland's first opposition.

'We played Pakistan in front of 35,000 people and the stadium was only half-full and, although going down 2–1, I get goosepimples when I think back on that game,' Burns said. 'In truth, we were made national heroes by the Pakistanis, who made us put autographs on motorbike tanks and anything else they could get their hands on.'

The injury jinx struck Burns again in 1991, when he broke his collar bone at the European Championships in Paris. Luckily he healed quickly and was selected later that year for the Irish squad that played in the Pre-Olympic qualifying tournament in New Zealand.

'I was delighted to get back on the Irish team after my latest injury, but the problem was that I was getting married on a Thursday and leaving for New Zealand the following Tuesday morning. I was very lucky to have an understanding wife.'

After breaking his ankle in 1994, Burns was determined to make it back for the 1995 World Cup in Dublin. He succeeded and it proved to be his swansong, as he bowed out of international hockey. He continued to play club hockey with Church of Ireland and finished his career on a high in 1999, when he helped them to win the Irish Senior Men's Cup.

'That was most certainly a highlight of my career at club level, especially as we had not won it for 30 years.'

The defender also had the distinction of playing for Munster for eighteen years, and there is no arguing that these achievements make him a very special player. There is little doubt that if Burns had had an injury-free career he would have amassed over 100 caps.

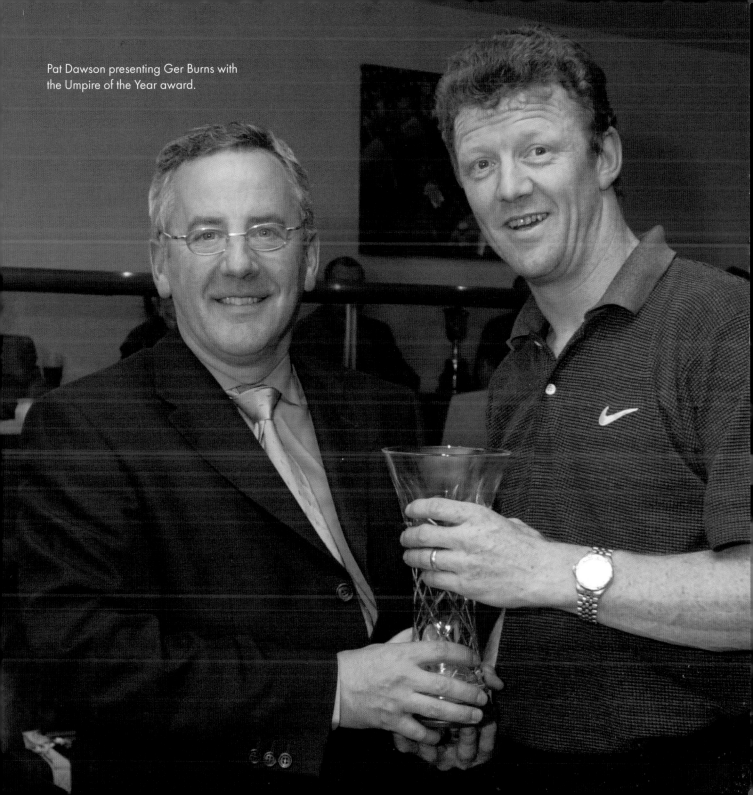

Pat Dawson presenting Ger Burns with the Umpire of the Year award.

> *"Cahalane is recognised as one of the greatest players ever to wear a Cork jersey."*

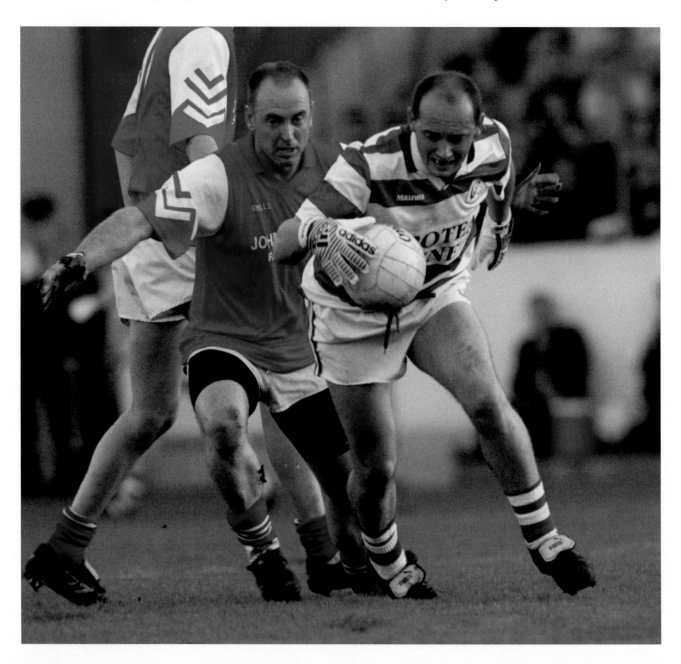

NIALL CAHALANE — FOOTBALL

Not many Gaelic footballers of the present generation would have the commitment to play at the top level until the age of 40, but in Niall Cahalane Cork has a man who defied all logic. Born in Castlehaven near Skibbereen, he has been involved at this local club for over 50 years, winning his first medal at the age of seven. The year 1981 was a special one for Cahalane's history, as his club clinched the West Cork Minor Championship. His longevity in top-class football can be put down in part to starting to play senior football for his club at the age of seventeen. His first taste of success came in 1989, when Castlehaven defeated the Barrs in the Cork County Senior Football Championship final. Five years later came the final that every West Cork football fan wanted to see—a local derby clash between Castlehaven and Skibbereen. After 60 minutes of compelling football, the teams couldn't be separated. Winning the replay was one of the high points of Cahalane's illustrious career.

'First of all, I was a captain, and not alone were we playing our great rivals and neighbours, we were also playing lifelong friends and former schoolmates,' he said. 'Thankfully we won the replay and, looking back, to be captain of my club to win that final was a dream come true.'

The county final of 1997 was one of the darkest days in Cahalane's career, when his club lost to Bear and a controversial incident after the game saw him cited. He was caught on camera shouldering referee Niall Barrett, resulting in a twelve-month suspension.

'That was the lowest point of my career, as I had let myself, family and club down at the one time,' he said. 'It was a horrible time, but with the help of family and friends I decided to return and learn from it.'

On the inter-county side, Cahalane is recognised as one of the greatest players ever to wear a Cork jersey. In 1981 he won an All-Ireland minor medal when the Rebels defeated a highly rated Derry side. Following a three-year wait, Cahalane was once again back on the steps of Croke Park when he captained Cork to the All-Ireland U21 football title with a win against Mayo. He won his first senior All-Ireland with Cork in 1989 against Mayo, and in 1990 they defeated Meath in another thrilling final.

In recent years the decline in Cork football has saddened Cahalane, but he's still hopeful that the good times will return. Two of his sons, Damien and Conor, are part of the Cork senior hurling squad, while his son Jack plays U20 football and hurling, his daughter Méabh plays senior camogie and football and his daughter Orlaith plays minor camogie.

'We are living in difficult times, as the youth of today go through the motions of life, and, looking back, my father (John) and mother (Maureen) enjoyed the simple things in life and were very proud of the service I gave to Cork football, just the same as I am of my own kids.'

NOEL CANTWELL — SOCCER

Noel Cantwell was one of the best defenders of his time, a magnificent player both for his home country and for West Ham United and Manchester United. He began his rise to fame with a junior club in Cork called Western Rovers, and later with Cork Athletic.

In 1952 the sturdy full-back joined English First Division club West Ham United for a fee of £750 and thereafter began to make his mark. Over the next fourteen years he became one of the most outstanding defenders in England. He attributed his remarkable success to the colourful influence of Malcolm Allison. Allison, the first player to take the FA coaching course at Lilleshall, shared his education with West Ham team-mates Cantwell, John Bond, Frank O'Farrell and Malcolm Musgrave, who all became successful managers. In 1958 Cantwell captained West Ham to the English Second Division title.

It seemed that the affable Corkman was all set to spend his career at Upton Park, but in 1960 Manchester United had other ideas and put in a bid for him that the Hammers could not refuse. That transfer fee of £29,500 constituted a record for a full-back. Cantwell only received a mere £650—a miserly reward for eight years of dedicated service to the east London club.

Cantwell's arrival at Old Trafford coincided with the creation of a new side to replace many of those who had lost their lives in the Munich air disaster. It was a difficult time, as players such as Bobby Charlton, Shay Brennan and Wilf McGuinness had all been there and had seen their friends killed. The new recruits could sense that some of the players and many of the fans were wishing that it could be like the old days again. Cantwell captained Manchester United to FA Cup glory in 1963 and to the league title in 1965. He retired from the club in 1966.

Cantwell won 36 caps for the Republic of Ireland and was joint top scorer for his country with fourteen international goals, despite playing at full-back for most of his career. He captained the team 22 times.

Shortly after retiring, he was appointed manager of Coventry City, and in the 1969/70 season he led the Sky Blues to sixth place in the English First Division, their highest-ever placing, which guaranteed them a place in the UEFA Cup for the first time. After four and a half years he was sacked and then immediately snapped up by Fourth Division Peterborough United, where the supporters regarded him as a local and chanted his name on the terraces. He left Peterborough in 1977 and returned in 1986. He later scouted for England's Swedish football manager, Sven Göran Erickson.

Cantwell died in September 2005 at the age of 73. For a man who had such an exceptional career, he never forgot his roots in his beloved city of Cork.

"Cantwell captained Manchester United to FA Cup glory in 1963 and to the league title in 1965."

Noel Cantwell with Denis Law. (© Cummins Photography)

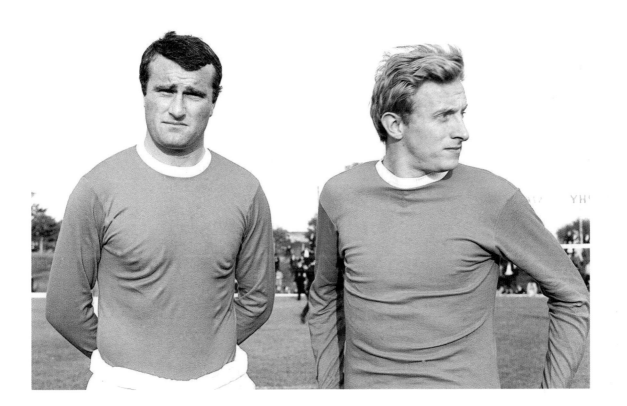

MARK CARROLL — ATHLETICS

Mark Carroll is one of the greatest middle-distance runners that this country has produced. Born in 1972, he grew up in Knocknaheeney and started his athletic education at the North Monastery under the guidance of athletics coach Brother John Dooley, whose advice he always valued.

'I was suffering badly with an Achilles tendon injury and the Irish championships were only weeks away. Brother Dooley called me in one day and said to me if I missed the national championships, it would give my injury time to heal, and I would have a better chance of winning a European title.'

The rest is history, as Carroll put in a remarkable final lap to be crowned European champion. He went to Providence College in 1991 on a four-year scholarship under the direction of Ray Treacy, and such was his progress that by the time he left in 1995 he had just missed out on Frank O'Meara's Irish 5,000m record of 13.13 in France. He later reached the 5,000m final at the World Championships in Gothenburg, where he finished twelfth. In 1996 a stress fracture of the leg forced him to pull out of the Atlanta Olympics. In 1998 he set two Irish records, as he broke Eamonn Coughlan's 3,000m record of 7.37 when he ran 7.33 at a meeting in Brussels. A few days later he was off to Berlin, where he ran 13.03 in the 5,000m to break the 13.13 by a big margin.

Probably the greatest race of Carroll's career was when he set the 3,000m record of 7.30.36 in Monaco, which could stand for decades. It's more than two seconds faster than Mo Farah has ever run and is essentially the equivalent of running two four-minute miles back to back. Prior to setting both records, Carroll won a bronze medal at the European Championships in Budapest, but he suffered more disappointment in 1999 when he was diagnosed with anaemia, resulting in another break from athletics.

Although Carroll loves athletics, the issue of drugs has always irked him. 'The one problem that I have with athletics is the number of drugs in the game, as my attitude to the sport is simple: it is a gift that shouldn't be abused.'

In 2000 Carroll won the Wannamaker Mile at Madison Square Garden in New York and the 3,000m gold in Ghent. Just when the country and city were getting over the celebrations, he produced another storming 27.46 run in the 10,000m to smash John Treacy's record of 27.48. Sadly for Carroll, he peaked too early in that season and the Sydney Olympics proved a personal disaster for him, when he lost out in the 5,000m heats. In 2002 he decided to change from track and field to marathon running. In his début race in New York, he ran a superb two hours and ten minutes to finish in sixth place.

No legacy is so rich as honesty—at least, according to Shakespeare—and Carroll will forever be remembered as a European champion who represented this city and country with pride and dignity.

"Probably the greatest race of Carroll's career was when he set the 3,000m record of 7.30.36 in Monaco"

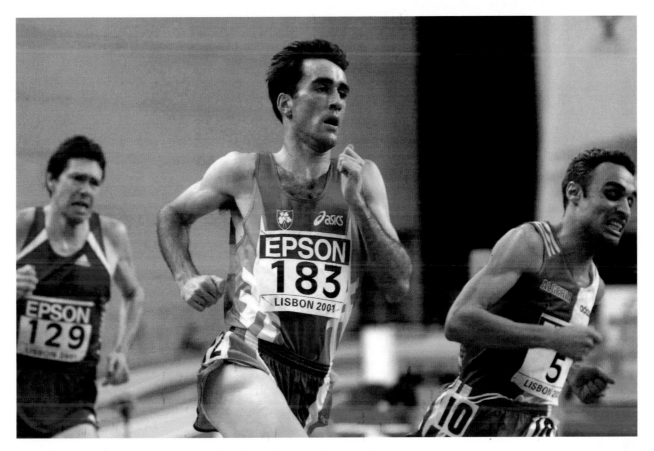

Mark Carroll in action in the 2001 World Indoor Championships in Lisbon.

> *"One of the classiest and most stylish hurlers for many years."*

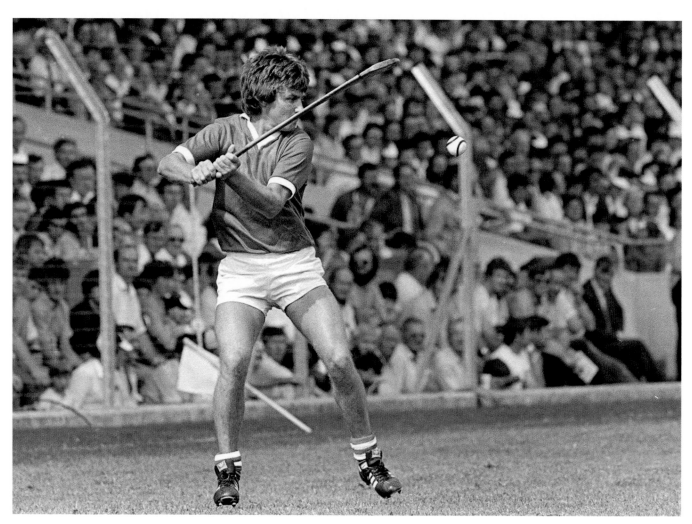

Tom Cashman in action for Cork in 1984. (© Ray McManus / Sportsfile)

TOM CASHMAN — HURLING

For Tom Cashman, rated as one of the classiest and most stylish hurlers for many years, the thrill of hurling is still in every bone of his body. His father, Mick Cashman, was one of the great Blackrock and Cork players of the 1950s and '60s, and had the distinction of captaining the Blackrock senior team when they won the Cork Senior County Championship in 1956. With a role model in his father, Cashman began his hurling with Blackrock. In 1971 Blackrock clinched their first National Féile na nGael club hurling title; although Cashman was only fourteen years old (the Féile was U15 in its inaugural year), he was the leading player in this famous win. It was a team that oozed class from U14 level to minor, as they won every honour possible.

In 1974 the team won the Cork Minor County Hurling and Football Championships, and in that same year Cashman, Dermot McCurtain, Danny Buckley and Finbarr Delaney won Inter-County Minor Hurling and Football Championship medals with Cork.

Cashman captained Cork in the All-Ireland Minor Hurling final against Kilkenny in 1975 but, sadly, they were defeated. Later that month, he made up for his disappointment when he was part of the Blackrock team that defeated Glen Rovers in the Cork Senior County final. This was the first of Cashman's four Senior County hurling medals, with titles coming his way in 1978, 1979 and 1985. The 1985 victory in particular stands out for him.

'That final was against Midleton, and with the Rockies not winning a championship in the early '80s, it was brilliant to see the club back on the winning trail again.'

On top of his four county medals, he won an All-Ireland Club Championship in 1979 when the Rockies defeated Ballyhale Shamrocks of Kilkenny.

Cashman made his senior hurling début for Cork in October 1976 in a National League game, and the following September he played midfield on the Cork side that won the All-Ireland final against Wexford. He added a second All-Ireland the following year when Cork defeated Kilkenny, but he had to wait six years before winning his third medal, which came in the Centenary All-Ireland final against Offaly in Thurles.

It's every player's dream to captain his or her county to win an All-Ireland, and Cashman's dream was realised in 1986 when Cork defeated Galway.

'I will always cherish that particular day, as I felt so proud when the final whistle went, and although it's hard for me to explain the buzz I got, it's a day I'll never forget.'

He was also a fine footballer with St Michael's, but despite playing in three Cork Senior finals between 1976 and 1978 he lost all of them, which was a huge disappointment. Cashman retired from inter-county hurling in 1989, with three All-Stars. After being a selector for a number of years with the Cork senior hurlers, he took over as coach in 2001. There is little doubt that he was a hurling artist, whose stickwork and sportsmanship are now a byword in hurling circles.

FRANK COGAN — FOOTBALL

It's virtually impossible to keep the Nemo Rangers club from being listed as all-time greats of Gaelic football. For Frank Cogan, their star defender for three decades, the honour of playing for both his club and his county is something on which he looks back with immense pride. He joined the club at the age of ten but had to wait a couple of years to play, as U16 was the first level at which you could play during that era. His first major honour came in 1961, when Cork won their first-ever minor All-Ireland football final after defeating Mayo in a thrilling decider.

In 1965 he made his debut for the Cork senior footballers against Dublin in the National Football League. There were years of disappointment for the footballers, losing the All-Ireland semi-final to Galway in 1966, to Meath in the final in 1967 and to Offaly in the 1971 final. After trying his heart out for eight years, Cogan eventually fulfilled his dream of winning a senior All-Ireland medal when Cork got the better of Galway in the 1973 final. He was Mr Consistency for the Rebels during the 1972 campaign and was awarded an All-Star for his efforts. His inter-county career came to an end the following year, when a bad groin injury meant that he could no longer keep up with the demands of playing for both club and county.

Cogan had to wait eight years to win his first senior championship with Nemo Rangers and, as sometimes happens in sport, more followed in a relatively short space of time, with the Trabeg club winning titles in 1975, 1977, 1978 and 1981. At the age of 38, Cogan called it a day and ended a truly remarkable career with the club.

'Nemo is an ordinary GAA club where you go training and then go home because the secret has always been the family atmosphere, as we were always more than teammates; more importantly, we were true friends to each other. Nemo is a small club but a united one, and that has always been the secret of our success.'

The influence of the legendary Billy Morgan is also a major factor in the success that Nemo Rangers have enjoyed.

'When Billy qualified as a PE instructor, he brought a level of fitness to Nemo that no other club had. To be fair, I have never met a more dedicated football man in my life than Billy Morgan, as he proved when leading Nemo to an All-Ireland club title in 2003 after losing out in the two previous finals.'

Surprisingly, the new style of football does little to impress Cogan.

'I am not overly impressed with some of the football that's played in modern times, and outside of watching Nemo I watch very little football, with the exception of Cork games.'

Cogan was a tough but fair football player, and not many players in this country can boast of three successful decades at the top level of their sport.

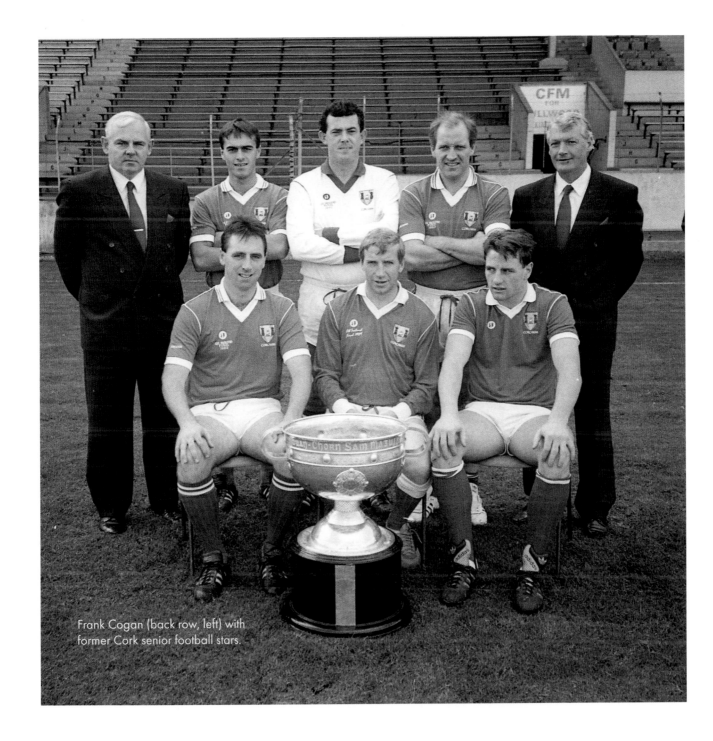

Frank Cogan (back row, left) with former Cork senior football stars.

"the greatest rally driver this country has ever produced."

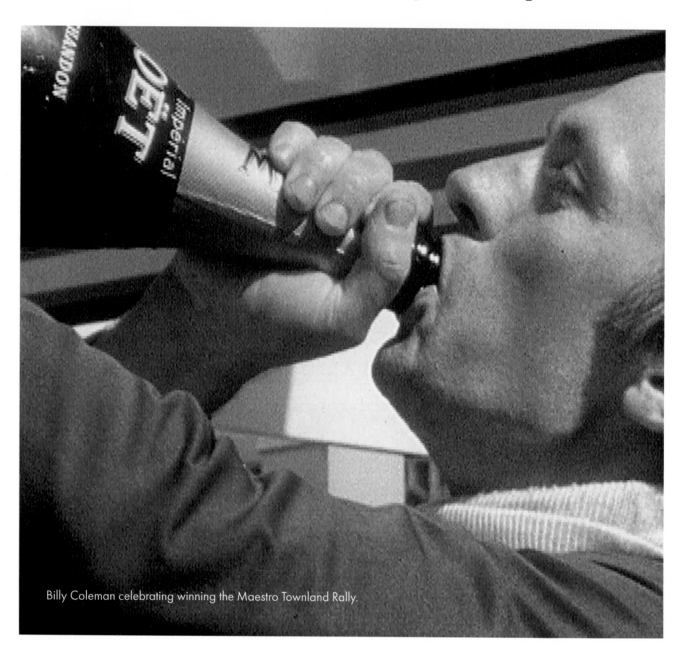

Billy Coleman celebrating winning the Maestro Townland Rally.

BILLY COLEMAN — RALLYING

Mention rallying in this country and Billy Coleman automatically springs to mind. He is without doubt the greatest rally driver this country has produced. Born in Millstreet in 1947, Coleman was said by some to have motor oil in his veins. His interest in cars and driving started at a very young age, as his parents were in the garage business. In 1967 he began driving at the Vernon Mount track. That same year he entered his first Circuit of Ireland rally, and it was an experience he never forgot.

'It was a fantastic experience for me, despite the fact that I only finished twentieth. My co-driver was Don O'Sullivan from Ballyvourney, and we were determined to eventually win this great race.'

Like the roads on which he raced, Coleman's career had many twists and turns. In 1970 he won the Cork '20' Rally in a Renault Alpine with Noel Davin as his navigator. In the Circuit of Ireland, Coleman/O'Sullivan, in a Ford Escort that had No. 25 on the doors, finished an incredible third overall. Coleman won the Circuit of Munster again in 1973, but his greatest moment was when he became the first Irish driver to win the British Rally Championship in 1974.

Success continued with victories in the Circuit of Ireland in 1975 and 1976.

'The Circuit of Ireland is one tough race, and after coming so close in previous years, the actual feeling when I did win it was hard to describe, as, make no mistake, this race is a very hard one to conquer.'

In 1978 he secured fourth place in the Scottish Rally, driving a Fiat 131 Abarth. He decided that he wanted to compete at the very top level and joined the European Rally championship. Driving a Ford Cosworth, he was up against the best drivers and almost snatched victory. The pressure saw Coleman take a five-year break, but he couldn't resist a return to his beloved sport. In 1984 he drove an Opel Manta to victory in the Circuit of Ireland. He joined the Rothmans Rally team the following year, winning the Donegal International Rally in a Porsche 911 works car. In his career, he won eleven rounds of the Tarmac series, including the Cork 20 International Rally in 1984 in an Opel Manta and in 1986 in a Metro 6R4.

His dream to compete against the best in the world was realised in 1985 when he travelled to Corsica. He finished fourth after a gruelling series of races, a major achievement for the Cork driver. The final two years of his career were rather low-key, with limited successes, after which he decided to call it a day. After a career that spanned twenty years, the Millstreet man had one regret.

'I always wanted to be crowned World Champion, and although I came close on a number of occasions it wasn't to be. I think everyone involved in sport at the top level has certain goals, because that's what keeps you motivated; however, when I look back on my career I can honestly say that I enjoyed every minute of it.'

Coleman will never be forgotten by the people lucky enough to have witnessed his skill behind the wheel.

SEÁN CONDON — HURLING

Seán Condon was arguably the greatest hurler ever to wear the blue jersey of St Finbarr's. Born in 1923 near Phair's Cross, he attended the Presentation Brothers school in Greenmount, better known as the College on the Hill — a school that produced many stars of Cork hurling.

He played minor hurling for the Barrs from 1937 to 1941, and also won minor football medals in 1940 and 1941. He made his senior début for the Barrs against Glen Rovers in the semi-final of the Cork Senior Hurling Championship, along with the legendary Christy Ring. They were a powerful team at the time, and Condon played a big part in their championship wins of 1942 and 1943. He later captained the victorious 1946 and 1947 Barrs teams to County Championship success.

On the intercounty scene, Condon made his début for the Cork senior hurling team against Kilkenny in 1942, when the counties clashed in a challenge game. Condon's performance at centre-field with Jack Lynch was the highlight, as Cork had unearthed a star of the future.

A few weeks later, Condon lined out against Limerick in the first round of the Munster Championship, and his two late points sealed a famous win for the Rebels on Shannonside. Cork went on to win three All-Irelands in a row in 1942, 1943 and 1944.

Condon was relegated to the subs bench in 1946, but his determination saw him return the following year as captain. Unfortunately, he was not to have a fairy-tale return and, despite a mighty performance from the Barrs man, Cork were denied at the death. The stakes were high for both sides, with Cork aiming for a sixth championship win in seven seasons and Kilkenny hoping to avoid becoming the first team to lose three consecutive All-Ireland finals. A Joe Kelly goal put Cork ahead with time almost up, but two later Terry Leahy points sealed it for the Cats 0–14 to 2–07.

In the 1950 Munster Senior Hurling final against Tipperary, Cork lost out to the Premier County despite Condon's contribution of nine points for the Rebels. He proved his versatility when he was selected for the Cork junior football team of 1951 that were crowned All-Ireland champions. Injury brought Condon's career to an abrupt end in November of that year.

He always had a special affection for Cork fans, especially during the war years, when the Rebel Army had to endure terrible hardships to see a Munster final. The Cork-based fans would cycle to Thurles, while the Cork soldiers stationed at Templemore would walk the seven miles to Thurles to support their heroes.

Condon will be forever remembered in the history of Cork hurling, and his death in 2001 was met with widespread sadness. In the words of the dedicated St Finbarr's supporters, 'A resting life to the gallant old blue!'

"arguably the greatest hurler ever to wear the blue jersey of St Finbarr's."

Seán Condon (left) with former team-mates, including the late Taoiseach Jack Lynch.

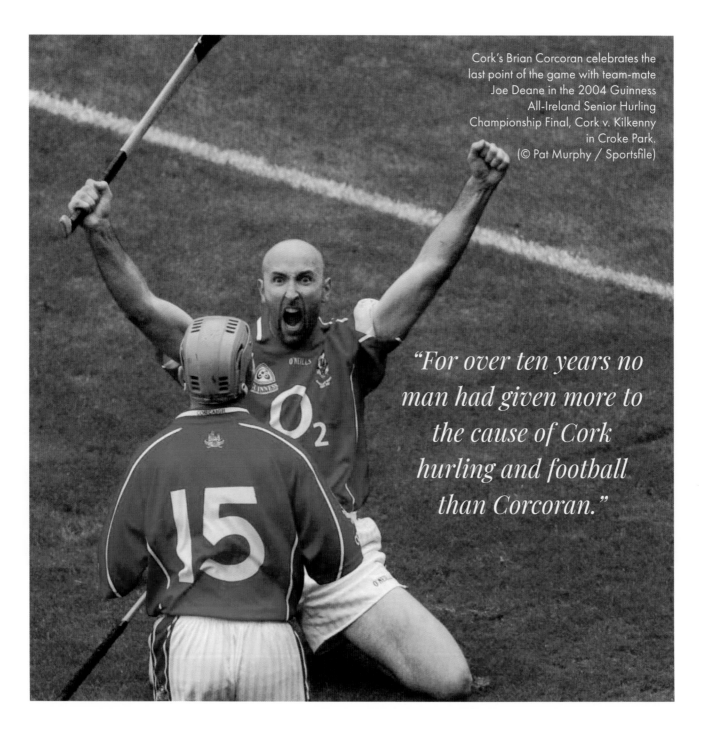

Cork's Brian Corcoran celebrates the last point of the game with team-mate Joe Deane in the 2004 Guinness All-Ireland Senior Hurling Championship Final, Cork v. Kilkenny in Croke Park.
(© Pat Murphy / Sportsfile)

"For over ten years no man had given more to the cause of Cork hurling and football than Corcoran."

BRIAN CORCORAN — HURLING

They named Brian Corcoran 'Cuchulainn' in Caherlag, after the fabled Irish demigod. It was an apt description of one of the greatest-ever hurlers. As a youngster, it was unusual to see the Cork star without a football or a hurley in his hand. All his practice paid off, and his championship win came in 1988 when Midleton won the Dr Harty Cup. His club, Erin's Own, won the East Cork U21 Hurling Championship in 1991 after beating a strong Midleton outfit. The year 1992 proved to be one of Corcoran's greatest at club level, as Erin's Own won their first Cork County Senior Hurling Championship when they came out on top against Na Piarsaigh 1–12 to 0–12. Along with Timmy Kelleher, he almost single-handedly shattered Na Piarsaigh's dream that historic day, scoring eleven points. He was selected for the Cork minor football team in 1988 at the age of fifteen, and won an All-Ireland with the side when they defeated Mayo three years later.

Corcoran joined the Cork senior hurling panel in 1991 and the following year tasted defeat when the Rebels lost out to Kilkenny 3–10 to 1–12. On the inter-county scene there was also disappointment for Corcoran in 1993, when Cork lost to Derry 1–14 to 2–18 in the All-Ireland final. September 1999 will be long remembered by all hurling fans, as Corcoran rose to new heights when the Rebels shocked the Cats 0–13 to 0–12 to win the All-Ireland. Corcoran was voted Hurler of the Year and received his second All-Star.

In 2004 Corcoran came off the bench against Limerick to famously shoot a point on his knees. He was part of Cork's All-Ireland triumphs in 2004 and 2005, earning an All-Star. Though Kilkenny halted Cork's three-in-a-row bid in Corcoran's last game for Cork, he signed off with a county medal after a memorable clash with Cloyne in which he shot two crucial points.

For over ten years no man had given more to the cause of Cork hurling and football than Corcoran, but at the age of 28 he shocked fans with his decision to retire. When Corcoran's name is brought up in conversation, the words 'burned out' always come up, mainly because people felt that he played too much hurling and football at all levels from a young age. Corcoran put the debate to bed, however, when he explained his reason for hanging up his boots.

'At the time, the whole structure of the GAA was mind-boggling, as just take 1991, when I played minor hurling and football with Cork. I was involved with senior hurling with Erin's Own and Imokilly and also part of the Cork senior football team. That brought my total to thirteen teams in one season,' he recalled.

'I was playing all these games week in and week out, and other players at the top level were lucky to be playing once a month. I am not personally blaming anybody because when I played I personally enjoyed it, but in later years it became a chore and I knew then it was time to say goodbye.'

BRIEGE CORKERY — CAMOGIE AND FOOTBALL

With eighteen All-Ireland medals across inter-county football and camogie, Briege Corkery is a true legend of the GAA. Both of Corkery's parents were involved in sport, and she and her siblings would have their own games in the garden. At ten years of age she began playing football with St Val's and camogie with Cloughduv, but she'd already been playing football with the boys' team at Aghinagh since she was five.

'Playing with Cork was never something I dreamt of doing, just something that happened.'

A golden age of camogie and football began for Cork in 2005, when they won both the camogie and football All-Irelands. It's only when Corkery looks back on that time that she realises how special it was. A winning culture, having the right management and the right people involved were crucial.

'Winning every match was very exciting,' she said. 'We did it a couple of times. We were always counting ourselves lucky.' The 2014 All-Ireland final ten-point comeback against the Dublin footballers is a highlight. 'It was phenomenal,' she said. 'The way the girls stepped up in the last ten–fifteen minutes, they really upped the ante. It was just a fantastic win.'

For camogie, the 2014 and 2008 seasons rank high. 'They were two years we really weren't expected to win,' she said. 'At the start of the year we just didn't know how we were going to go, but as the year was progressing, there was confidence building all the time.'

Éamonn Ryan in football and Fiona O'Driscoll in camogie were instrumental in Cork's success. 'Éamonn would have been a huge influence,' Corkery said. 'He made sure we were keeping our feet well on the ground and our heads weren't getting swelled from any winning. He said "last year's gone now, and we'll move on". It was great for us. 'Fiona O'Driscoll really brought a whole new level of professionalism. She made you more willing to train harder.'

Despite her personal successes in the game, including sixteen All-Stars, it's not something Corkery focuses on. She has yet to watch her own episode of Laochra Gael, a TG4 series which profiles GAA icons. 'It was always nice to get the chance to get one All-Star. It's all about the team around you. [Awards] didn't bother me in the slightest.'

At club level, Corkery has three County Senior Championship medals. In 2013 St Val's won their first Senior Cork Championship final, beating Inch Rovers.

'We really worked hard in 2013,' she said. Inch had played the camogie county semi-final the night before, which perhaps gave St Val's an 'extra edge.'

'After putting in all the hard work, a stroke of luck went our way, which every match needs.

'After the match I was nearly crying; I don't really cry after anything. I couldn't even believe it when the ref blew the whistle to say it was over. It was unbelievable.'

Undoubtedly, Corkery was an exceptional player for Cork, playing a key part in our glory days and running herself into the ground for the red and white jersey. She's an inspiration to players across the country.

"With eighteen All-Ireland medals across inter-county football and camogie, Corkery is an inspiration to players across the country."

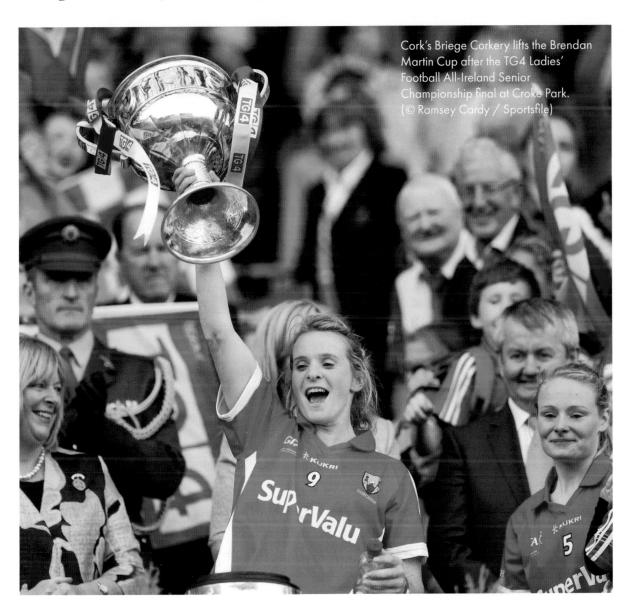

Cork's Briege Corkery lifts the Brendan Martin Cup after the TG4 Ladies' Football All-Ireland Senior Championship final at Croke Park.
(© Ramsey Cardy / Sportsfile)

*"The All-Ireland Club Football final of 2003 will live long
in the memories of the Nemo faithful."*

COLIN CORKERY — FOOTBALL

The skills of the former Nemo Rangers star Colin Corkery always stood out. Corkery, from Ballyphehane, began his footballing career in 1981 with Nemo Rangers. He attended Scoil Chríost Rí and Coláiste Chríost Rí, where he won the Munster Colleges Senior Football final against St Brendan's, Killarney, in 1989. The honours continued to flow at Nemo Rangers, as they won a minor city and county double the same year.

Corkery joined the club's senior ranks in 1990 but had to wait three years to win his first County Senior Football Championship title. He'll never forget 1994, as they won the All-Ireland Club Championship—another glorious day for the southside club, which, however, had to wait until the millennium year before winning the Cork County Senior Football Championship again. During the interim, Corkery built up quite a reputation for his free-taking. Following defeat by Crossmolina in the 2001 All-Ireland Club final, Nemo bounced back in 2002 to win their second consecutive Cork Senior Football Championship. That year they lost their second All-Ireland final to Ballinderry, a defeat that shattered Corkery and his team-mates.

'To lose one All-Ireland club final was bad enough, but when we lost the second it sent shock waves through the club. To be fair, we got together and pledged that if we came out of Cork and Munster there would be no way we would lose another final.'

Nemo went on to win the Cork Senior County Football Championship for the third time in a row. The All-Ireland Club Football final of 2003 will live long in the memories of the Nemo faithful, as they at last succeeded in breaking their sequence of defeats in the competition. Crossmolina of Mayo were once again their opponents, but in a truly terrific game of football the Cork side prevailed. Looking back, Corkery believes that the contribution made by coach Billy Morgan was immense on the day.

'Billy Morgan's influence is a major factor in the Nemo success story over the years, as it takes a special coach to come back after being beaten in two All-Irelands and instil belief into the team. That is what Billy is all about, getting players to believe in themselves, and remember he also did it with the Cork senior football team—that speaks volumes for the man.'

In 1989 Corkery won the U21 Football Championship with Cork, beating Galway 2–8 to 1–10. He made his senior championship début for Cork in 1993, as he contributed 2–5 against Clare. The Rebels reached the final against Derry, but a red card for Cork and a late Seamus Downey goal saw Derry win their first and only All-Ireland title.

In his time playing football, Corkery suffered from an irregular heartbeat that restricted his routine and prevented intense training, with the result that he gained excess weight at various times in his career. Thankfully, his attitude saw him through, as his kicking skills graced many pitches in Ireland. He will be remembered as a special talent in his beloved city.

MARIE COSTINE — CAMOGIE

The East Cork village of Cloyne has produced two of the greatest sportspeople ever to hold a hurley. It's the birthplace of the late Christy Ring as well as of camogie star Marie Costine, whose stirring displays at full-back made her famous in the 1960s and '70s. Born in 1947, Costine began playing at the age of seventeen for the Oil Refinery club, helping them to win a Junior Championship. Two years after her début in camogie she joined Youghal, where she remained until 1971.

Honours were hard to come by with the seasiders, and it wasn't until Cloyne set up its own camogie club that things began to change for Costine. Two years later, they won the 1973 Cork County Junior Championship title and the Intermediate Championship soon followed. Costine was part of the Imokilly divisional team that won four Senior County Championship titles between 1972 and 1975. Incredibly, she went on to win another four Senior County Championships, this time with Killeagh in 1980, 1981, 1982 and 1984.

Costine began playing for Cork in 1967 and won her first All-Ireland with them in 1970, completing the hat-trick with wins in 1971 and 1972. She captained the Rebels to All-Ireland victory in 1975, when they beat Kilkenny by a single point.

'It was a day I will never forget, as I was always proud to wear the jersey of Cork, but to captain the All-Ireland winning team was the proudest moment of my camogie career. The game itself was nail-biting from start to finish, but we just about held on for that memorable win.'

Back then, camogie was only twelve-a-side, but the Costine family were not far from fielding a full family team. In the 1973 Cork Intermediate Camogie Championship final, in which Cloyne were victorious, Costine and her six sisters all featured.

'It was unreal and unusual, but my six sisters Bunnie, Bernie, Kathleen, Rita, Geraldine and Ashlyn all played on the day and that meant a lot to all of us, playing together with our beloved club.'

Indeed, the family is steeped in sporting tradition, as Bernie is the mother of the former Cork senior hurling goalkeeper Donal Óg Cusack. Marie looks back on her career with pride but believes that more support at games is needed.

'The present-day players are a lot fitter, but to me attendances at games have not improved that much from my time, as all young people want to do is watch TV and play on their laptops and phones, and a lot of outdoor sports have suffered in a big way.'

After what could only be described as a remarkable career, Costine retired in 1987 at the age of 40 after twenty years of playing at the top level. If Ring is considered the king of Cloyne, then surely Costine would be classed as queen, as her sporting honours in camogie are another great chapter in Cloyne's history.

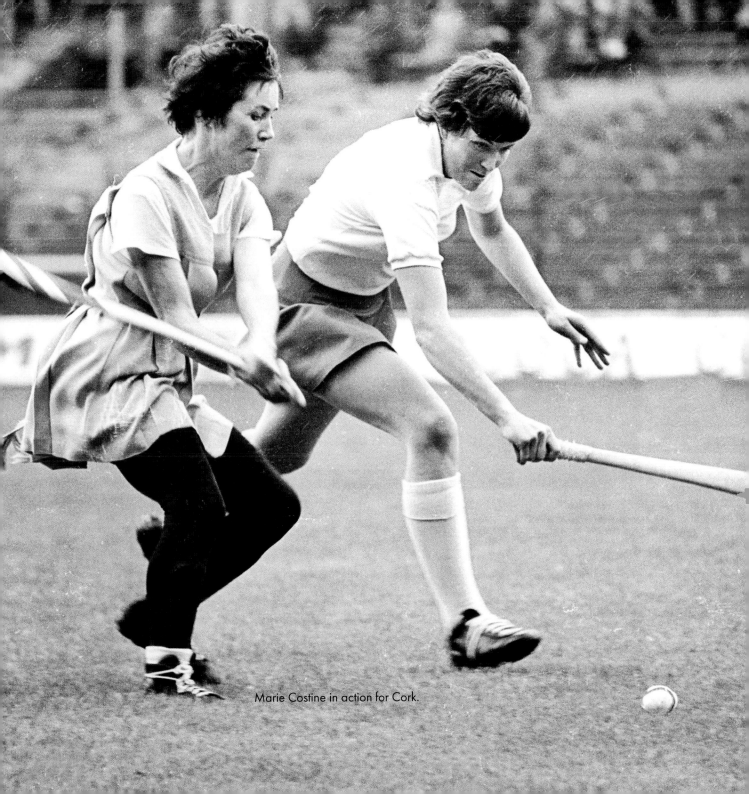

Marie Costine in action for Cork.

"The first man to captain Cork to win the Munster Senior Football Championship twice"

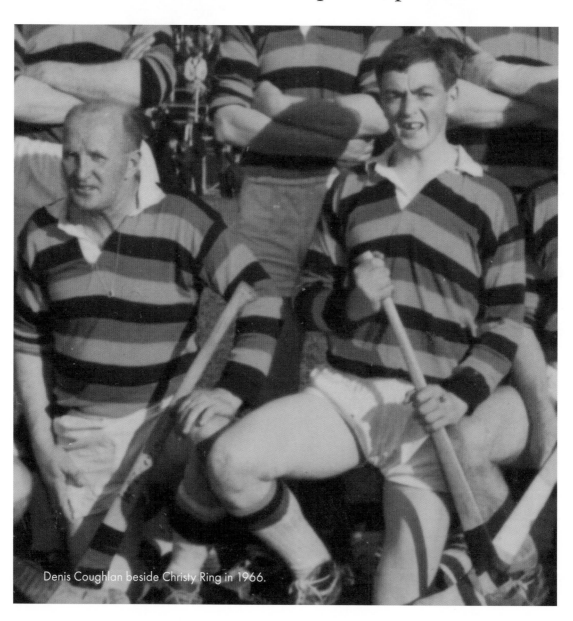

Denis Coughlan beside Christy Ring in 1966.

DENIS COUGHLAN — HURLING AND FOOTBALL

The Glen Rovers club from Blackpool has produced some of the greatest hurlers of the last century. Greats like Christy Ring, Jack Lynch and Charlie Tobin were all players of rare quality who played with this famous club. The name of Denis Coughlan is another outstanding one in that long list of players, as he was immense for the side in the 1960s and '70s.

Born in 1945 at Maddens Buildings, he began playing with Cuchulainn's in the juvenile section of Glen Rovers, run by Jimmy O'Rourke. After a series of disappointments at underage level, fortune began to smile on Denis in 1964, when he won an All-Ireland junior football medal with Cork. In the same year, he won his first Cork senior hurling county medal with Glen Rovers, and a year later added his second hurling championship as well as helping sister club St Nicholas to a senior football title. Coughlan captained the Cork senior footballers in 1967, but they came up short in the final and lost to Meath 1–9 to 0–9.

Coughlan suffered more disappointment in 1968, when the Cork senior hurlers were easily defeated by Kilkenny in the All-Ireland final, and the following year, after he was dropped, Cork won the title but the elusive medal passed him by. Throughout this period he was the most consistent dual hurler and footballer, but in 1972 he suffered a third All-Ireland defeat when Cork lost an eight-point second-half lead, as Kilkenny once again broke the hearts of Leesiders. There was consolation that season when he won a senior county medal with the Glen and also picked up his first All-Star award.

A year later, his hard work began to bear fruit when he played centre field in the Cork football team that defeated Galway 3–17 to 2–13 in the All-Ireland final. In 1974 he became the first man to captain Cork to win the Munster Senior Football Championship twice. After their magnificent win against Kerry, Cork were hot favourites to retain their All-Ireland crown, but they were stunned in the semi-final when they lost to Dublin. After a two-year break, Coughlan returned to the field in 1976. Over the next five seasons he won three senior All-Ireland hurling titles with Cork, in 1976, 1977 and 1978, with three All-Stars in the same years. He also won four Munster hurling medals and a National Hurling League medal in 1980.

Medals and trophies aren't the most important thing when you're playing sport, according to Coughlan.

'Some of the greatest people I have met have been involved in the GAA, where I developed a lot of close friendships. as you can only play sport to a certain age but friends and friendships should last a lifetime.'

True words from a gentleman in every sense of the word, whose contribution to Cork will always be respected.

EUDIE COUGHLAN — HURLING

Blackrock hurling club has produced many superb hurling stars since its foundation, but one name that will always be synonymous with the Rockies and Cork is that of Eudie Coughlan. As a young boy, he swung his first hurley on a grassy pitch at the 'Pound'.

He played his first senior game for Blackrock in 1918 against Kinsale and his class caught the eye of the Cork selectors. He won his first senior All-Ireland medal as a sub with Cork in 1919, the Rebels' first All-Ireland in sixteen years and the first time they wore the now-famous red and white jerseys. Seven years later, Coughlan was one of ten Blackrock men on the Cork team that won the 1926 All-Ireland title, defeating Kilkenny in the final. After two further All-Ireland medals in 1928 and 1929, Coughlan proved to be the master again in the 1931 final, where it took three games to decide the eventual winner. Kilkenny looked to be on their way to victory in the first game, when they led by a point in the closing seconds, but right at the death Coughlan scored a brilliant point on his knees that forced the game to a replay. The second game is rated the best hurling All-Ireland final in the history of the sport. After that hectic encounter, the third game was anti-climactic, with Cork having a comfortable 5–8 to 3–4 win. That win was a dream come true for Coughlan, as he captained the victorious team, and with great pride he accepted the All-Ireland trophy from the Bishop of Hobart on that cold November evening in 1931.

The 1931 finals were still fresh in the minds of hurling supporters when the news of Coughlan's retirement hit the national newspapers. Many of the Cork faithful couldn't believe that the 31-year-old had called it a day so early in his career. Coughlan later revealed that the county board had taken the selection of the Cork team away from Blackrock, which incensed him after the success of the team and made him walk away from the game, but many pundits felt that there was more to his retirement than the county board decision.

He once told a close friend, 'You know, it used to take me a fortnight to get over a game and feel normal again. I know it was a great honour to represent your club and county but I sometimes wonder was it worth all that pain.'

Perhaps Coughlan felt that a decade in the red jersey was enough, as he had given the best that any player could dream of giving and was retiring before his admirers could detect a decline in his brilliance. He left behind memories of a truly great player, with 1931 not only the conclusion of his career but also the end of the golden era of Cork hurling from 1926. Coughlan was one of the best.

"On a cold November evening in 1931, Coughlan accepted the All-Ireland trophy from the Bishop of Hobart."

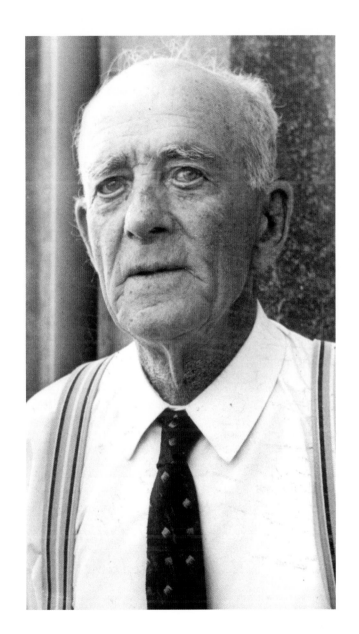

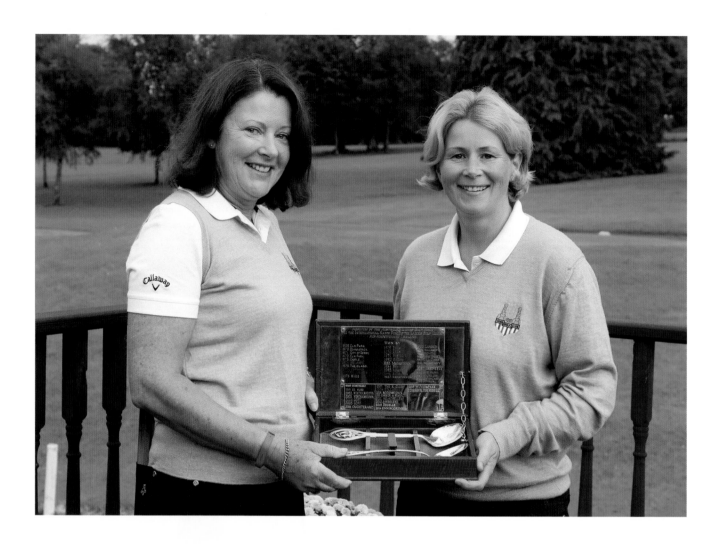

"The will to win, coupled with her unbelievable skill, has always been the hallmark of Coughlan's game."

Claire Coughlan and Oonagh Barry, winners of the 2017 Australian Spoons All-Ireland Final.
(© Jenny Matthews, cashmanphotography.ie)

CLAIRE COUGHLAN — GOLF

As one of Cork's finest golfers, Claire Coughlan has shown her class on the country's golf-courses for over 27 years. She began playing in 1980 at the age of ten, mainly thanks to a lot of encouragement from her grandfather, Mick Twohig.

'My house was only 100 metres from the first tee and my grandfather was stone mad on golf, and for many years he caddied for me and was the inspiration to me since I began playing,' said Coughlan.

By the time she was fourteen, Coughlan had already been crowned U16 Irish champion, and two years later landed the Munster Championship. In 1997 she produced another majestic display to win the Midlands U18 championship. It wasn't long before the Cork girl's talent caught the eye of the national media, and in 1998 she was named Irish Junior Golfer of the Year. The following year was another historic one for Coughlan, as she won four major championships, including the Lancôme Irish Ladies Close Championship.

'I also won the Lahinch Irish Open but the win in the Irish Scratch Cup was something special, as over the years, when I won championships, I always tended to treasure the moment, as there is always more downs than ups in all sports.'

It's always special to win the local Scratch Cup and Claire was on the winner's rostrum in 2000, and was ever-present on Munster and Irish teams for many years. There was disappointment in 2000 when she lost out in the Irish National Strokeplay Championship, but a year later she won the Munster championship. In 2002, despite losing some of her form, she retained her Munster championship title, and another dazzling performance helped her win the inter-provincial title at Mount Wolseley near Carlow. The will to win, coupled with her unbelievable skill, has always been the hallmark of Coughlan's game but, as she herself says, it was never easy to remain a top player in this country.

'Golf is no different to any other sport, as you need to be very dedicated with your preparation to compete with the best, as I have had a few seconds in my time,' she said. 'But sometimes it is not easy to make that final step, as Pádraig Harrington found out on a few occasions.'

In 2003 Coughlan once again showed great form with Munster in the inter-provincial championship and took silver medals in the Cork and Lahinch Scratch Cups. A trip to the Helen Holm Scottish Championship saw her finish a credible fifth against the best players in Britain and Ireland. She played with the Irish senior ladies team for four years and was omitted in 2002.

After showing some dazzling form, Coughlan was named one of six new caps on the 2004 Great Britain and Ireland Curtis Cup team to face the United States. Although on the losing side, Coughlan won all three of her games and was the sole player of that side to make the 2006 team that lost 11.5 to 6.5 to Oregon. In a career that took her to the top level of the sport she will be remembered for her undoubted class, both on and off the golf-course.

SHANE COUGHLAN — BASKETBALL

Former UCC Blue Demons star Shane Coughlan will be remembered as one of the best produced by the Sundays Well club. At seven years of age he joined the Demons nursery under the guidance of Seánie Murphy. At juvenile level, it was noticeable from an early stage that Coughlan was a star in the making when he was voted MVP twice in the prestigious Billy Kelly tournament that attracts the élite sides to Cork.

Before Coughlan graced the courts, his late father, Peter, had played with the Demons at the top level, and his Uncle Joe was a former Irish senior international. Anyone who had followed the Irish game over the 'noughties' at Super League level would be familiar with the casual grace with which his father played. For a few years in Cork city, basketball was the only show in town. Who could forget the packed Parochial Hall in Gurranabraher and the Neptune Stadium?

With basketball in his veins, it was natural for Coughlan to try and ensure that his club would reach the summit of the sport. It began for him in the 1998/9 season, when he first played in the Super League. After winning nine National Cups and three Super Leagues and captaining teams unbeaten through the 2014/15 season, the mojo came to an end in the summer of 2015 after travelling to China. At 36, he couldn't accept getting little or no time on the court. He recalled that nightmare tour.

'I had worked so hard over the season to win the treble with Demons, and whether the coaching staff thought they were giving me a junket, they certainly didn't understand the real Shane Coughlan.'

To have played at Super League level for eighteen years and been awarded MVP in consecutive cup finals is some achievement, but Coughlan believes that it's not about individuals.

'Thankfully, I played with some outstanding Irish and American players, but for me Niall O'Reilly was the best signing Demons made, and crucial to us during our glory years.'

The debate about quality American players is always interesting, and Coughlan summed up his experience of playing with professionals.

'I think in different years Patrick Pope and James Singleton were great players you could look for when games were on the line, and I really enjoyed playing with Lehmon Colbert at the end of my career, as he was strong in the post and knew when to dish it out and when players were in better scoring positions.'

Sadly, Coughlan's father died in August 2018. 'It was a tough day for all my family but, when I look back, I do honestly think he was proud of my achievements in the sport, but always kept his feelings close to his chest.'

The greatest sportspeople in the world are sometimes unassuming individuals, and it was Coughlan's habit of always doing his talking on the court that easily put him into the Leeside Legend category.

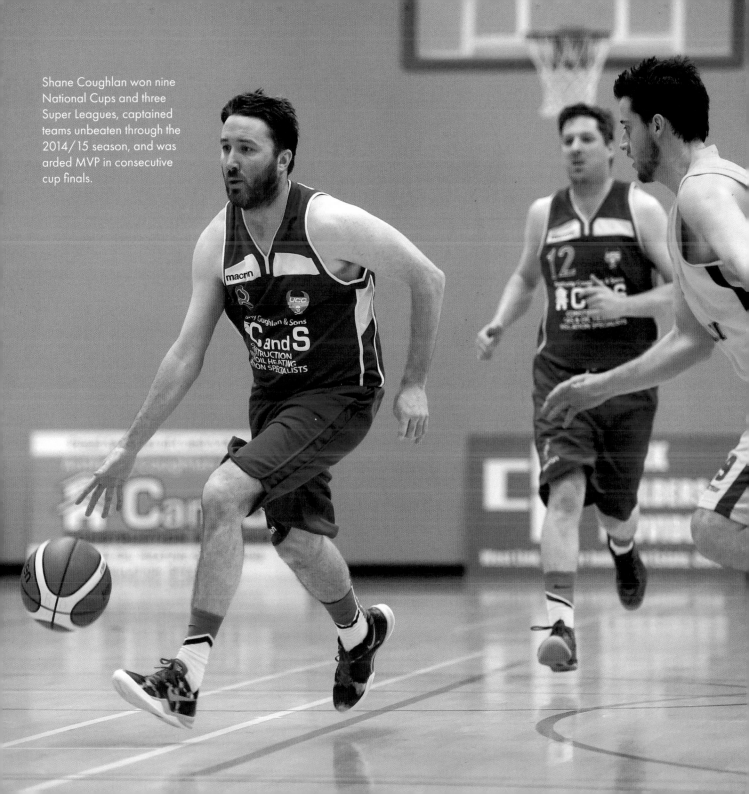

Shane Coughlan won nine National Cups and three Super Leagues, captained teams unbeaten through the 2014/15 season, and was arded MVP in consecutive cup finals.

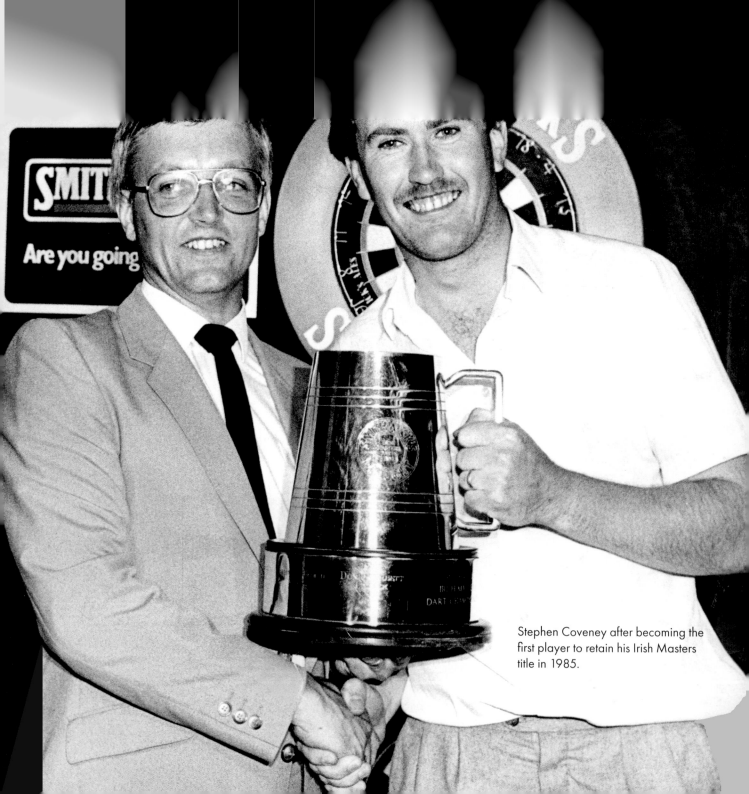

Stephen Coveney after becoming the first player to retain his Irish Masters title in 1985.

STEPHEN COVENEY — DARTS

Stephen Coveney's record in darts over 36 years made him a household name in his beloved city. Reared on Cork's north side, Coveney took up the sport in 1979, beginning his career in the Boothouse Bar. He won his first singles tournament in 1982, and a year later was crowned the Benson and Hedges Munster Singles Champion. The list of his achievements in the years that followed is mind-boggling, as he won the Cork Murphy's Irish Stout Singles tournament in 1986, 1989, 1990, 1993, 1996 and 1997. He added another eight titles from 2002, coupled with three Beamish Doubles Championships. He also won seven Cork Summer Singles titles, a record that has never been beaten.

When a player dominates his own city's darts tournaments, there is only one way to find out how good he really is. For many years Coveney was determined to mix it with the best players in the country. In 1985 and 1986 he became the first player to retain the Irish Masters titles. He also has the distinction of reaching the last 32 of the World Masters in London, where he lost to the eventual winner, Dave Whitcombe of England.

Coveney was a leading figure in the Con O'Donovan's pub team that set a record when completing a five in a row in the prestigious Smithwick's Cup. This was a major achievement, as it was considered the toughest team competition in Cork darts.

The names of famous dart players like Eric Bristow, Bobby George and Cliff Lazarenko were well known on the British professional circuit, but they all lost to Coveney during exhibition games in Cork over the years.

According to Coveney, the sport requires serious practice to stay on top of your game.

'To get to the top in darts you have to practise regularly, as the days of turning up on Monday night and playing with your local team are now well and truly gone,' he said. 'The majority of the top players have a dart board at home and consistently practise every night.'

He believes that the sport has grown significantly. 'There is a huge following for the sport all over the world, and that's justified by the viewing figures from Sky for the World Championships.'

After a glittering career, Coveney retired from competitive darts in 2018, as he felt that he had achieved everything he set out to do over four decades.

'I always said I would retire at the top, as there was nothing left for me to win, but I still enjoy a Friday night in the Joshua Tree, having a game with the lads.'

The winning of individual championships over four decades testifies to the brilliance that Stephen Coveney brought to the sport of darts, and his winning mentality ensured that he will be remembered as one of the all-time greats.

JOHNNY CROWLEY — HURLING

They didn't come much better than the sterling and stout-hearted defender John Crowley, who was born at Enniskeane in 1956. Following his Intermediate Certificate (Junior Certificate) exams, Crowley moved to St Finbarr's Seminary College in Farranferris in September 1973, where he helped them win their third Munster Colleges Dr Harty Cup. In 1974 Crowley commanded the centre-back role as his school won another Harty Cup title and went on to be crowned All-Ireland champions at the expense of their old rivals St Kieran's of Kilkenny. That year, Crowley completed a double with the Cork minor hurling and football teams, a feat that has never been replicated since that year.

He joined the Cork senior hurling panel in late 1975 and by the following September had established himself as the number one centre-back. The Bishopstown player won the first of his senior All-Ireland medals in 1976 when Cork defeated Wexford, and further victories over Wexford and Kilkenny in 1977 and 1978 made it a hat-trick of medals. There was major disappointment for Crowley in 1982 and 1983, when they lost consecutive finals to Kilkenny, but that was soon behind him in 1984 when the Rebels defeated Offaly in the Centenary decider at Thurles. Many of the shrewd pundits that day regard his performance in that final as his finest in a Cork jersey.

Two years later, he took his senior All-Ireland medal haul to five when they shocked red-hot favourites Galway. There's little doubt that Crowley was Cork's most consistent performer between 1976 and 1986, and how he didn't receive more than one All-Star (1984) over a decade beggars belief.

Crowley retired from inter-county hurling in 1987 and finished his club career with Bishopstown in 1989. He became a selector with the Cork senior hurling team and helped guide Cork to 1999 success under coach Jimmy Barry Murphy. He joined ranks with Barry Murphy again from 2011 to 2015.

'Jimmy was always a fantastic friend and team-mate and played a leading role with us winning in 1999, and his contribution both on and off the park to Cork was remarkable.'

Speaking about his illustrious career, Crowley only had one regret: 'Not winning a county medal with Bishopstown, as I will always hold this club close to my heart'.

He added: 'Playing for my county was a huge honour, as I was very fortunate to play with some outstanding hurlers over the years. Cork supporters have a serious passion for hurling that is almost beyond belief, and it was a privilege to help bring All-Ireland success to this great city.'

"it was a privilege to help bring All-Ireland success to this great city."

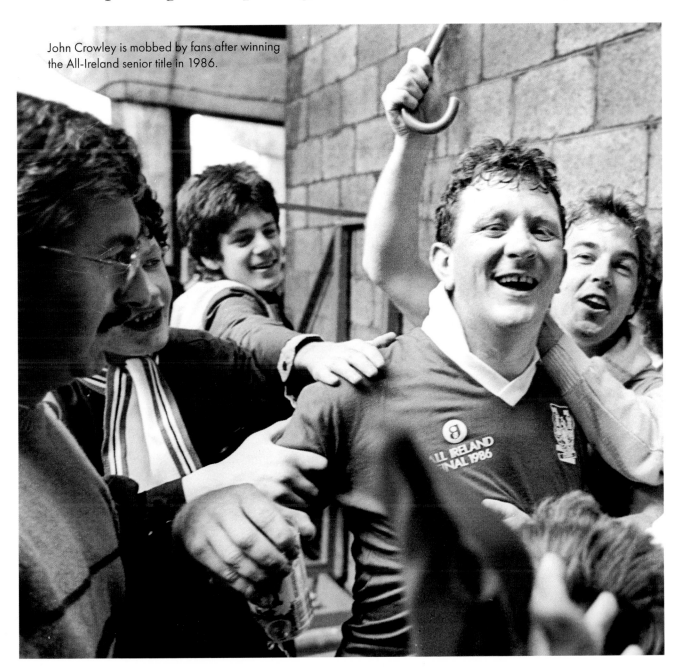

John Crowley is mobbed by fans after winning the All-Ireland senior title in 1986.

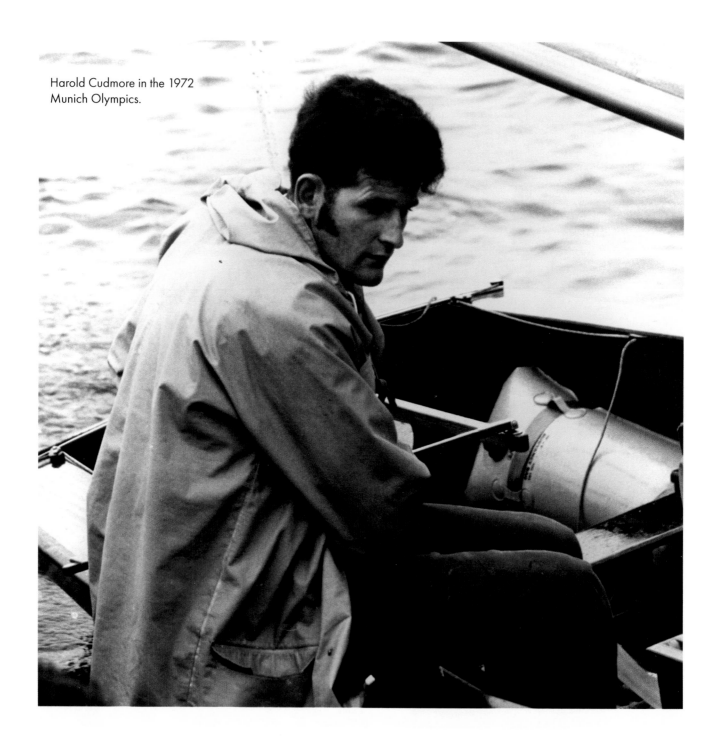

Harold Cudmore in the 1972
Munich Olympics.

HAROLD CUDMORE — YACHTING

It's a sad fact that one of Ireland's and Cork's most successful international sportsmen is better known outside his own country than at home. Ireland's top yachtsman, Harold Cudmore, has represented Ireland on numerous occasions all over the world. During his career he gained several firsts in single events and has been a revelation over many years in his beloved sport.

Cudmore comes from a well-known Cork family and was educated at the Christian Brothers' College. During his youth he developed a keen interest in sailing and by the age of sixteen he had established himself as something special. He was prepared to sail in anything from a Cadet dinghy to one of the beautiful cruisers that graced the harbour, and he amassed a huge amount of expertise in a relatively short period. He achieved his first success at national level sailing in Enterprise dinghies, a class that is still recognised as ideal for young sailors to acquire the skills and seamanship that will hopefully produce the experts of the future.

He came to international prominence in the 1950s and '60s, and with Chris Bruen (son of the late golfer Jimmy) as his crew had excellent results in the World Championships. Perhaps the most notable achievement was a second place in the 1969 championships in Argentina. Cudmore moved to the Flying Dutchman class in 1971 with the aim of being selected for the 1972 Irish Olympic team. He achieved this aim and, crewed by Richard O'Shea of Crosshaven, represented Ireland with distinction in Kiel, Germany.

A campaign for the 1976 season was planned, using the undoubted talents of the Ron Holland design team. Some subtle modifications to the extremely fast *Silver Shamrock* produced a yacht that everyone hoped would be even quicker. The budget was very limited, but an outstanding performance at Cowes Week, where they won all six races against some of the hottest competition in the world, gave them a huge boost in their attempt to win the World Half Ton Cup Championship in Italy. A journey across Europe by trailer and a car that had seen better days was in itself notable, as they found that the only way to keep the car from continually overheating was to drive with the bonnet open—a source of much amusement for the natives of France, Germany and Italy. Against the best in the world, a team of Corkmen led by Cudmore achieved the most remarkable success in the history of Irish yachting by winning the coveted trophy.

Cudmore won the British Championship five times, and had major wins in the USA, Australia, New Zealand, Italy and France. The 1981 season will be remembered for two main reasons. First, Cudmore was in the wars when skippering the Australian yacht *Hitch Hiker* in the Admiral's Cup series; more importantly, he got involved with Frank Woods of Dublin in what was to become the World One Ton Cup-winner *Justine 3*.

Cudmore was well known and respected as a master tactician and was considered to be one of the top two or three in the competitive field of match racing. He is saluted for his magnificent achievements and for the excellent way in which he brought recognition to the city of his birth and to Ireland.

RAY CUMMINS — HURLING AND FOOTBALL

Blackrock's Ray Cummins brought a new dimension to forward play in both hurling and football. He had an excellent role model in his father, Billy, who was a prolific player with the Cork minor hurling teams of 1938 and 1939. Cummins won his first Senior All-Ireland Hurling Championship in 1970. It was the turn of the big ball in 1973, when he played on the Cork side that won the All-Ireland Senior Football Championship.

'There is a tremendously loyal football following in Cork, and it was only when we brought the trophy to different places that we could appreciate what it meant to those people.'

From 1976 Cummins was an integral part of the hurling team that completed the elusive treble, bringing his medal tally to five. He was equally busy on the club scene with Blackrock, as they won the Cork Senior Hurling Championship in 1971, 1973, 1975, 1978 and 1979. On top of this incredible record, he helped Blackrock to All-Ireland club success in 1971, 1973 and 1978. His genius and artistry were recognised when he won a hurling and football All-Star in 1971 and 1972, followed by another football one in 1973 and his last hurling All-Star in 1977.

Cummins named Derry Cremin and Joe McGrath as the two most influential men in his career. Playing the game fairly and forging friendships was more important than winning medals for the Blackrock man.

'I enjoyed the camaraderie between players and the spirit that was built up, whether you won or lost. To me, the most important thing was the friendships, but while I was out in the field I always tried hard to win.'

Contemplating the great opponents that he faced, he said: 'I look back with most satisfaction on the players I played directly against and in Limerick's Pat Hartigan we had some great battles on the field, but we always shook hands at the final whistle.'

The present standard of football worries Cummins. 'I think there is an over-emphasis on the physical side of the game, and I would like to see more coaching given to quick and accurate kicking that I am sure would be more fruitful for all concerned.'

Winner of almost every honour in the game and twice a captain of All-Ireland-winning teams, he surely will never be forgotten by his legion of Cork fans, who simply loved his style and sheer class.

"Winner of almost every honour in the game and twice a captain of All-Ireland-winning teams, Cummins was an integral part of the hurling team that completed the elusive treble."

Ger Cunningham, Brendan O'Sullivan, Denis Walsh and coach Fr Michael O'Brien celebrate Cork's victory over Galway in the All-Ireland hurling final at Croke Park, 1990.

GER CUNNINGHAM — HURLING

One of the strengths of Cork hurling over the years has been the excellence of its goalkeepers, as a succession of dependable men between the uprights has provided the cornerstone for our All-Ireland-winning teams. In truth, Ger Cunningham was one of the best ever to don the red and white jersey of Cork. Born in 1961, like many other youngsters in this community he began playing in the St Finbarr's Street Leagues.

'The games would always be on Sunday mornings and were witnessed by large crowds who would stop and watch on their way home from church. If you were lucky enough to get to the final, you would change at the Lough Community Centre and a band would play both teams down the hill to the pitch.'

When he joined the Cork minor ranks his keen eye and fast reflexes brought him to the fore, and he won two minor All-Ireland medals in 1978 and 1979. He soon broke into the Barrs' senior team and the county medals began to flow, with victories in 1980, 1981, 1982, 1984, 1988 and 1993. They weren't very lucky at national level, as they lost the 1981 All-Ireland Senior Club final to Shamrocks of Kilkenny, but Cunningham believes that winning the county championship was the most important thing at his club.

'Without making excuses, I do not think we looked at the All-Ireland Club Championship seriously enough, but in the present era it is a major title to win. But back then it was all about winning in Cork and that's all that mattered to us.'

He broke into the Cork senior hurling team in 1980 in a challenge game against Kilkenny. The Centenary All-Ireland final against Offaly in Thurles gave him his first medal, and two more followed in 1986 and 1990. His artistry was appreciated at national level and he received All-Stars in 1984, 1985, 1986 and 1990, as well as the Texaco All-Star in 1986.

Cunningham is modest about his success. 'I was lucky along the way that I stayed injury-free, and the selectors who picked the teams obviously felt I could do a job for them and at the end of the day I am thankful, as it was a bonus to have got so far in the game.'

In 1999 Cunningham called time on his career at the age of 38, but the previous year is one of which he can justifiably be proud, as he captained the Barrs to a senior county Championship win.

'To captain my club to a Senior County win was very special for me, as my parents Jim and Mary were Barrs people all their lives and I wanted to do it so much for them.'

Cunningham had a stint as manager of the Dublin hurlers but is now back with the Cork management team under Kieran Kingston. If good goalkeepers are worth their weight in gold, Cunningham is priceless.

WILLIE JOHN DALY — HURLING

Willie John Daly of Carrigtwohill was a brilliant hurler and one of the star figures of the Cork side that won a hat-trick of All-Ireland Senior Hurling Championships from 1952. Although Daly was small in stature, he was renowned as one the toughest players of his era. He played hard, gave the knocks without apology and took them without complaining.

Daly was born in Carrigtwohill in 1925 at a time when hurling was enjoying great success in the parish. From the outset of his distinguished career, he took inspiration from his own boyhood hero, Tom Barry, who won his third successive All-Ireland in 1931. From his early days Daly thought about nothing else but hurling, and Carrigtwohill meant an awful lot to him, as he consistently put his club ahead of everything else.

A standout goal for Daly came against Tipperary in the 1948 National League final, when he blasted the ball past Tony Reddin, one of the best goalkeepers of all time. He loved playing against Tipperary and believed that those famous Cork–Tipp games did much to enhance the sport over the years. In 1952 Cork put a stop to Tipperary's four-in-a-row bid, beating them in the provincial championship by 1–11 to 2–06. They went on to win the All-Ireland that year against Dublin 2–14 to 0–07, retaining the title in 1953 and 1954.

Daly believed that the three most important traits for hurling are skill, dedication and heart, pointing out that the hurlers of Cork had these qualities in abundance during his time playing with the county.

Before his death, Daly opined that the modern players were not better than those of his era.

'There is no first-time hurling now like the stuff we played, and when is the last time you saw a goalie puck a ball out and a midfielder double on it in the air and send it up to the other end of the field?' he asked. 'The art of doubling is gone and with it the speed of hurling that is so essential.'

Some of the toughest players that Daly faced included Mickey Byrne, Pat Stakelum, Tommy Doyle and Jimmy Finn of Tipperary, Seán Herbert of Limerick, Ned Wheeler of Wexford and Vinny Baston of Waterford. You will rarely come across a man who derived so much enjoyment from talking about his favourite sport.

He believed that his friend and team-mate Christy Ring was the greatest hurler ever.

'It was an honour to play with him and our friendship was a close one, even after we both retired from the game.

'He used a hurley four ounces heavier than usual and he could wield it with no trouble, and looking at him striking the ball, it was like a bullet because he had [the] wrists and the power to swing it.'

Up to his death in 2017 at the age of 92, Daly's love for hurling was unquestionable, and he will always be remembered as the fearless powerhouse of his era.

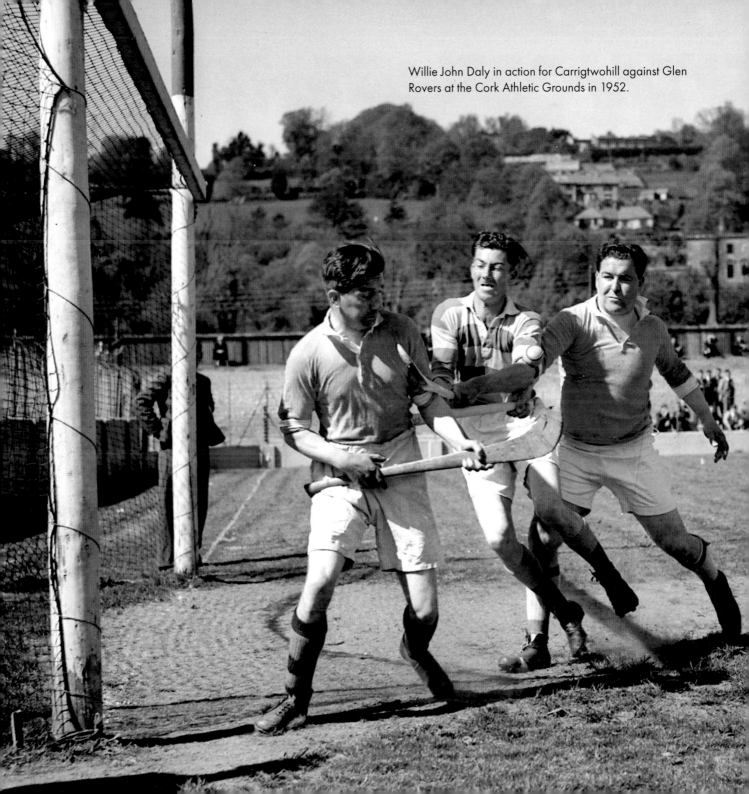

Willie John Daly in action for Carrigtwohill against Glen Rovers at the Cork Athletic Grounds in 1952.

Cork Hibernians players (from left) Frank Connolly, Joe O'Grady, Miah Dennehy and John Lawson celebrate after winning the League of Ireland play-off decider against Shamrock Rovers at Dalymount Park, Dublin. Dennehy scored twice in Hibs' 3–1 victory.

MIAH DENNEHY — SOCCER

One of the biggest names in Cork soccer in the 1970s was the former Cork Hibernians star Miah Dennehy, whose scoring skills made him a household name nationally.

It was his talent on the GAA pitch with St Vincent's hurling and football club that got him noticed initially. A ban by the GAA at the time restricted Dennehy to playing the odd game of soccer with his uncle's club, Northvilla on Cork's north side. Word of his talent spread, and through the late Paddy Long he was introduced to the then manager of Cork Hibernians, Amby Fogarty. Fogarty invited him to the Mardyke to play for Hibs against UCC in the 1969 Munster Senior Cup, and he scored four goals in their 5–4 win.

Dave Bacuzzi, who took over the reins of Hibs, quickly identified Dennehy's immense talent and made him one of the cornerstones of his team. He was paid five pounds a week, a paltry amount when you consider what some of the top players are presently earning. Hibs became the giants of Irish football, and with talented players like Sonny Sweeney, John Lawson and the late Dave Wigginton, to name but a few, they won the League of Ireland in 1971.

In 1972 Dennehy became the hero of Cork when he scored a hat-trick in Hibs' epic FAI Cup win over Waterford. Fifty years on, it isn't the goals that remain foremost in his mind but being chaired from the field and the songs sung in the dressing room afterwards.

'It was certainly the greatest day of my life, and after the game I realised what this success meant to the people of Cork,' said Dennehy.

The cross-channel scouts were out in force to secure Dennehy's signature and it was Dave Mackay who brought him to Nottingham Forest. He had a good spell under Mackay but the arrival of Brian Clough as manager was to see the end of his playing career with the side. He went on to play for Walsall and Bristol Rovers.

'For some reason Brian Clough didn't like me, and I never got the chance to fulfil my true potential with him.'

In his international career, Dennehy got eleven senior caps for Ireland, three amateur caps and one U23 cap. He showed his true class against Poland in 1973, when he scored the only goal of the game. That goal made him a folk hero for the Irish fans, but it was the local derby games between Cork Hibs and Cork Celtic that were always special.

Years after being released by Forest, Dennehy met up with Clough at a squash club where he used to work out. After watching Dennehy play a game, he remarked, in typical Clough fashion, 'If I knew you could play squash so well I never would have sold you'.

Dennehy played with Mayfield side Village United in the Cork AUL until he was 51. He will always hold the Cork sporting football public near to his heart, as he believes that they are the greatest in the world.

JACK DOYLE — BOXING

Jack Doyle, the Gorgeous Gael from Cobh, was tabloid material in an age without tabloids. A larger-than-life character, Doyle was a major celebrity whose claim to fame was that he could sing like John McCormack and box like Jack Dempsey. Born Joseph Doyle in 1913, at the age of twelve he began working on the coal boats and was well able for the tough and demanding work. It was about that time that he began reading How to Box by Jack Dempsey, who was then regarded as one of the greats of heavyweight boxing, and it was to have a profound influence on young Doyle. He decided there and then that boxing was to be his sport and changed his name from Joseph to Jack in honour of his boxing hero.

At the age of sixteen he applied to join the Irish Army but was turned down on account of his age. He was then accepted into the British Army without being asked for his birth certificate, and he represented the Irish Guards in the Defence Forces Boxing Championships, as there wasn't a boxer to match him in any of the forces. He left the British Army in 1931 to commence training as a professional boxer, leaving behind him an unbeaten record of 28 undefeated fights—incredibly, 27 of those victories were by knockout.

Doyle's first professional fight was at London's Crystal Palace on 4 April 1932 and his opponent, Chris Goulding, was floored within seconds. The fight was all over in 30 seconds, as Goulding couldn't withstand Doyle's power and was knocked down a second time; the victory earned Doyle £50. He went on to win his next six professional fights, including four knockouts. In October 1932 he fought the highly rated Jack Pettifer and duly knocked him out in the second round, earning £750 for his efforts.

The following year he fought Jack Petersen but was sensationally disqualified in the second round for hitting his opponent below the belt. Doyle's troubles didn't end with the boxing authorities, known as the British Board of Control; he was due to be paid £3,000 for the Petersen fight, but they held back the money pending an investigation. He took the case to the high court and won but the Board of Control appealed the case and reversed the original decision. To add to Doyle's problems, he was having difficulties with his managers. The pressure finally got to him, as he grew tired of the officialdom and declared that he would never fight again.

Doyle left for the US, where he mixed with the rich and famous, with film stars Errol Flynn and Clark Gable being among his many drinking buddies. After a string of failed relationships, he went from bad to worse, and at one stage was left homeless after his 29-year relationship with Nancy Keohane ended in 1976. Socialising and drinking took its toll, and in December 1978 he died homeless and destitute. His immense talent will never be forgotten by the boxing fraternity of Ireland, especially in his home town of Cobh.

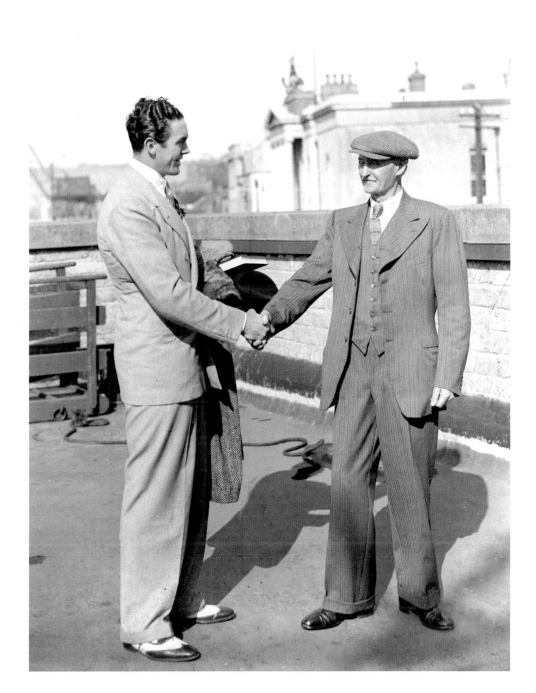

Jack Doyle (left),
the Gorgeous Gael,
arrives in Cork for his
21st birthday.

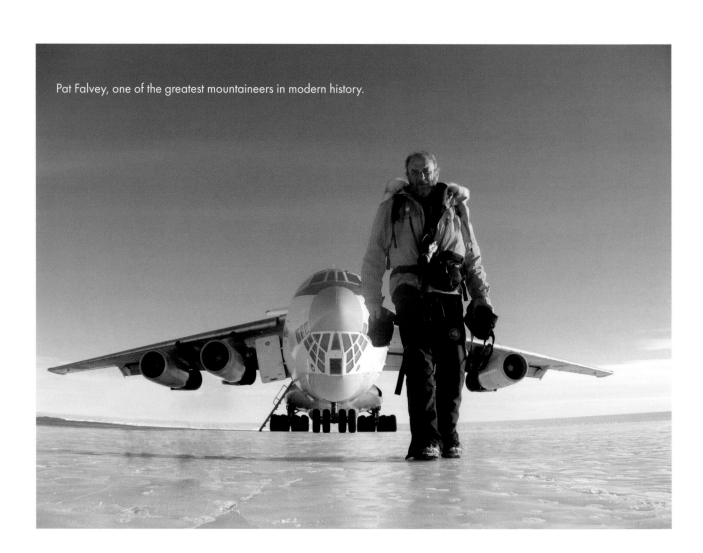

Pat Falvey, one of the greatest mountaineers in modern history.

PAT FALVEY — MOUNTAINEERING

Pat Falvey was a full-time adventurer who has set records beyond belief since he took up the sport in 1986. Reared in Bakers Road, his story is quite inspiring, as it shows what determination can do for any person.

Falvey left school when he was fifteen and joined his father's construction company. At the age of 23 he was a millionaire, but six years later he was broke and depressed. By his own admission, Falvey is a changed man from the millionaire of the 1980s. That change started in 1985, when he got involved in too many ventures and lost his fortune.

'What happened is probably the best thing that ever happened to me, even though I didn't see it that way at the time,' he said. 'I still have the old aspirations I have as a businessman, but I have taken them into a new arena.'

The road to recovery began when Falvey did a mountain walk with Val Deane at Mangerton in Kerry, and on his way down remarked that he would like to walk Carrauntoohil.

'Val laughed, but he decided that he would walk with me a week later, and once again I was getting more and more confident, enjoying every step I made, and after this venture my ambition was that one day I would walk Everest,' he said.

Falvey joined the Kerry Mountain Rescue team in 1987 and, with the encouragement of his grandmother, he was determined to be a top climber. In 1991, under expedition leader Con Moriarty, he climbed the Himalayas—a great achievement given that he hadn't been long in the sport.

In 1992, on Falvey's first climb of Everest, one of his fellow climbers—Mark Miller, a 29-year-old Scotsman—died suddenly, and that experience was shattering for Falvey. The expedition failed to reach the summit, being beaten back by horrific weather conditions. Determined to succeed, Falvey reached the summit in 1995 and again in 1997. He ascended Everest via the South-Southeast Ridge and led the expedition that saw the first Irish woman, Dr Clare O'Leary, reach the top. Falvey and O'Leary completed the Seven Summits on 16 December 2005. Falvey was the first person in the world to have climbed Everest from the Tibet and Nepal sides, including scaling the Seven Summits twice. He has climbed Mount McKinley in North America, Elbrus in Russia, Kilimanjaro in Africa, Aconcagua in South America, Mount Vision in Antarctica and Carstensz Pyramid in Australasia.

Falvey has led 36 successful expeditions all over the world and has spent time with people from over 40 fascinating tribes while investigating their ways of life. Outside of his adventuring, Falvey is a motivational speaker, sharing his philosophy and beliefs on how best to find success and fulfilment in everyday life.

Falvey's life is a story of successes and failures, disappointments and triumphs, and how to turn adversity into advantage. It's a sketch of the effects of living life with an optimistic outlook and of how to turn negatives into positives.

JOHN FENTON — HURLING

Every now and again a county produces a hurler of exceptional ability, one who seems to have that little bit extra that marks him out as a player apart. In a county like Cork where superstars are common, John Fenton of Midleton certainly left a big imprint during the 1970s and '80s.

Fenton was one of the mainstays of the side that won the Cork Intermediate Hurling Championship in 1978. Unfortunately, Midleton's first four years in the senior ranks were to end in disappointment, as they lost four consecutive semi-finals in the Cork Senior Hurling Championship to St Finbarr's. It was a case of 'keep trying' for the side, and they were finally rewarded in 1983, when they beat St Finbarr's 1–18 to 2–9 in the county final. Later that year they also won the Munster Club Championship when they defeated Tipperary side Borrisoleigh after a replay, though they would fall short against Gort in the All-Ireland. They didn't retain the county crown but bounced back in 1986 to make it two titles in four years. Midleton were winners again the following year against Na Piarsaigh, and showed their class when winning the Munster Club Championship against Waterford side Cappawhite. They followed up with an All-Ireland Club Championship at last, beating crack Galway club side Athenry. Fenton had to wait another four years for his next county medal, when Midleton saw off Glen Rovers, but it was a great way to conclude his club career.

In 1976 Fenton was on the Cork U21 team that beat Kilkenny in the All-Ireland final. That year, he was a substitute on the Cork senior team that won the All-Ireland hurling final, defeating Wexford 2–21 to 4–11. The biggest thrill in his inter-county career came in 1984, when he captained Cork to win the Centenary All-Ireland final against Offaly in Thurles. A special season for the GAA turned into a special season for Fenton, as he lifted three trophies and finally got his longed-for Celtic Cross on the field of play. A second All-Star and Hurler of the Year award topped a remarkable year which saw the midfielder finish as top championship scorer with a tally of 1–33 over four games. Two years later, he clinched his third All-Ireland senior medal when Cork defeated Galway.

In 1987 Fenton scored a goal at Semple Stadium that is rated by many as the goal of the century. It came so fast that it was almost impossible to remember the build-up, but Tomás Mulcahy won possession and flicked the ball in the direction of Fenton, some 50m from the Limerick goal. Amazingly, Fenton came from nowhere and flicked the ball forward into open space before unleashing an unstoppable shot into the roof of the late Tommy Quaid's net.

Fenton retired from inter-county hurling in 1988 on the back of five successive All-Stars but played with his club for another three years. He was professional in his approach to hurling and the Cork fans hailed him during his career as a pure artist.

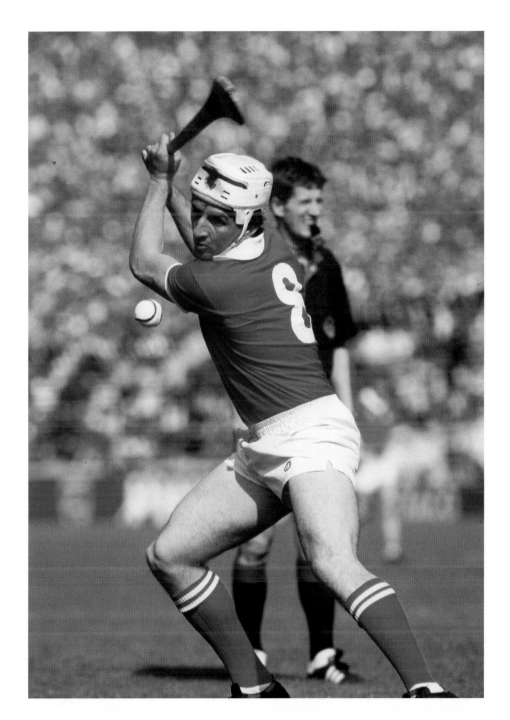

John Fenton in action during the
1986 All-Ireland hurling final.
© Inpho/Billy Stickland

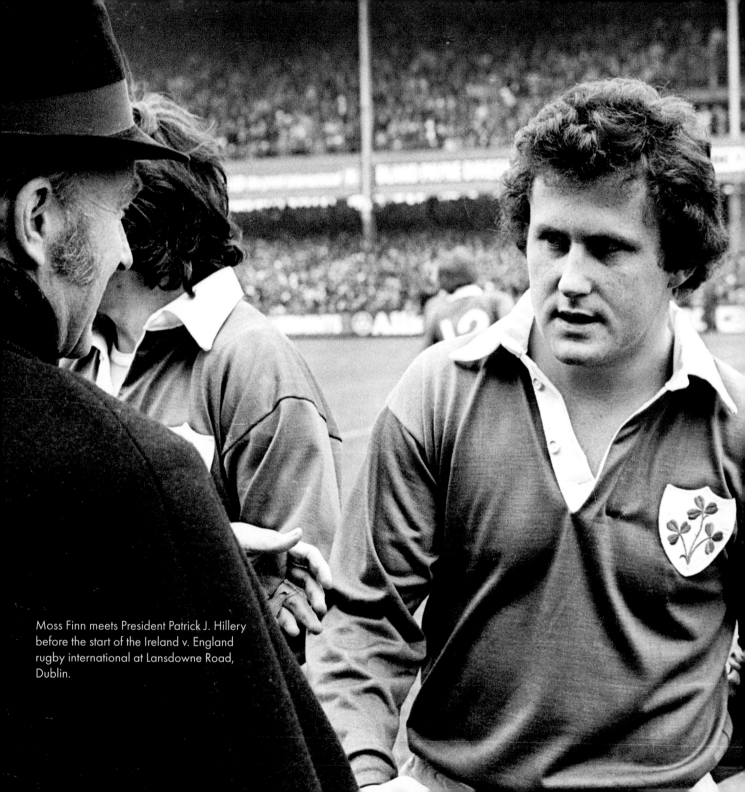

Moss Finn meets President Patrick J. Hillery before the start of the Ireland v. England rugby international at Lansdowne Road, Dublin.

MOSS FINN — RUGBY

Munster made history when they defeated the All-Blacks in 1978 in front of an ecstatic crowd of around 12,000, who witnessed an epic victory for the Irish provincial side. In the months and years after this famous win, up to 100,000 claimed to have been at the game. Moss Finn was one of the lucky players involved on that day.

Born in Bishopstown in 1957, he played underage rugby with Highfield and attended the Presentation Brothers College, Cork, for secondary school, playing a major part in their Munster Junior Cup win in 1973. In 1975 he captained them to win the Munster Senior Cup title, their first win in this competition for six years. During his schooldays, Finn also won a Munster U16 Sprint Championship and was a member of Cork athletics club Leevale.

In 1976 he was on the winning UCC team that defeated Dolphin in a thrilling Munster Cup final. He spent a year in London studying for a physical education degree, playing his club rugby with London Irish, before returning to play with Cork Constitution. In his nine years at Cork Con they won five Munster Senior Leagues and three Munster Senior Cups. He played for Munster from 1977 to 1989, and the victory over the All-Blacks in 1978 is the highlight of his time playing for the province.

'I remember Tony Ward's performance on the day, as he was out of this world,' he said. 'Another memory was coming onto the Thomond Park pitch at half-time where the crowd gave us a standing ovation at the resumption, which really instilled passion into our game.'

Finn got his first international cap in 1979, but an injury saw him sidelined for a year and he was not recalled to the Irish team until 1982. The Triple Crown-winning team of 1982 was outstanding. Finn recalled the game against Wales that season.

'I got a knock in the head scoring my first try and although scoring a second I actually cannot recall getting over the line,' he said. 'I actually asked Willie Duggan with five minutes remaining what the score was but his reply to me is unrepeatable.'

Munster's great run over the last few years is one of the best things to happen to rugby, according to Finn.

'The Munster teams gave the whole province and, indeed, many corners of Ireland a huge lift over the years.'

Finn gained fourteen international caps in his career and recalls those days fondly.

'Injuries didn't help my cause when it came to chalking up international caps, but I was proud of representing my country fourteen times, and when you look at Ollie Campbell, who had only twenty caps, you realise it wasn't easy back in those days.'

Finn served clubs, province and country with honour, and the city of Cork will always appreciate his contribution to his chosen sport.

SANDIE FITZGIBBON — CAMOGIE AND BASKETBALL

The sport of camogie has always been a relatively successful one for this county and the outstanding Sandie Fitzgibbon made a huge contribution to that success during her playing career. Her accolades include winning seven consecutive senior county medals with her beloved Glen Rovers. She began playing with the Glen as a nine-year-old and won her first All-Ireland minor medal in 1978 at the age of fourteen.

Her achievements in camogie are nothing short of amazing and her most notable achievement was playing in thirteen senior All-Ireland camogie finals in Cork. At club level she won ten Cork senior medals with Glen Rovers. She also has eight senior Munster Championship medals and, just to round off her club career, she won four senior All-Ireland medals in 1986, 1990, 1992 and 1993. She looks back on her career with mixed emotions.

'I would say that losing six All-Ireland titles in a row was the most disappointing for me but, in a nutshell, it was the same for all my team-mates,' she said. 'Thank God our luck changed, and it was a dream come true when I captained Cork to win the senior All-Ireland title in 1992.'

Two years later, after giving the Glen 26 years of incredible service, she decided that it was time to bow out.

Fitzgibbon was also a top basketball player. At senior level, she helped Blarney win four National League titles and three National Cups. She also played with Lee Strand in Tralee, helping them to win National League and Cup honours in her three years there. Her skills were dazzling and, despite being only 5ft 6in., she wreaked havoc on the court and won a total of 64 caps for Ireland at senior level. Her talent is still talked about in basketball circles and representing her country at the highest level of the sport speaks volumes for her skills.

Amazingly, Fitzgibbon was never fazed by the demands of mixing camogie and basketball. The busiest week of her career came in October 1990. On Sunday she played an All-Ireland Camogie Club semi-final with Glen Rovers in Derry, and immediately after the game she travelled to Boston to play three senior internationals with Ireland. Having returned to Ireland on Friday, she only had two days before lining out with Glen Rovers in the All-Ireland camogie club final. She once again showed her incredible skills as the Glen defeated St Paul's in the decider.

To round off her silverware collection, Fitzgibbon won the Munster Youth Sports Star in 1983 and the Jury Sports Star in 1990 and 1992, was named Camogie Player of the Year in 1992 and 1995, and received the Delta Airlines Olympic Basketball award in 1992.

In 2000 Fitzgibbon was presented with the Millennium award in Cork for her achievements in sport, an honour she richly deserved. There are many legends in the sporting world on Leeside, but Fitzgibbon will always be remembered with affection as one of Cork's finest.

" ...thirteen senior All-Ireland camogie finals, ten Cork senior medals with Glen Rovers, eight senior Munster Championship medals and, just to round off her club career, four senior All-Ireland medals."

Sandie Fitzgibbon, in action for Cork in the All Ireland Camogie Final, Croke Park.
© Ray McManus /Sportsfile

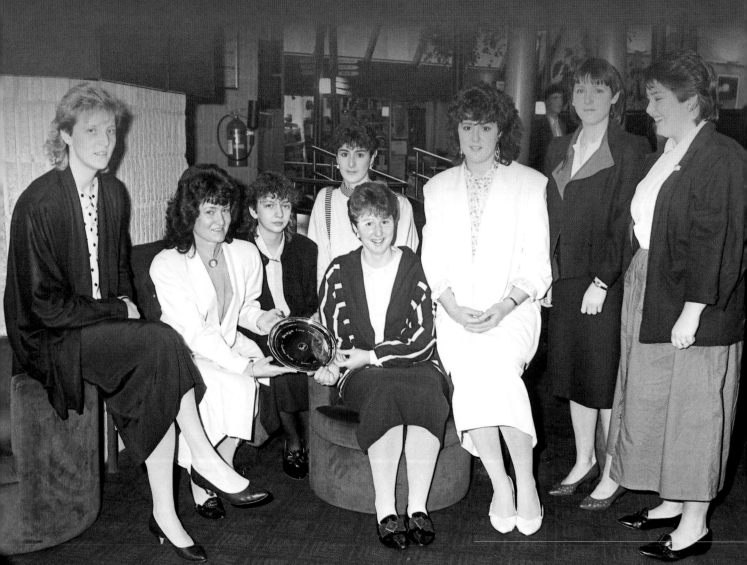

"Arguably the greatest Irish women's basketball player of all time."

Caroline Forde and family at the Jury's Awards in 1987.

CAROLINE FORDE — BASKETBALL

Caroline Forde is arguably the greatest Irish women's basketball player of all time. Born in 1967, she began playing National League basketball at the age of thirteen, and her long international career began when she was selected onto the Irish U15 team for two years. It all started for the Blarney woman back in 1977, when she was introduced to the sport by Bernie Murphy before coming under the guidance of Dommie Mullins, as mid-Cork conquered basketball nationally with a superb team. During the glory years Blarney, inspired by Forde and her late sisters Miriam and Annette, were simply awesome and were known as the 'Flying Fordes', such was their ferocity on the court.

Forde won every honour in the game, including Player of the Year and Young Player of the Year on more than one occasion, National Cup Final MVP, Jury's Hotel Sports Star Awards, three National Cups, four National Leagues and four Top 4 titles. When you have played with and against the best players in the country, surely one who impressed you sticks in the mind: surprisingly, Forde named one of her former teammates.

'Sandy Fitzgibbon was an incredible player to have on your side and, to be honest, even at training she made you work hard, as she possessed a fantastic attitude,' said Forde. 'When I was coming to the end of my career, Michelle Aspell came on the scene and I think she was another class, as her work ethic on court really impressed me.'

Forde has played for Ireland in European and Olympic Championships; she was the highest-scoring Irish women's player in the 1988 Pre-Olympic tournament, averaging sixteen points per game. She accumulated 100 international caps for Ireland from U15 to senior levels, and toured the east coast of America on several occasions.

Nowadays Forde takes in some games watching her daughter Simone, who is part of the Singletons Supervalu Brunell Super League squad, and her views on the modern game are interesting.

'First of all, I cannot believe how small the basketball has reduced to from when I played but, look, generally the modern players do their best, but for me I don't think the Irish players are going to develop, with the amount of Americans and Europeans playing in the league.'

It's the experiences, friendships and memories, and in particular those forged playing with her beloved sisters, that Forde cherishes most of all.

'Personally, when you lose two sisters who were very close to you it's a tough experience, but on the other side of the coin, I am glad I shared so much quality time with them.'

Finally, Forde has some advice for up-and-coming players in this country.

'When a coach teaches you the skills of the game, you have to do more than just train with the team. To bring yourself to the next level, you must train twelve months of the year, as I kept myself in shape during the off season and I am sure it helped me throughout my career.'

ROB HEFFERNAN — ATHLETICS

Rob Heffernan will be remembered in Cork and Ireland as a great competitor and as the proud holder of a bronze medal that he secured at the London Olympics in 2012. It all began for Heffernan in his school-days.

'It was at Scoil Chríost Rí in Cork when I won the school mile race, and the following year when attending Coláiste Chríost Rí, I was possibly the best runner, but my love was really playing football with Nemo Rangers.'

It was all football for Heffernan in his youth. He captained Nemo at U16 level, which was a great honour. One evening, however, while attending the multi-gym at the school, he was approached to get involved in athletics. After school he did an apprenticeship in plastering with his father and didn't really get into the groove of race walking until he grew a few more inches at the age of seventeen.

'I went back to do my Leaving Cert at Coláiste Chríost Rí and then moved to the North Mon for a year on the advice of Brother John Dooley, and in 1997 getting picked for the European Championships in Slovenia was a huge achievement.'

Heffernan's first Olympics was in Sydney in 2000, where he finished in 28th place in the 20km race. After disqualification in Athens in 2004, he came back stronger in 2008 in Beijing, finishing in eighth place in the 20km race. At the 2012 Olympics in London, he finished ninth in the 20km walk. A week later he finished just outside of a medal in fourth place, an incredible feat and seven minutes faster than the previous national record. He was deservedly upgraded to a bronze medal in 2016 when Russian Sergey Kirdyapkin's results were disqualified by the Court of Arbitration for Sport. In November of that year, Heffernan was presented with his medal at City Hall in Cork—a wonderful occasion for him, his family and his supporters. In 2016 he became the first athlete to represent Ireland at five Olympic Games and earned sixth place in the 50km race.

Outside the Olympics, he finished fourth at the 2010 European Athletics Championships, which was upgraded to a bronze medal in 2014 when Russia's Stanislav Emelyanov was found guilty of doping. Heffernan later won a gold medal in the 50km walk at the 2013 World Championships in Moscow. It was Ireland's first gold at the World Championships since Sonia O'Sullivan's in 1995 in Gothenburg.

Throughout his career, Heffernan's wife Marian, also an Olympian, was steadfast in her support, and he credits much of his success to her. He believes that it's essential for children to get involved in sport, as the benefits are endless.

'I love watching kids play hurling or whatever sport they choose, and it's not just about winning or losing, it's seeing what they need to develop. If you can steer these talented players, they could absolutely thrive.'

Inspiring words from a true Leeside Legend!

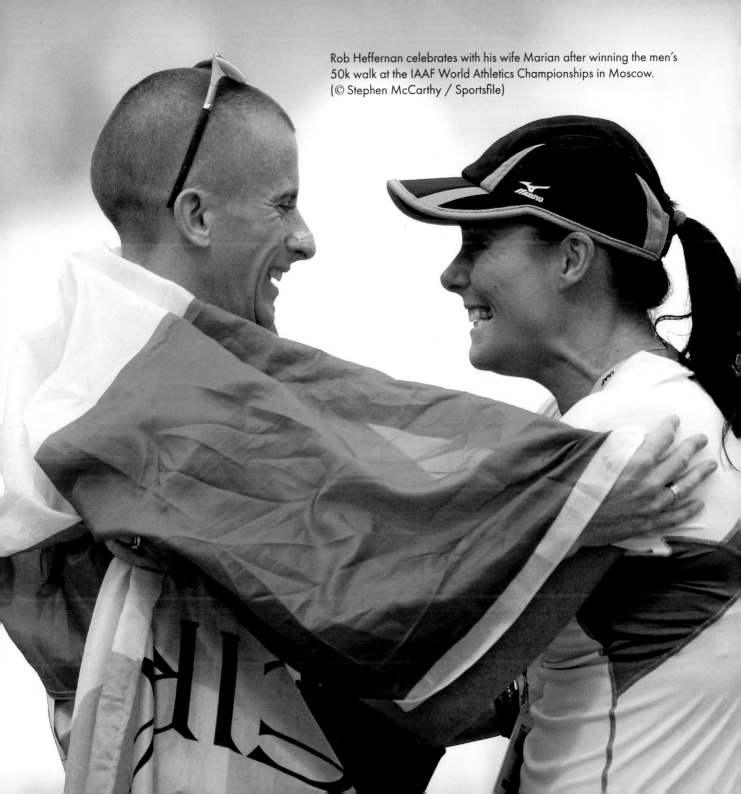

Rob Heffernan celebrates with his wife Marian after winning the men's 50k walk at the IAAF World Athletics Championships in Moscow. (© Stephen McCarthy / Sportsfile)

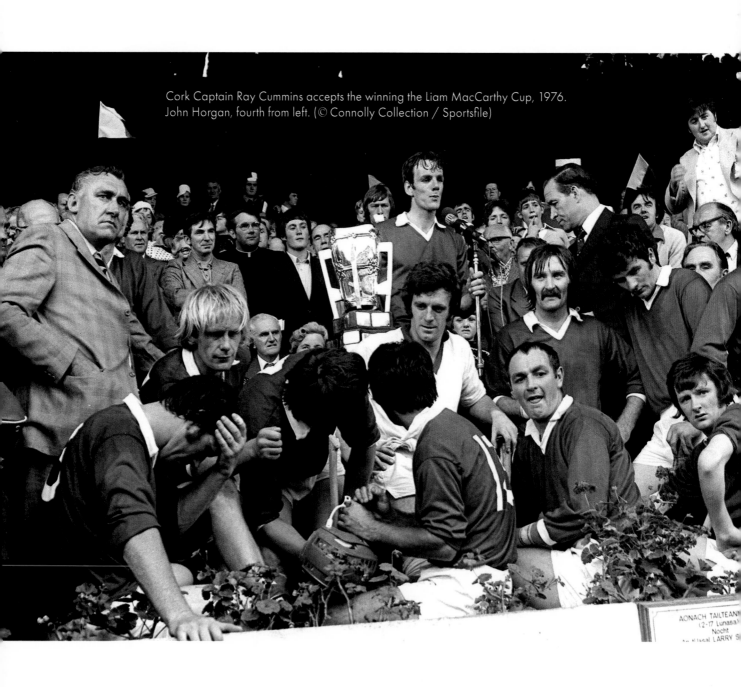

Cork Captain Ray Cummins accepts the winning the Liam MacCarthy Cup, 1976. John Horgan, fourth from left. (© Connolly Collection / Sportsfile)

JOHN HORGAN — HURLING

The late John Horgan was an integral part of the great Cork and Blackrock teams of the 1970s, and his performances for club and county made him a firm favourite on and off the pitch. Horgan—or 'Blondie John', as he was affectionately known—was a great reader of the game, which helped him win many honours in the sport. Born in 1950, like many youngsters he began playing in the Street Leagues at Blackrock. He was selected for the Cork minor hurling team for three successive years from 1966 to 1968.

In 1970 Horgan joined the Cork seniors and landed a double when the Rebels won the National Hurling League and the All-Ireland Senior Hurling Championship. In the early '70s he lost his place on the team, but some sensational displays for his club saw him fight his way back into contention in 1973. The following year he was rewarded with a hurling All-Star and the rest is history, as he played a leading role in the Cork team that clinched the three in a row in 1976–8. There was disappointment for Horgan, however, when he captained the Cork team that was defeated by Galway in the All-Ireland semi-final.

In 1981 Horgan brought the curtain down on a brilliant career, as his club achievements are just as impressive as his inter-county record. He won the first of his five Cork Senior County medals in 1971 and had the honour of captaining Blackrock to three All-Ireland titles.

'I did not realise it at the time but now, when I look back, I feel very honoured, because no other player had done that at club level.'

Looking back on his introduction to inter-county hurling, Horgan recalled how proud his family were when he was selected.

'My father (Tim) and mother (Esther) were two of the most innocent people you could meet, and when I was selected on the Cork minor team in 1966 both of them shed a tear.'

Horgan had a brief coaching stint in 2001, guiding Castlelyons to the Cork Senior County semi-final, but terminated his coaching career after one season.

'I didn't have the temperament to be a coach, but I must say I was very proud of the Castlelyons team as they were a great bunch of lads.'

Horgan passed away in 2016. His former team-mate Jimmy Barry Murphy recalled how the Blackrock man was the stalwart of the team.

'I played with John and he was an inspirational player, because his type of play with his long striking and the scores he got were fantastic and lifted our team on many occasions. He was an incredibly popular player across the clubs, and he wasn't into club rivalries that a lot of us were into, as he was above all that. He was a one-off and a free spirit type of player.'

Fitting words from one Leeside Legend to another.

CHARLIE HURLEY — SOCCER

In the annals of Irish soccer there is no more sterling defender than Charlie Hurley, a towering and inspirational figure for club and country. Hurley, who earned 40 caps for Ireland over twelve years, was born at Devonshire Street in 1936 and left Ireland when he was seven months old. He showed exceptional ability at an early stage of his career and impressed scouts when playing with Rainham youths. He was signed by Millwall in October 1953, playing 105 times with the club before making his way to the north-east to play with Sunderland in 1957.

The £20,000 that Sunderland paid for him proved to be one of the bargains of the century, and during his eleven seasons at Roker Park he was idolised by the supporters, who christened him the 'King of Roker'. In Paul Hetherington's book Sunderland Greats, he is referred to as the player 'constructed from pre-cast concrete'—a tribute to his strength and courage on the pitch. He played 358 times for Sunderland and scored 23 goals, an excellent return for a centre-half.

In 1957 he made his début for Ireland in a vital World Cup tie before a record-breaking crowd at Dalymount Park. England needed just a point to advance, while wins against Denmark and England would have given Ireland a play-off game against the auld enemy. England were forced to pull out all the stops, only scraping through with a last-minute equaliser, but Hurley was magnificent and completely blotted out the legendary Tommy Taylor.

At a function in Cork, when receiving the Cork Soccer Legend award, he recalled that memorable game.

'When I told my father I was marking Tommy Taylor, he gave me a little bit of advice: "Don't leave him breathe, boy. Stick to him like glue. Even if he goes to the loo, follow him."

'I took dad's advice, as I went everywhere with Taylor; at every turn he made, I was there in front of him, and even when he stooped to tie his shoelace I stood over him. When he was being treated after a tackle I smiled mischievously at him, but I didn't follow him to the loo, because when the final whistle blew I noticed he made a mad dash in that direction.'

Hurley is the most-capped international player in Sunderland's history. He captained Ireland on 21 occasions, scored twice in the green jersey and was Irish coach during the last three matches of his international career.

In June 1969 his career took a new path when he became player/manager of Bolton Wanderers, making 42 appearances for the Burden Park club. In June 1972 he was appointed manager of Reading and held the post for five years. Hurley became the first recipient of the Irish International Hall of Fame award when honoured at an FAI banquet in 1989. He was simply one of the most committed defenders during his illustrious career.

"the most-capped international player in Sunderland's history, captaining Ireland on 21 occasions, and Ireland coach during the last three matches of his international career."

Charlie Hurley acknowledging the fans at Turners Cross in 2007 during a Sunderland visit.

Fans and players show their appreciation for Denis Irwin, with children Liam, Lauren and Katy at Old Trafford, August 2000.
(© Getty Images)

DENIS IRWIN — SOCCER

Modest and unassuming, Denis Irwin was one of the most effective and respected defenders in the modern game. Blessed with ability, mobility and vision, he was a vital cog for Manchester United and the Republic of Ireland.

Born in October 1965, his first venture into the sporting arena was at St Finbarr's GAA club before he joined Everton of Cork as a schoolboy. He first played for Leeds United in 1983 and made 72 appearances with the Yorkshire club before being released in 1985. It turned out to be a godsend for Oldham Athletic, as Irwin helped them to the League Cup final and an FA Cup semi-final against Manchester United in 1990.

His performances against Manchester United impressed Sir Alex Ferguson, who paid £625,000 for his services in the summer of 1990. The United chief later admitted that Irwin was one of his best buys ever. He won the European Cup with the side in 1991. A year later he was back at Wembley for yet another League Cup final, but this time United were on the winner's rostrum following their 1–0 win over Nottingham Forest. In the 1992/3 season Irwin was ever present, playing 40 league games and scoring five goals, most notably a 30-yard piledriver against Coventry. He added five more Premiership titles, two FA Cup medals and a Champions League medal to his collection. He played a key role for the Red Devils in their memorable 2–1 Champions League win over Bayern Munich in Barcelona. In his international career, Irwin was capped 56 times for the Republic of Ireland, scoring four goals and playing on the 1994 World Cup side. He retired from international football in 2000 but signed another one-year extension to his Old Trafford contract to complete a full decade at the Manchester club.

He wrote in the Evening Echo: 'It was reaching the stage where I was away more and more because of the demands of playing with Ireland. I am now able to give more time to my family and that's something that will continue for years to come.'

His final year at United was celebrated with his testimonial against Manchester City at Old Trafford. It turned out to be a full-blooded encounter and Irwin was forced to leave the pitch injured. It wasn't serious and he recovered in time to play his part in another successful season. His last game for United in May 2002 was an emotional one, marking the end of twelve glorious years, including 529 appearances and 33 goals. He wore the captain's armband in the 0–0 draw with Charlton and at the final whistle received a standing ovation from the Theatre of Dreams faithful.

Irwin finished his career at Wolverhampton Wanderers, the team he supported as a young boy. On 26 May 2003 he helped his team back into the Premiership with a 3–0 win over Sheffield United. At the age of 37, he was voted one of the eleven best players in the nationwide league for the season. The quiet man of football always let his feet do the talking.

KIERAN JOYCE — BOXING

Muhammed Ali was a man who touched the hearts of millions all over the world, including that of Kieran Joyce, a nine-year-old in Cork's northside who adored him and swore that one day he, too, would be a boxer. Joyce's record in the ring made him one of the greatest boxers that this country has produced in modern times. Born in Fair Hill in 1964, it was through the encouragement of his neighbour Mossy O'Callaghan that he took up boxing and joined the Sunnyside club. He won numerous All-Ireland titles up to the age of sixteen, and moved up to the welterweight division.

Looking back on those early days, Joyce recalled achieving one of his greatest feats in the ring in 1982. He had just won the All-Ireland U18 title and the Irish senior team were due to fight in the United States. The Americans had a tough welterweight, Joe Walter, and the leading fighters in Ireland refused to fight him. The prospect of taking on the American became a reality for Joyce.

'My coach Albie Murphy put my name forward, and although Walter knocked me down in the opening round, I recovered my composure to win the fight and I never lost my place on the Irish senior team again,' said Joyce.

The following year saw Joyce win a bronze medal at the European Championships, and in 1984 he was off to the Olympic Games in Los Angeles. Unfortunately for Joyce, he lost on a split decision at the quarter-final stage, when he went down against Joni Nymam of Finland after boxing exceptionally well in the opening two rounds. Once again, at the 1988 Olympics in Seoul the judges weren't in his corner, as another split decision at the quarter-final stage denied him another medal. Joyce's patience finally ran out with the judging system and he decided to retire at the young age of 26.

'To be honest, I just got fed up with losing on split decisions when I knew in my heart and soul that I won both Olympic quarter-finals,' he said. 'Don't get me wrong, I was never a bad loser, but after four years of training diabolical judging finally killed the fire inside me.'

By the time he retired in 1990 he had fought 85 times for Ireland at senior level, as well as in three World Championships and two Olympic Games. Joyce, now head coach with the Sunnyside club, is always quick to pay tribute to people like his former coach and late parents, Brian and Lily, who supported him throughout his career.

The life of a boxer can be a lonely one, as many of the top fighters train 365 days a year and it takes a special dedication to make it to the top. Joyce will long be remembered for his contribution to boxing in Ireland and, although he is no longer floating like a butterfly nor stinging like a bee, it goes without saying that boxers like him are born and not made.

Kieran Joyce with his coach, Albie Murphy of Sunnyside.

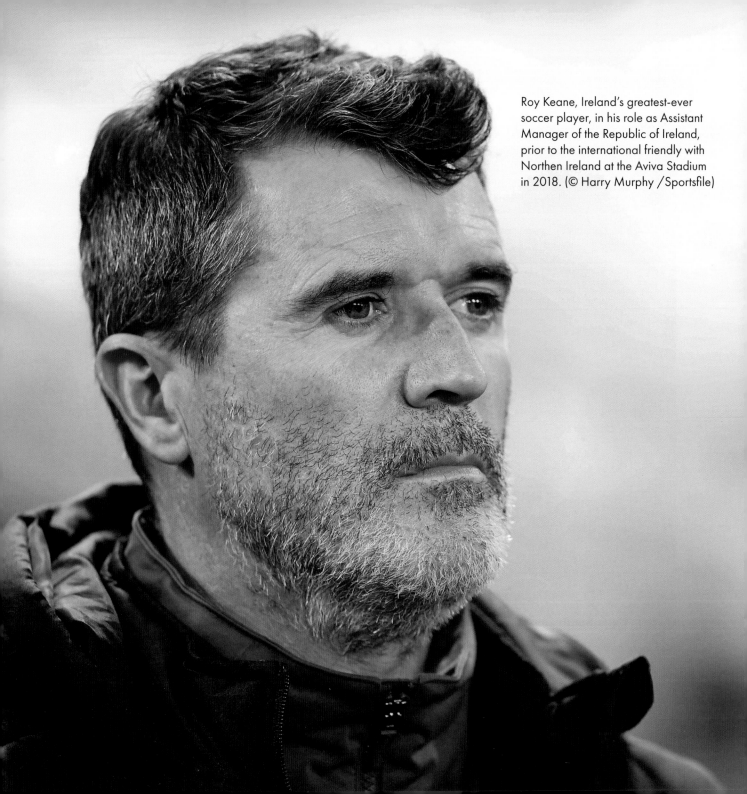

Roy Keane, Ireland's greatest-ever soccer player, in his role as Assistant Manager of the Republic of Ireland, prior to the international friendly with Northen Ireland at the Aviva Stadium in 2018. (© Harry Murphy /Sportsfile)

ROY KEANE — SOCCER

In a county that has produced a galaxy of sporting legends, Roy Keane is unquestionably among the greatest. His rise to fame from playing with Rockmount and Cobh Ramblers to the heights of the Premiership, Champions League and World Cup is the stuff of which dreams are made.

He joined Rockmount as an eight-year-old and stayed with them right through to the age of eighteen. He played with some tremendous players there, like Alan O'Sullivan, Paul McCarthy, Len Downey and Damien Martin. Together they conquered the underage scene in the Cork Schoolboys League, going unbeaten for four years. That Rockmount team was the basis of the Cork Kennedy Cup-winning team of 1984, with Keane playing a leading role.

Keane suffered many disappointments in his youth, but those setbacks only made him more determined to succeed. He was snubbed by the Irish selectors for the national U15 team but he kept working hard. The next step was for Keane to write to every English club, but clubs like Derby County and Chelsea all gave him a firm 'No' in their replies. When Cork City failed to register Keane with the league as one of their players, Cobh Ramblers stepped in and the rest is history, as he was snapped up by Nottingham Forest following a youth game against Belvedere of Dublin in 1990. He went to the City ground at Nottingham Forest on a contract of €250 a week under the guidance of Brian Clough, and made his first-team début against Liverpool in Anfield.

'I was determined to make it as a professional footballer, as outside of my football ability it was my will to succeed that pulled me through. I had shown no interest in my schooling and I had little else to go back to Cork for.'

After three successful seasons with Forest, he was signed by Manchester United for £3.75m in 1993. United won the Champions League in 1999, beating Bayern Munich in a dramatic final that saw United complete a historic treble of league, FA Cup and Champions League titles. Sadly, Keane missed the Champions League title, as he picked up a second yellow card in the competition after singlehandedly dragging United back into the semi-final against Juventus when they fell two goals behind early in the game. Keane scored a vital header in that game and most of his critics point to it as one of his greatest performances for United. In 2005 he signed for Celtic, where he won a domestic double before he retired from playing in 2006. He finished his career with one Champions League title, seven Premier League titles and four FA Cups.

Keane played at international level for the Republic of Ireland for over fourteen years, earning 67 caps and scoring nine goals. The controversy that surrounded him at the 2002 World Cup is well and truly behind him.

'I have no regrets whatsoever, because if I did not stand up for my beliefs, players would be suffering 30 years from now.' As manager of Sunderland, Keane took the club from 23rd position to win the title and gain promotion to the Premier League. From 2013 he spent five years as the Republic of Ireland's assistant manager under Martin O'Neill.

Roy was his own biggest critic both on and off the field and consistently sought perfection. In his present role as a pundit for Sky and ITV, he enthrals his audience with his directness and honesty.

CHRISTY KEATING — DRAG-HUNTING

The famous Kerry Pike Harrier club was founded in 1823, and its success in drag-hunting since then has made it the most powerful club in the sport today. Two hundred years later the sport is alive and well and has produced many legendary trainers, none more so than Christy Keating, arguably the greatest trainer of all time.

Keating was born in Kerry Pike in 1949, and it was the late Tim O'Connor who introduced him to the sport. For the last 62 years, his dedication has seen him train winners in every major event. In 1964 he trained his first hound, called Rambler, and within two years he was producing winners.

The Kerry Pike club purchased only the second hound from Cumbria in England to come into this country. The hound, Thornlea, certainly made his mark in Irish drag-hunting. After winning numerous drag-hunts, he was crowned champion hound in 1966. Injury forced him to retire.

'We did everything we could to get him healed but a stifle injury is one of the worst a racing dog can get, and in the end he eventually lost the fight and had to be retired,' said Keating.

Keating soon overcame that disappointment and in 1974 he began training Cargate Laddie. This partnership proved to be unbeatable over the following years, with the hound winning the senior championship in 1976, 1977 and 1978. One of the few titles to elude this supreme hound during this period was the Senior All-Ireland Championship, in which he finished runner-up on three occasions. He became the first hound to win the inaugural international match between Ireland and England in 1975.

In 1983 Keating trained another senior international winner with Montego Bay, and to the present day holds awards for training international winners. In 1997 he struck gold once again when he purchased a puppy from England that he named Mason, who in his début season notched up 22 wins. When Mason stepped up to the senior ranks in 1998 he broke all records, winning the Senior Championship, the Munster Championship and the All-Ireland title to become the first hound to complete the Grand Slam.

'In the sport of drag-hunting you have got to get the right hound; the adage that "you cannot train a donkey to become a classic winner" is very true, and it's the same with hounds.

'I also think you have to be kind to your hounds, and if they are good enough, they will repay you.'

Keating has set the records in drag-hunting and, although he doesn't have high-flyers in his kennel at present, his love for the sport hasn't waned. His contribution will never be forgotten, and he remains the best trainer this country has produced.

Opposite: Christy Keating and his drag-hunting dogs at Clogheen.

Sarah Kelleher displaying her skills for Ireland, for which she was capped 127 times.
©James Meehan/INPHO

SARAH KELLEHER — HOCKEY

When the great hockey players are discussed in the years ahead, Sarah Kelleher will surely be named among the most élite group of players ever to have graced the sport.

Kelleher was born in 1970 and reared in Ballinlough. Her interest in hockey stemmed from her parents, who were members of Harlequins hockey club. Her career took off while she was attending the Regina Mundi Secondary School in Douglas, where, under the watchful eye of coach Aoife Lane, it soon became evident that she had skills to burn. She won numerous trophies while at school and represented Munster and Ireland at U18 level.

Before she finished school, Kelleher joined Harlequins and through sheer determination soon broke into a strong first team, with whom she later went on to win Munster Senior League and Cup medals. She later won an inter-varsity title with UCC before joining the famous Muckross club in Dublin, where she was part of a strong team that represented Ireland in the European Championships, an experience she will never forget.

'The difference in pace was unbelievable and, despite having a strong squad compared to the Dutch and the Germans, we were a league below them,' said Kelleher.

Between 1992 and 1999 Kelleher amassed over 100 caps for her country. She captained the team from 1992 to 1995 and looked back on that period with great pride.

'To play for your country is an honour, but to lead out the side was something I will never forget,' she said.

After university, Kelleher moved to England and joined Slough in London. In 1999 they won the Premier League in both indoor and outdoor as well as the Cup, becoming the first club to achieve this feat.

Having played hockey all over the world, Kelleher has many great experiences to treasure, but her most prized memories are those of 1994, when the World Cup was held in Dublin.

'To play in such a prestigious tournament is wonderful, but to play in front of your home fans … that is certainly among the happiest memories of my career.

'Remember, there are a lot of disappointments when you play at international level because you lose more games than you win, but for me it was the competing that always drove me on.'

Kelleher is still working in London, where she has her own marketing businesses, but she still finds time to visit Cork.

'I love coming home to see family, but I have a great career in London and that is where I am presently berthed.'

Kelleher represents everything that's good about successful sportspeople.

JOHN KERINS — FOOTBALL

The late John Kerins was one of the best goalkeepers that Cork has produced. He was a commanding figure between the posts for his beloved St Finbarr's and of course for the Rebels, making plenty of match-winning saves for both. Born in 1962, Kerins grew up in the Lough area of Cork and, like many of his peers, he joined St Finbarr's at a very young age. In secondary school he played many a game for Coláiste Chríost Rí.

Kerins was a prominent hurler in his early teens and played in goal with the Cork minors in the 1980 Munster Championship against Tipperary. That year he was part of the St Finbarr's side that won the Cork Minor Hurling Championship. His career in hurling after that included playing as number one choice with the Barrs' intermediate side and as reserve to Ger Cunningham for five years. In 1980 he played with the Cork minor footballers who lost to Kerry in the Munster final, and a year later he was reserve keeper to Michael Creedon after Cork defeated Galway in a replay to win the U21 All-Ireland Football Championship.

He made his senior championship début against Clare in 1984 and, with one exception, he played in every championship game up to the All-Ireland semi-final of 1994—a record of which few can boast. When Cork finally made a breakthrough in 1987 under Billy Morgan, Kerins played a significant part. His reflexes and quick thinking were at their best when Cork were trailing by a single point against Kerry after Mikey Sheehy had scored a late goal. The end result saw Cork get a free kick from the huge Kerins kick-out, which Larry Tompkins put over for a point to force a replay in Killarney. While Cork suffered back-to-back defeats by Meath in the All-Ireland finals of 1987 and 1988 (in a replay), the county won four provincial titles back to back for the first time. Following two years of sheer disappointment for Kerins and his Cork team-mates, All-Ireland success finally came their way in 1989 when the Rebels defeated Meath in the decider. Kerins played a key role in the win, making a crucial save to deny Meath early in the second half.

In 1987 St Finbarr's won the All-Ireland after beating a highly rated Clann Na Gael from Roscommon. Kerins received the first of his two All-Stars that year. The second came in 1990, and he represented Munster in the Railway Cup final of 1991.

There was great sadness in the world of GAA when Kerins died of cancer in 2001 at 39 years of age. Such was his popularity that Cork footballers and GAA fans in many corners of Ireland turned out to pay tribute to the man. Stories of his character and quality will be told for many years to come, and Cork fans will always remember him with special affection.

The late John Kerins in action for the Cork senior footballers versus Meath in the All-Ireland Football final, 1990.
(© Ray McManus/Sportsfile)

Tom Kiernan leads the Irish rugby team onto the field for the match against France in his first game as Ireland's captain. Behind Kiernan are Cecil Pedlow, Sid Millar, Paddy Dwyer and Ray Hunter.

TOM KIERNAN — RUGBY

The Cork Constitution club has had many outstanding players, but in Tom Kiernan they produced one of the best full-backs ever to grace the Irish rugby scene. Kiernan was born in 1939 and educated at the Presentation Brothers College, where he won Munster Junior Cup and Senior Cup medals. It was evident from his schooldays that he was a star in the making. He won three Munster Senior League titles with UCC and ten Munster Senior League medals with Cork Constitution.

At the famous Cork Con club, the older members still speak very highly of the contribution that Kiernan made to their great club. Noel Murphy (Snr), an old friend of Kiernan's and well known in rugby circles, recalled Kiernan's first-ever experience in rugby.

'It is incredible to think that 76 years ago the mascot on the day was no other than Tom Kiernan, and he was led out by International referee Dickie McGrath. Tom was to kick the ball to start the game, but as he went to kick it he completely missed it.'

That was the last time he made that mistake, as kicking became his forte. Kiernan was the prototype for the attacking full-back and he was also a gifted place-kicker. He played many tremendous games for his country, also playing for the Lions in their 1962 tour of South Africa and returning six years later to captain the side, again in South Africa.

Kiernan had an incredible record off the field, coaching the Munster team of 1978 that defeated the All-Blacks at Thomond Park.

The former Ireland and Cork Con winger Moss Finn said of Kiernan: 'Tom was a superb coach who knew the game inside out and he gained a lot of support from the players, who respected his man-management style.'

Four years later, Kiernan was a hero once again when Ireland won the Triple Crown. At administration level, Kiernan became the youngest person ever to be president of the Munster Branch in 1977/8 at the age of 38. Cork Con, the club that Tom served so well, bestowed on him the honour of making him centenary president during the 1991/2 season. Following his retirement from the IRFU in 2001, Cork Con held a dinner to mark the occasion.

The Heineken Cup is now one of the biggest championships on the rugby calendar, and Kiernan played a huge part in setting up this coup for all clubs in Europe. He wanted to do something about the high numbers of Irish players leaving their clubs and was instrumental in getting provincial teams to reward their players financially. Tom Kiernan certainly was a man of vision, both on and off the field of rugby, and the Cork rugby-supporting public will always appreciate and salute his immense contribution to the sport.

RACHAEL KOHLER — HOCKEY

In the galaxy inhabited by the stars of Irish hockey, the name of Rachael Kohler shines brighter than most. Her dedication to the sport has been incredible, as her skill and stamina, coupled with her composure both on and off the pitch, were outstanding features. Born in 1974, Kohler began playing hockey for Roxboro Primary School and five years later she joined the Harlequins. At university she won two inter-varsity titles with UCC. She won many international honours at U16, U18, U21 and senior level, and has represented Munster at all levels. She won the Munster Senior League and Cup on numerous occasions with Harlequins, but her greatest triumph came when her club won the 2000 Irish Women's Cup and the European Club Championship.

On the international circuit she has amassed a staggering 166 caps and is Ireland's most-capped women's hockey player, thirteen caps ahead of the retired Mary Logue. She also had the distinction of playing in two World Cups with Ireland, in 1994 and in 2002 in Australia, where she captained the side.

'The trip to the World Cup was probably my best experience in hockey, as it gave me the opportunity to play against the top players in the sport and it truly was a wonderful experience. We finished fifteenth out of the sixteen nations, but with a bit of luck we could have clinched twelfth place,' Kohler said.

Another milestone for the Cork ace was reaching 100 caps in March 2000. It hasn't all been good for Kohler, however, as she recalled certain disappointments during her time at the top level.

'I was very down when we lost on the golden goal to China in the Pre-Olympic Games at Milton Keynes in 2000,' she said. 'We were also 35 minutes away from qualifying for the Sydney Olympics after losing 2–0 to Spain. The other two setbacks were missing the tour to America in 1996 owing to illness, and an injury I got that required nine stitches in my face wasn't a good experience.'

There was huge disappointment for Kohler in 2003 when Harlequins lost 3–2 to Loreto of Dublin in the Irish Senior Women's Cup final.

'We were gutted, but sometimes in life you just have to stand up and admit that the best team won on the day.'

Kohler is adamant that the standard of hockey in this country is rising all the time.

'I believe that the nineteen- and twenty-year-olds of today are much more advanced than I was at their age,' she said.

'All the Irish players have nine-to-five jobs and have to go training afterwards, but I was fortunate with my employers, who have been so understanding when I had to travel for games and tournaments.'

In a sport where there have been magnificent talents over the years, Kohler will be remembered as one of the greatest hockey players that this country has ever produced.

Rachael Kohler, capped 166 times for Ireland and one of the greatest hockey players this country has produced.

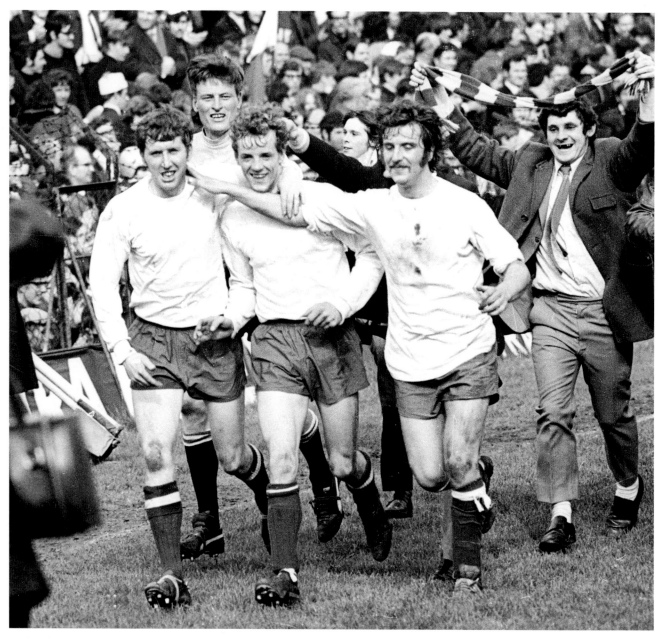

Cork Hibernians players (from left) Frank Connolly, Joe O'Grady, Miah Dennehy and John Lawson celebrate after winning the League of Ireland play-off decider against Shamrock Rovers at Dalymount Park, Dublin, 1971.

JOHN LAWSON — SOCCER

The Cork Hibernians team of the 1970s had many talented cross-channel players, including midfield ace John Lawson. Born in Glasgow in 1952, Lawson played with the Glasgow Celtic youth team before moving to Leeds United as a fifteen-year-old. He served his apprenticeship at Leeds during the Billy Bremner, John Giles and Eddie Gray era.

Lawson made his début for Cork Hibernians in 1970 and quickly established himself as a football legend in his adopted city. The collapse of the club in 1976 is something he will never forget.

'We were on tour in the USA when we were told of the news and for the life of me how a club like Cork Hibernians that generated so much money over the years could have gone into liquidation overnight.'

After the glory years with Hibs, he played out the remainder of his League of Ireland career with Athlone Town and Thurles Town. In 1980, after playing in Ireland for eleven consecutive seasons, Lawson decided to call it a day owing to an ongoing knee problem.

Two players who really impressed Lawson during his League of Ireland career were Jimmy McGeogh of Waterford and Terry McDermott of Finn Harps. Sonny Sweeney, his midfield partner at Hibs, was also a major influence on his career. 'I grew up with Sonny in Glasgow and to this day we are still great friends, as his greatest strength was his ability to win the ball. As a midfielder, when you have a player of that calibre playing next to you it makes life that little bit easier.'

Over the years Lawson watched the career of Roy Keane with interest. 'Roy was an inspiration to all the young players who hope to make it in England with one of the big clubs and his rise to fame was truly remarkable.

'Denis Irwin was another outstanding player and ironically he was another player that Leeds allowed to leave, and I think he showed them in later years that was a big mistake.'

Lawson regards the loss of Flower Lodge to the GAA as a crying shame for soccer in Cork. He hasn't followed the fortunes of Cork City in the last few years but knows what it will mean to the people of Cork if they regain their status as a top club.

'There are people who still stop me in the street and talk about the great days of Hibs and the one thing I do know is that Cork people like nothing better than a winning team, no matter what sport it is.'

Lawson recalled the day he arrived on Leeside to begin his incredible contribution to Irish football.

'I was fortunate to join a great club in Cork Hibs and the one memory I will always have is the dedication of the Cork supporters. The people of Cork deserve a successful soccer team and every effort must be made to ensure it happens.'

It is all of 51 years since John Lawson arrived in Cork to display his midfield skills, and to the present day he still enjoys talking about the glory days that made him one of the most popular Scotsmen to grace the soccer pitches of Ireland.

DONAL LENIHAN — RUGBY

The story of former rugby international player Donal Lenihan unfolds from the playing fields of Brian Dillons as a youth to becoming one of Ireland's finest second-rows. Born in 1959, he was reared in the St Luke's area of Cork, and while attending St Patrick's National School he was an eager hurling and football player with the local Brian Dillons club. He played with the Cork primary schools football team that defeated Limerick in 1971 at the Cork Athletic Grounds (now Páirc Uí Chaoimh). He attended the Christian Brothers College for secondary education and, once there, he was destined to take up rugby under the diligent coaching of Brother O'Reilly. In 1974 he captained the school to the Munster Junior Cup, when they defeated Crescent College of Limerick. Two years later they were on song again when they lifted the Munster Senior Cup, and in the following season of 1977 Lenihan won his second Senior Schools Cup when they defeated arch-rivals Presentation Brothers College. When Lenihan finished his education he moved to UCC, where he helped them win the Munster Senior Cup in 1981—the last time the students won this trophy.

After university, Lenihan was an excellent addition to Cork Constitution, winning Munster Cup titles with them in 1983, 1985 and 1989, as well as a number of league titles. They achieved possibly their greatest feat in 1991 when they won the inaugural All-Ireland League.

'At club level, that win was the best we achieved at Con, but we had a good panel of players at the time,' said Lenihan.

Lenihan had just as much success when he made his début against Australia in 1981. A year later Ireland made history by winning the Triple Crown and championship, helped by the brilliance of Lenihan under the captaincy of Ciaran Fitzgerald. Three years later the same feat was achieved, with Lenihan once again playing a major role in their success. The fact that Ireland hadn't won a Triple Crown or championship since 1949 brought a huge buzz to our nation and to the rugby fraternity in general.

'Looking back, I must say the 1982 season was brilliant, as I was proud to have helped Ireland to win their first Triple Crown in 33 years.'

He went on tour with the Lions in 1983 and 1989.

'I would say that the best thing that can happen to you when you are playing rugby is to play senior rugby for your country. When you are selected on the Lions team, it's the ultimate honour in the game, and I was proud and fortunate to have gained both honours.'

Lenihan retired from international rugby in 1992 after earning his 52nd cap against Wales. Looking back on his career, it was simply polished both on and off the pitch, from captaining Ireland to playing with the Lions, and rounding it off by managing the Lions in 2001.

Donal Lenihan congratulating members of the British and Irish Lions.

At the 23rd European Athletics Championships at the Olympic Stadium in Amsterdam, IAAF President Lord Coe hands a flag of her local athletics club, Loughrea AC, to Olive Loughnane after presenting her with her gold medal for the women's 20km walk from the 2009 IAAF World Championships in Berlin. (© Sportsfile)

OLIVE LOUGHNANE — RACE WALKER

Olive Loughnane carried the torch for Irish women race walkers on the world stage, appearing in four consecutive Olympics, half a dozen World Championships and two Europeans. In a distinguished career, which began in 1999 and finished after the London Olympics in 2012, she set the example for others to follow.

Loughnane was born in Cork and lived in the city until she was four years old, when her family moved to Galway. She was always very active as a child and joined her local athletics club, Loughrea, when she was a young teenager. She graduated from NUIG in 1996 and set her sights on the Olympics.

She was 24 when she made her Olympic début in Sydney in 2000, finishing in 35th spot in a time of 1.38.23, and that set in motion a sequence of higher placings and quicker times. She came seventh in her third Games in Beijing, crossing the line in 1.27.45. That season she also produced a sixth-place finish in a World Cup race in Russia. She carried that form into the following season, crossing the line in fourth place in a European Cup race in France, clocking 1.34.52 in the process. In her final games in London in 2012 she finished in eleventh place, with a time of 1.29.39.

Her walking highlight was obviously the gold medal in the 20km at the World Championships in Berlin in 2009. She finished second on the day behind Russia's Olga Kaniskina in a very creditable performance, but was elevated to first place after the winner was stripped of her title because of doping violations. She produced a season's best time of 1.28.58 in chasing Kaniskina and seeing off the threat posed by China's Liu Hong. Even though it took all of seven years for authorities to prove that Kaniskina was a drugs cheat, Loughnane had no doubt, saying that it was worth the wait.

She attended the European Championships in Amsterdam in 2016 to ascend the podium gladly and accept the gold medal from Seb Coe, the former middle-distance great and then IAAF president.

A clearly emotional Loughnane spoke of her delight.

'There's value in sentiment and it was great to share the moment with all the Irish fans here,' she said.

Outside of her 2009 success, she came thirteenth in her first World Championships in Canada in 2001, twelfth two years later in France, seventeenth in 2007 in Japan, and thirteenth in 2011 in South Korea.

She bowed out in February 2013 after a remarkable career, having represented Ireland at the highest level and making the Rebel county incredibly proud.

ALEK LUDZIK — SOCCER

The date was 30 November 1969, the place was Flower Lodge, the occasion a derby game between arch-rivals Cork Hibernians and Cork Celtic, and the subject of most of the post-match comment was a young goalkeeper with an unusual name. 'Brilliant debut by Celtic keeper', proclaimed the headline on the following day's *Cork Examiner*, with the paper's reporter going on to substantiate his account of how Celtic's new signing, nineteen-year-old Alek Ludzik, almost single-handedly kept Hibs at bay for all of 70 minutes. His performance drew gasps of disbelief from the large crowd, as he made a series of electrifying saves. Ludzik was eventually beaten by a close-range Dave Wiggington effort that gave Hibs a 1–0 win, but Ludzik proved an instant hero when he capped a fine display by stopping a Carl Davenport penalty two minutes from time.

The son of a Polish father and an Italian mother, Ludzik was to become one of the star acts in the League of Ireland during its halcyon days. Born in Derby, England, in 1950, he began his apprenticeship in his home town before moving to Cork in 1969. Five years later he was still with Cork Celtic, and this partnership culminated in their winning the League of Ireland in what proved to be a marvellous year for Cork's acrobatic keeper.

After the league success of 1974, Ludzik got a call from Peter Taylor to play at Brighton. Ludzik was determined to resurrect his cross-channel career, but Celtic were looking for a transfer fee that stopped his dream move. He returned to Cork five months later and vowed never to play for Cork Celtic again. He joined Albert Rovers, who later played in the League of Ireland under the name of Cork Alberts. He pulled Alberts out of the fire on numerous occasions, entering the record books in 1977 when he scored straight from a kick-out against Dundalk. When Alberts went out of football, Ludzik joined Limerick, then managed by Eoin Hand, where he played for five years before spending another five years playing for Cobh Ramblers. He was assistant to Cobh Ramblers manager Alfie Hale when they signed a young Roy Keane. His swansong came in 1994, at the age of 44, when Cork City won the League of Ireland under the management of Noel O'Mahony.

Ludzik died suddenly on 12 December 2002 at the age of 52. Hundreds of friends and relatives attended the removal and funeral, at which the coffin was draped with his trademark yellow jersey. Football folk from all corners of Munster and further afield—and, indeed, opponents—came to pay their personal tributes. In his League of Ireland career he played over 900 games, and his untimely passing left his family without a dedicated father and Cork without another sporting legend.

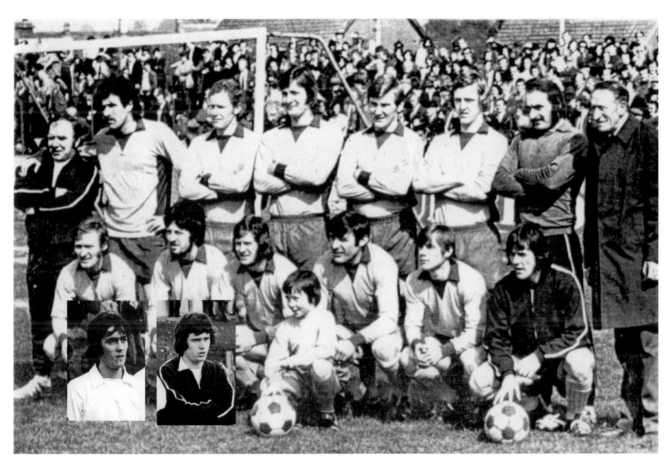

Cork Celtic, 1974. Back: Paul O'Donovan, Ben Hannigan, John McCarthy, John Carroll, Barry Notley, Alec Ludzic and Dinny Ryan. Front: Alfie Hale (absent v. Drogheda), Mick Tobin (absent), Paddy Shortt, Bobby Tambling, Richie Brooks and Frank O'Neill. Mascot: Don Moore. Insets: Gerry Myers and Brian McSweeney.

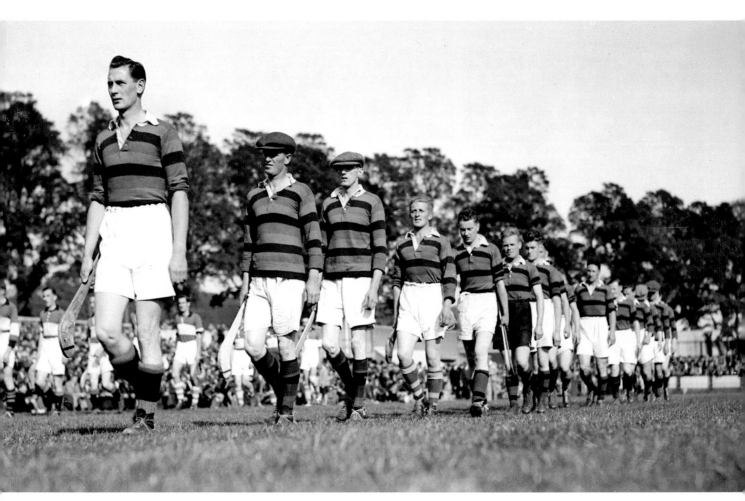

Jack Lynch leading Glen Rovers in a championship final.

JACK LYNCH — HURLING AND FOOTBALL

Jack Lynch, future Taoiseach, is one of the most famous names to be associated with the GAA in this country, a superstar before the term was invented. Lynch, born in 1917, was one of a family of nine children living in the Shandon area of Cork. From this working-class background came the youngster who was destined to occupy an unrivalled niche in the annals of the GAA. At the Northern Monastery school he earned a reputation as an excellent hurler and an outstanding scholar. He helped his school win three Harty Cup titles in a row from 1935 to 1937.

While still at school, in 1934 he helped Glen Rovers to win the Cork Minor Hurling Championship for the first time in the club's history. In his time at Glen he was one of the few to collect all eight successive Cork County medals, starting in 1934. In all, he won eleven county medals, picking up two football medals with St Nicholas, the Glens' sister club, in 1938 and 1941.

One of the most famous stories of his football career centred on the 1938 County Final in Bandon. The match was played on the old Bandon field, which, as the older followers of the GAA will remember, had a river running parallel to it. In those days footballs were a scarce enough commodity, and the club had only two of them on the day of the final. The first ball got punctured early in the game and later, with St Nick's ahead and looking in control, the second ball was kicked into the middle of the river. Lynch, knowing that the game would be abandoned if the ball was not retrieved, leaped into the river and got the ball, and St Nick's subsequently went on to win the title.

The first of Lynch's senior hurling medals came in 1941, when Cork demolished Dublin 5–11 to 0–6 in the All-Ireland final. In 1942 Cork's dreams came true once again, as they defeated Dublin 2–14 to 3–4. Another victory in 1943 over Antrim saw Cork set themselves for the 1944 All-Ireland final, where under captain Seán Condon they easily accounted for Dublin. Lynch would continue with his incredible All-Ireland success but this time it was with the Cork senior footballers, who in 1945 created a major shock when they beat Kerry in the Munster final in Killarney. It was 34 years since Cork had won an All-Ireland football title, but they came up trumps against Cavan 2–5 to 0–7. Lynch also won three national hurling titles, six Munster championships and eight Railway Cup medals.

He retired from club hurling in 1950 after the Glens won another county title that brought his remarkable career to an end. In October 1999 the city was saddened when Lynch died at the age of 82. Thousands of people lined the streets of Cork to pay tribute to the great man who was loved by the majority of Corkonians for his leadership both on and off the field.

DERMOT MACCURTAIN — HURLING

When the name of Dermot MacCurtain is mentioned in hurling circles, it is invariably accompanied by comments about his stunning displays for Cork and Blackrock in the 1970s and '80s.

MacCurtain began his hurling and football career with the Dublin Hill club Delanys, and played with them up to the age of seventeen. In 1974 he got his first taste of success. Coláiste Iognáid Rís, better known as Sullivan's Quay CBS, had a historic double when they won the Dr Harty Cup and the Corn Uí Mhuirí, the Colleges Senior Hurling and Football titles respectively. That year, MacCurtain was on the Cork sides that won the All-Ireland hurling and football minor double.

'It was the first time that the school won the Harty Cup, which would have made it a very special year, but then when we won the Munster Schools Senior Football Championship against St Brendan's, Killarney, it was an incredible double.

'What a way to end the year, but to win a double with Cork in the minor hurling and football was incredible, and that was a very special year in my young career,' said MacCurtain.

The year 1975 was also a good one for MacCurtain, as Blackrock had a clean sweep in the minor grade and he was also part of the Cork U21 All-Ireland-winning team of 1976. He was brought into the Blackrock senior team and in 1975 he won his first Cork County Senior Hurling Championship when they defeated Glen Rovers in the final. There were plenty more medals to follow, with further victories in 1978, 1979 and 1985, plus two All-Ireland club titles.

In 1977 he won a Senior All-Ireland medal, with Cork defeating Wexford in the decider. The following year there was a lot of pressure on Cork, as they were bidding to complete a hat-trick of titles against Kilkenny.

'The Cats were really fired up to deny us our three in a row, but we luckily lifted our game and ended up champions again,' he said.

Cork hurling went through a few more lean years after that win and MacCurtain had to wait until 1984 for his next senior medal. Two years later, he won his fourth and final All-Ireland medal against Galway, ending a truly remarkable inter-county career on a high note.

MacCurtain disagrees with many GAA pundits that the present generation of hurlers are far fitter than during his time playing. 'I get annoyed when I am told that players in my time were only half-fit, because the truth is we were very fit and trained very hard,' he said.

'Don't get me wrong, there are some fabulous players in Ireland, but in my book, when we played there was a much higher level of striking and picking up the ball.'

The former Blackrock star will never forget the support he got from his father Pat, and Cork supporters will forever hold memories of the brilliance that MacCurtain produced during his career.

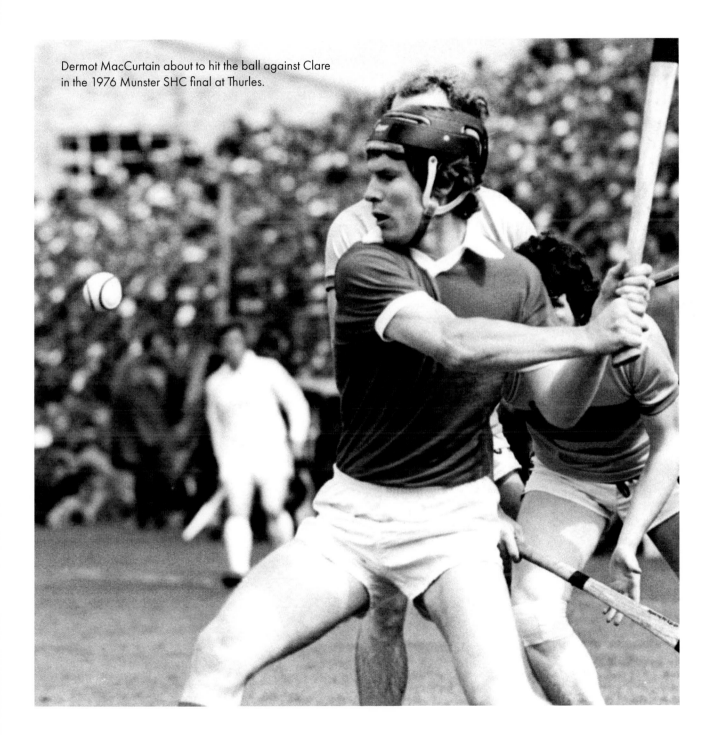

Dermot MacCurtain about to hit the ball against Clare in the 1976 Munster SHC final at Thurles.

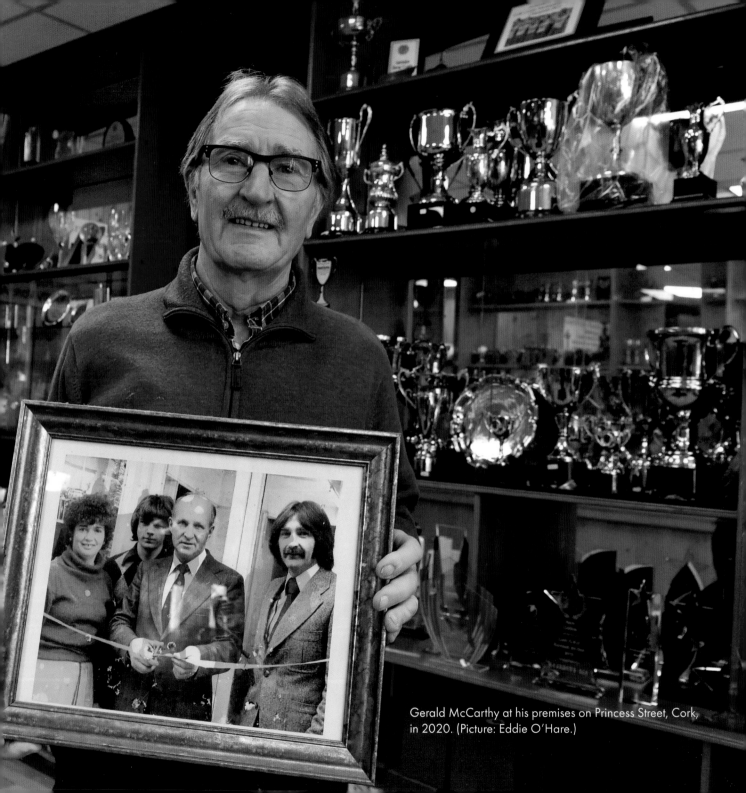

Gerald McCarthy at his premises on Princess Street, Cork, in 2020. (Picture: Eddie O'Hare.)

GERALD MCCARTHY — HURLING

Gerald McCarthy is rated by many as one of the best midfielders ever to wear a Cork jersey. He's especially revered for his breathtaking skills, which made him a hurling icon in the 1960s and '70s. McCarthy, who comes originally from Bandon Road, was born in 1945 and it was only natural that he would soon wear the blue jersey of St Finbarr's, where he showed incredible talent at juvenile level.

In 1966, a year that McCarthy will always remember, he made history in the sport of hurling. First, he led Cork to an All-Ireland U21 hurling title, and that September he captained the Cork senior hurling team to All-Ireland victory over a highly fancied Kilkenny team. To this day, he stands out in GAA history as being the only player to captain a team to All-Ireland glory at both U21 and senior levels in the one season.

'I do not know if any player will ever captain an U21 and senior team in my lifetime, so I will enjoy the record for now,' he said.

He had to wait four years for his next senior All-Ireland, when Cork, captained by Paddy Barry, defeated Wexford. There followed a few more bleak years for Cork at inter-county level, but they bounced back in 1976 with another title. In 1977 they were crowned champions again and in 1978 they achieved the magical treble that culminated in McCarthy's being named Man of the Match. Incredibly, he achieved only one All-Star in 1978, but it doesn't concern him.

'I have only one All-Star but that is fine, as awards are really for team effort and you should always remember that you are receiving them on behalf of your team.'

The 1969 All-Ireland defeat by Kilkenny is something that still lurks in McCarthy's mind as one of the saddest days of his career.

'Con Roche hit a wonderful point in the second half that gave us a seven-point lead but, amazingly, in the last quarter we remained static and ended up losing the game.'

McCarthy's record at club level is just as impressive, as he won his first Cork Senior County Championship medal in 1965 and followed it up with three more in 1968, 1974 and 1977. All-Ireland club success with the Barrs came in 1975 and 1978, and his outstanding skills at centre-field always played a huge part in his team's victories.

McCarthy was coach of the Cork All-Ireland-winning team of 1990, and in 1997 he took over as coach of the Waterford senior team until 2001. In 2006 he was reappointed as the Cork senior coach but stepped down in 2009.

He reckons that the standard of hurling today is 'a lot better to look at' than in the 1960s, '70s and '80s.

'In my time, the full-back's job was to pin his hurley against the back of the full forward, restricting him from getting near goal, but nowadays the full-back must be the complete player on the team.'

Few in the game would argue that McCarthy was a colossus in the game of hurling.

STEPHEN MCCARTHY — BASKETBALL

When the great basketball players in this country are discussed, the name of Stephen McCarthy will always figure among them. McCarthy began his career playing with northside club St Vincent's and soon found his liking for the sport. He then played for new club GH Dodgers at the Parochial Hall in Gurranabraher, where he reached a Billy Kelly final. He subsequently became good friends with Gordon Elliot and decided to join Neptune.

'The first year at Neptune was my last playing U17, and I have to credit Noel Allen, who did a great job coaching us, and I do feel he is one of the best teachers of the sport in this country.'

The progression to National League in 1989/90 was easy, as Neptune won the double and McCarthy was named MVP in the Cup final. In the 1990s, many of the stars of the all-conquering Neptune team began retiring, but with McCarthy and Gordon Fitzgerald developing into talented players they continued to dominate proceedings. They won the title again in 1994/5 and 1996/7, with McCarthy named as Player of the Year in the latter season. In 2000 he was an integral part of the side that were crowned League champions, with American Ricardo Leonard and coach Gerry Fitzpatrick.

McCarthy's brilliance saw him sign with Manchester Giants on a professional contract in 2001/2 but, sadly, their sponsor pulled the plug and he had to return to Cork six months into the season. In the 2002/3 season Neptune were successful again, but it was a year that McCarthy will never forget.

'There was a lot of turmoil in that season, as Emmett Neville died unexpectedly, and although Gordon and I were joint captains, there were a lot of young guys on the team that were clearly distraught,' he said. 'There were only five games to go in the season and the team, under the late Martin Ahern, sat down after the funeral and made a pledge to win it, and thankfully we did the business.'

He praised Ahern's influence on his career.

'I think Martin gave me the confidence and guidance to go forward in my young days, and for him to be my coach at Super League level and win it is something still close to my heart.'

Two years later he retired owing to persistent injuries, and after coaching Neptune for a season and a half he decided that it was time to go. McCarthy was simply an awesome talent, and his skills made him one of the best ever to play basketball in this country.

Neptune captain Stephen McCarthy (centre) is presented with the ESB Super League trophy by Finn Ahern, President IBA (left), and P.J. Kavanagh, ESB Cork.

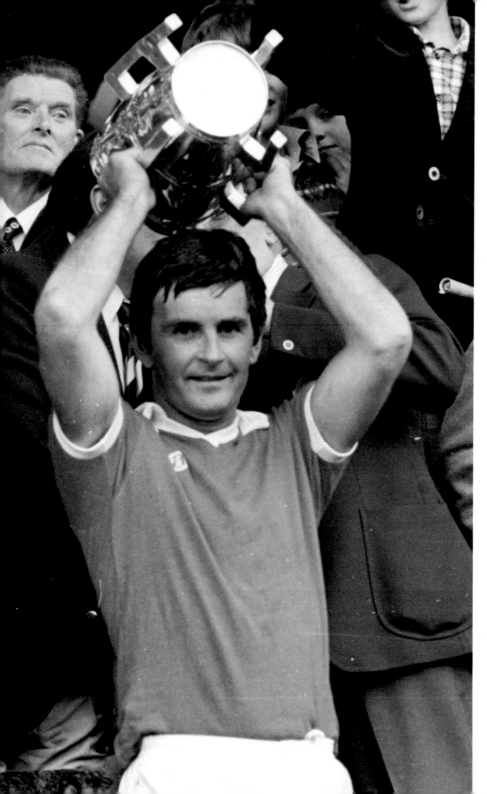

Cork Captain, Charlie McCarthy,
lifts the Liam McCarthy after victory
over Kilkenny in 1978.

CHARLIE McCARTHY — HURLING

The hurling skills of Charlie McCarthy during the 1960s and '70s were widely recognised, and it was evident from a young age that he was destined to play at the top level for his county. The five-time senior All-Ireland medallist joined his beloved St Finbarr's as a young lad but he had to wait until 1963 for his first taste of success, when he helped his club win the Cork County Minor Football Championship. The following year he won his first All-Ireland medal with Cork when they won the minor hurling title, and this was to be the beginning of the McCarthy fairytale in the sport.

St Finbarr's won the 1965 Cork Senior Hurling Championship, and further successes in 1968, 1974, 1977, 1980 and 1981 brought McCarthy's Senior Hurling Championship medal haul to six. In 1966 he won his first senior All-Ireland medal, followed four years later by his second. He recalled his call-up to the 1966 team.

'We were due to play Clare in the quarter-final of the Munster championship but I wasn't in the squad, and after a night out with my girlfriend Pauline (now my wife) I arrived home to be told by my mother that I was to be in Cook Street at 10am on Sunday morning, as she got a call from selector Tony O'Shaughnessy, and I don't think that would happen in today's scene.'

McCarthy was one of the rocks on which Cork's famous treble was built, and his skills when games hung in the balance helped the Rebels over the line. Cork romped to victory in 1976 and, after winning the title again in 1977, fate dictated that McCarthy would be the man who would lift the Liam McCarthy in 1978.

'It was always an honour to win an All-Ireland but for me to captain the team in 1978 to the magical treble is something I will never forget,' said McCarthy.

He won nine Munster senior hurling medals with Cork and four National League titles. He bowed out of inter-county hurling in 1980 and recalled the talented players of that area.

'I was proud to share the field with some outstanding hurlers and, to me, each and every player that I played with had their own special qualities.'

According to McCarthy, when you had to pit your wits and skills against Jim Treacy of Kilkenny and John Glennon of Tipperary, you would certainly know you had been involved in a game of hurling.

For many years he had the luxury of watching his son Cathal don the blue jersey of the Barrs at senior level, but nowadays it's all about getting to as many games as possible to support his beloved club. When you speak to the majority of genuine and trusted GAA people and McCarthy's name pops up in conversation, the word 'gentleman' is always associated with the great man. Many great hurlers have been proud to wear the famous red and white jersey of Cork, but McCarthy is right up there amongst the greatest of them.

TEDDY MCCARTHY — FOOTBALL AND HURLING

The role of the dual hurler and footballer has been somewhat diminished in the modern GAA game, but the numerous stirring displays by Teddy McCarthy in both codes will never be forgotten. At fifteen years of age he won his first major hurling championship, when he starred with the North Monastery as they won the Dr Harty Cup in 1980. He went on to win three All-Ireland U21 Football Championships in 1984, 1985 and 1986. In 1989 he was part of the Rebels side that won the National League and bounced back from two consecutive All-Ireland football final losses to defeat Mayo. That year McCarthy earned both an All-Star and the Texaco Sport Star award in football.

Just when he thought it couldn't get any better, Cork won the hurling and football senior double in 1990, with McCarthy playing a leading role in both victories—the only player in history to do so. This is an achievement that may never be equalled again, as the modern-day inter-county demands do not produce men like McCarthy, whose record looks safe. In 1992 Cork were champions once more when they defeated Kilkenny in the All-Ireland Hurling Championship final.

On the football side, Cork were defeated by Derry in the 1993 final. There was more heartbreak for McCarthy in 1995, when Cork lost to Dublin in the All-Ireland semi-final. McCarthy retired from football in 1996 and a year later bowed out of the hurling scene after Cork were humiliated by Limerick in the Munster Championship.

McCarthy revelled in playing both codes but reckons that, with the back-door system, it would be nearly impossible to play both games if he was still playing.

'It was hard enough when you had to win four games to win an All-Ireland, but in the present system I don't think any player could manage to get through the tough schedules in both hurling and football.'

McCarthy singles out Meath's Gerry McEntee and Liam Hayes as his hardest opponents on the football field, while Joe Hayes of Tipperary gets the vote as his toughest hurling opponent.

After playing with Sarsfields for his entire career, McCarthy got involved with coaching at the club for a number of years, and thanked Glanmire businessman Eddie O'Connell for being a true friend during his years of playing for club and county.

After winning three All-Ireland U21 football medals and two All-Ireland Senior football and hurling titles, it is little wonder that Teddy will always be remembered as one of the greatest dual stars this country has produced in the last 70 years.

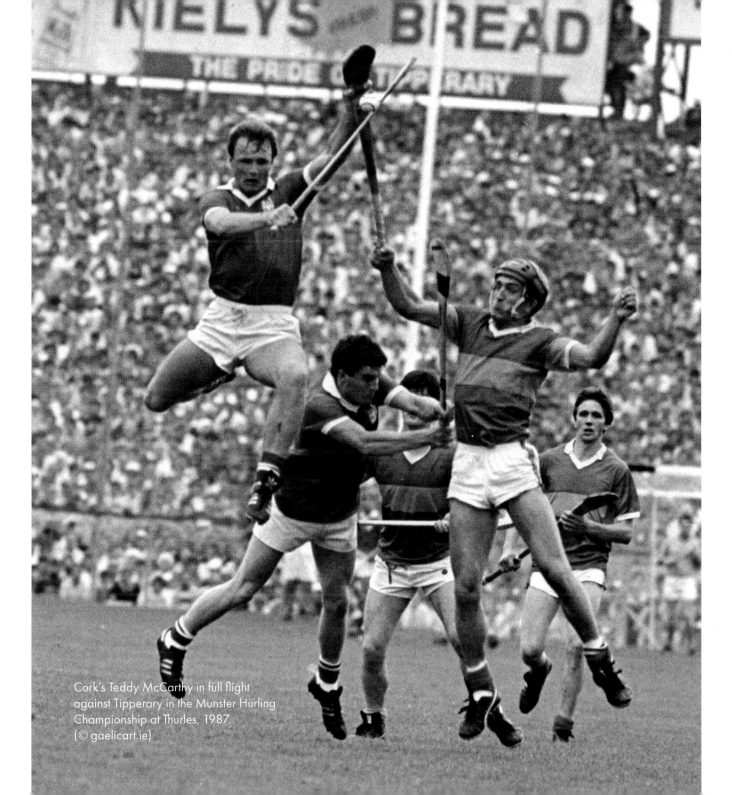

Cork's Teddy McCarthy in full flight against Tipperary in the Munster Hurling Championship at Thurles, 1987. (© gaelicart.ie)

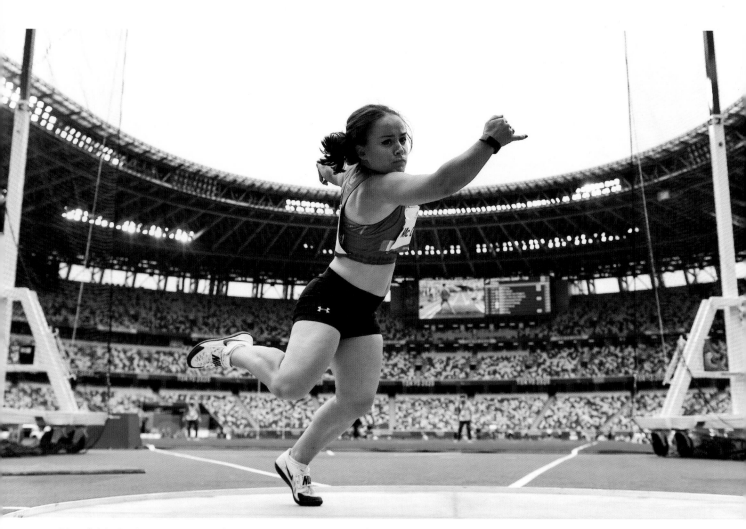

Niamh McCarthy, competing in the F41 Women's Discus Final at the Tokyo 2020 Paralympic Games.
© Sam Barnes/Sportsfile

NIAMH MCCARTHY — DISCUS

Niamh McCarthy, Paralympic bronze medallist, is one of the best discus-throwers in the world. The Carragaline woman took up the sport after a Paralympics search at UCD in 2012.

'I didn't even know it [the Paralympics] existed,' she said. She tried a few different sports, with her options limited owing to her classification, and found that she had a natural talent for discus.

Although she was prepared for the level of training required, it was 'still kind of a shock to the system'. She was repeating a year in college, and the time she had available in the day changed significantly. She took on more hours in work to help with funding and decided to leave college.

Her first major medal came at the World Championships in Doha in 2015, when she won the bronze. 'I was unprepared for how serious it was,' she said. It was her first time seeing her competitors in person rather than just as names on a ranking. One of her training sessions 'went horribly wrong' and she burst into tears because she was terrified. She knew what doing well could mean for her funding. 'It went my way in the end and I got the bronze,' she said.

As for the 2016 Paralympic Games in Rio, she'd love to relive it. She went in with confidence and perhaps a little arrogance, ranked third but knowing that the girl ahead of her was only just. The competition wasn't going well for her at all and she was ranked fifth by her fourth throw. Those last few minutes waiting to see whether her competitors would top her or not were agonising, but she pulled it out of the bag. Her attitude, which she now says was naïve, was 'I don't see why I couldn't get a medal', and she was correct.

There have been a lot more nerves involved in the last few years. There was a lot of uncertainty and a lot of pressure, with people expecting her to win medals. 'I at times paid too much attention to it,' she said.

For the 2020 Games in Tokyo, she didn't have her 'ideal set-up'.

'It didn't feel entirely real until we were on the plane. There was something slightly off this year.'

She came fifth in the F41 final, and she's happy with her result and that she competed, because at one point she considered dropping out.

The three-time world championship medallist announced her retirement from discus in October 2021 after an outstanding career. 'I've achieved a lot and I'm sure I could could push myself to get more', but 'for my own health and happiness, I just had to let go,' she said. She's achieved at the highest level, including two gold medals and one silver medal at the European Championships, and feels that now is the right time to go.

She'd like to be involved in the 2024 Paralympics in Paris, perhaps in a reporting role. She's recently completed a Pilates instructor course and plans to launch her own Pilates business next year. 'One of the best things about sport is getting fit and active, and I don't plan on stopping,' she said.

BARRY MCGANN — RUGBY

Although Barry McGann won 25 caps playing rugby for Ireland between 1969 and 1976, he came from a varied background in a sporting sense. He played most sports, including golf, cricket, Gaelic football and hurling. After playing soccer with Young Elms, McGann was spotted by the Dublin scouts and later went to play soccer with Shelbourne. He also earned caps with the Irish youth team and was the only Cork player selected on a side that included Mick Leach and Terry Conroy, as Ireland finished sixth of the 24 competing nations. The highlight for McGann was when Ireland defeated the Netherlands, as the Dutch had the legendary Johann Cruyff on their side.

McGann began his rugby education at the Presentation Brothers College and in 1966 he captained the school to win the Munster Schools Senior Cup. After finishing school he went straight to Cork Constitution, and on his first day at the club he was approached by Noel Murphy, who said, 'You just play ball and we will look after you'. McGann took Murphy at his word, and three years later he made his international début.

In Ireland's game against France, McGann came on as a replacement for Mike Gibson. He played brilliantly, stopping a goal in their 17–9 win, their first victory over France in eleven years. When Gibson returned, he had to be content with a place in the centre, as McGann held his place at out-half. England were next to be dispatched, as Ireland defeated them 17–15 in Dublin, followed by a 16–0 win against Scotland in which McGann scored his first international try. The Triple Crown was now on the cards and the Cardiff Arms Park showdown is best remembered for the most controversial punch in the history of international rugby, when Murphy was floored by Welsh forward Ryan Price. McGann finished his international career in 1976 against New Zealand with a total of 72 test points, including that memorable try against Scotland.

McGann has great memories of his rugby career and he recalled one towards the end of his career under coach Syd Millar.

'Because of work I was late for training and I approached Syd, knowing he didn't believe me, and asked him what could I do. He duly asked me to warm up. Instinctively I rubbed my hands and said, "Okay, I am ready".

'Moss Keane was in stitches, but I will never forget the look on Syd Millar's face, and I think in reality that incident cost me about ten caps.'

McGann was a warm and genial man and will be remembered as an outstanding sportsman.

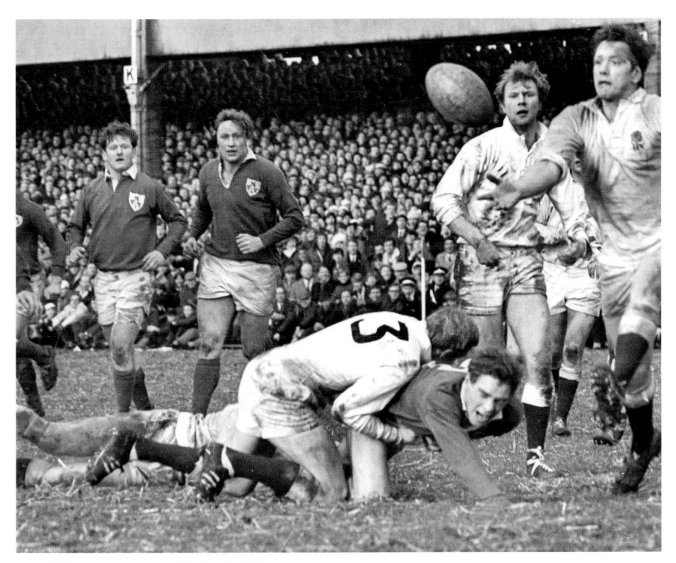

Barry McGann in action against England in 1969.

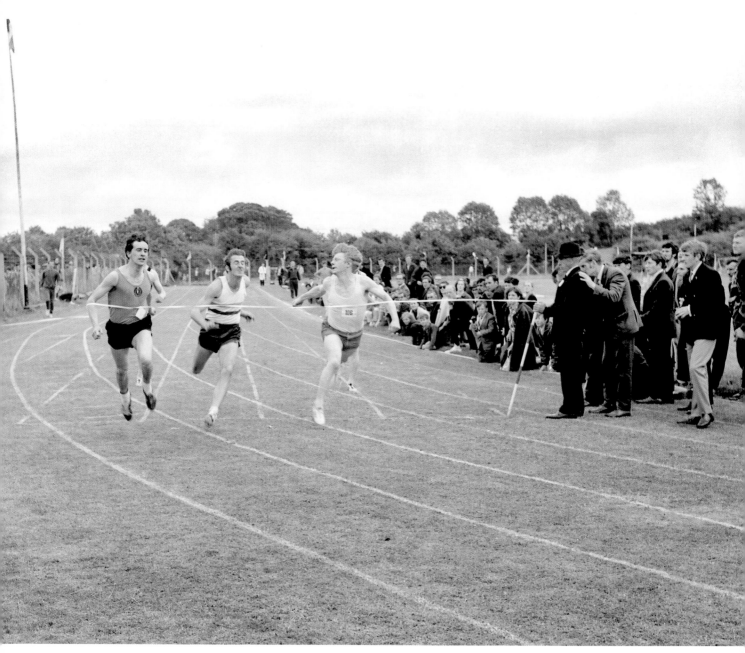

Fanahan McSweeney (centre) winning the Banteer Sports in 1970.

FANAHAN MCSWEENEY — ATHLETICS

In the world of athletics, few could match the achievements and courage of the late Fanahan McSweeney. His grit, determination and style marked him out as an athlete and a man apart from many of his peers. In 1970 McSweeney became the first Irishman to go on an athletics scholarship to McNeece University in Louisiana. He was attracted there by the name of Bob Hayes among the athletics coaches on the college syllabus. To his dismay, he discovered on arrival that the Bob Hayes mentioned wasn't the celebrated American who had won the Olympic sprint title in Mexico two years earlier but a rather avuncular field events coach.

McSweeney was troubled at the time by a recurring back injury, which would later manifest itself as a disease that he'd have to fight against for his life. Such was the bravery of McSweeney that, travelling to Helsinki in 1971 for the European Athletics Championships, he was in so much pain that he had to be carried off the plane, but mere days later he was back on the track and sufficiently recovered to reach the semi-finals of the European 200m Championship. He competed in the men's 400m at the 1972 Olympic Games in Munich.

McSweeney is still an Irish record-holder of the now defunct 880 yards event. He set the record in typical style, going out in 48 seconds in Houston's Astrodome and taking a full twelve seconds longer for the second quarter for a European indoor best of 1.48. He broke the European 400m indoor record in February 1970 in 46.3 seconds and broke the record for the 200m in 21.1 seconds. Those records stood for fourteen and sixteen years respectively. That was an illustration of the swashbuckling style of the man whom many would regard as the most exciting relay runner of his generation. He won 48 consecutive international 400m races. McSweeney anchoring the 4 x 400 was never more riveting than on a summer's evening in Reykjavik in 1972 when, taking the baton some 25 metres down on the anchor leg, he electrified the crowd and won on the line.

McSweeney suffered from cancer for ten years before eventually passing away in 1995 at the age of 47. Before his death, he wrote a best-selling book titled *Living and Loving with Cancer*, which gave a full account of his illness.

The legendary Eamon Coughlan said at the time of McSweeney's death: 'Fanahan was a unique man who through all his years of suffering gave so much hope to so many others in similar circumstances. Because of injury he never had the chance to reach his full potential as a top international athlete, but in life generally his impact was enormous.'

LINDA MELLERICK — CAMOGIE

The All-Ireland Camogie final of 2002 was a classic game and one that brought the sport to a higher level in front of a new television audience. One of the most skilful players on display that day was Linda Mellerick, who clinched her sixth All-Ireland medal.

Mellerick was actually born in Tipperary in 1967, but moved to Cork at a young age. During her first year of secondary school, St Patrick's was canvassing for camogie players and she decided to give it a go.

'To be honest, I did not know what I was going to play and had no idea what type of sport camogie really was, but I was told by one of my friends that it was similar to hockey and that it sounded fun,' said Mellerick.

She had a spell with Brian Dillon's before joining Glen Rovers, moving into their senior team in 1990 after playing two seasons at junior and intermediate level. The Glen senior team were simply unstoppable at the time, winning seven Cork Senior Championships from 1990 to 1996. Mellerick won five Munster Senior Championships and three All-Ireland Senior Club medals. They suffered a shattering defeat by Lisdowney in the 1994 club final, when, after being nine points ahead with twelve minutes remaining, four goals from the legendary Angela Downey killed their dream. Mellerick fondly recalled her first All-Ireland club title, when the Glen defeated St Paul's (Lisdowney).

'The team that we had at the Glen was just something out of the ordinary, as we had great players, but most of all we had the most unbelievable team spirit that epitomised the whole team in general.

'It was an honour to play with such a great gang of girls and I will forever remember the great times we had, as I made some great friends playing with the Glen and that was just as important as winning medals.'

The inter-county scene was just as successful for Mellerick, as she won All-Ireland Senior Championships in 1992, 1993, 1995, 1997, 1998 and 2002, captaining the side to victory in 1993 and 1997. The 1995 final in particular stands out for Mellerick, as she played a huge role in Cork's win against arch-rivals Kilkenny in an epic final.

'Everyone was saying there was no way that we would beat Kilkenny and, with the game in the melting pot, we trailed by one point with a minute remaining. Amazingly, we won by four points and Kilkenny looked shell-shocked at the final whistle, but we were naturally over the moon.'

Mellerick retired from inter-county camogie after the epic 2002 All-Ireland win. She's regarded as a colossus of camogie and is without doubt a fitting example for the up-and-coming players of the sport.

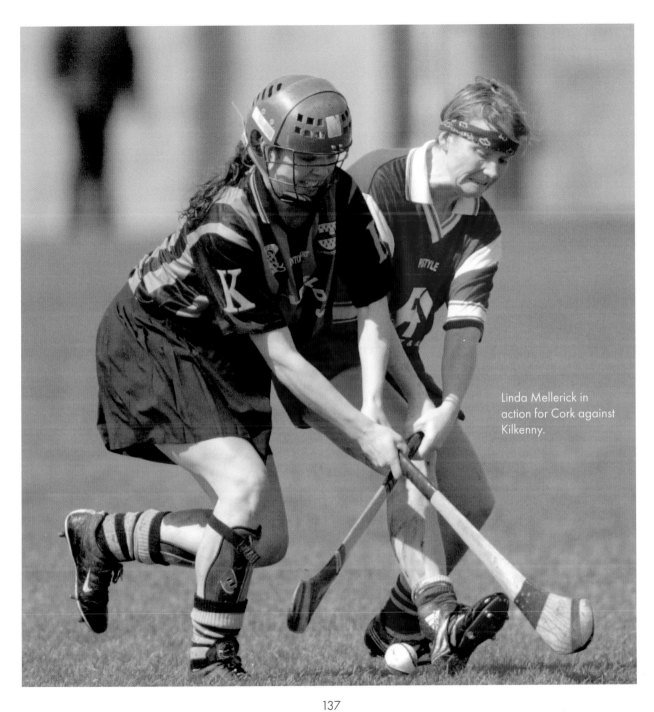

Linda Mellerick in action for Cork against Kilkenny.

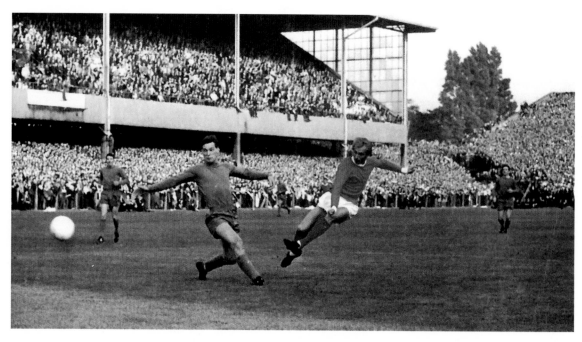

Jackie Morley in action against Manchester United in the 1969 European Cup.

JACKIE MORLEY — SOCCER

As a centre-half Jackie Morley had few peers, as he was one of the classiest defenders and was greatly respected and admired both on and off the field. At a time when soccer was on a high and attracting huge crowds on Leeside, Morley was one of the stars of the game. He signed for Evergreen United as an amateur in 1954 at the age of twenty under the management of Tommy Moroney. He began his apprenticeship playing in the reserves, his breakthrough coming when Gerry Lynch emigrated to England, and he came in as left-half for a Donnelly Cup game late that year. It took two more years for Morley to establish himself in the side and it wasn't until 1956 that he played before a huge crowd at the Mardyke, when Evergreen lost a famous cup tie.

He signed for West Ham United in September of that year. The West Ham match programme the following week read: 'The six-footer is only 20 years of age … his skills include being a good ball player and he has been pursued by many clubs.' His move to London proved difficult, as he found it hard to break into the first team and was confined to just seven league games. He returned to Cork in 1959 and began a nine-year stint with Cork Hibernians, during which he won eleven inter-league caps.

Morley's next move saw him join Waterford United, where his arrival saw the club rise to new heights. The Waterford side had been a sleeping giant but Morley's arrival triggered an immediate response, as his personal commitment to the team off the pitch was mirrored by his team-mates on the pitch. Morley's dedication was such that he used to take two weeks' holiday in Tramore to participate in a fortnight's pre-season training, and the dedication paid off as Waterford were crowned 1969 League of Ireland champions.

One remarkable day at Lansdowne Road saw Waterford United play Manchester United in a European Cup tie that attracted 52,000 people to watch United win 3–1. The icing on the cake for the Waterford team was their return trip to Old Trafford to face a United team that included stars like Bobby Charlton, Denis Law, Paddy Crerand and the legendary George Best. Despite a gutsy performance, they were blitzed 7–1 by the Red Devils.

The 1972 thriller at Flower Lodge against Cork Hibs is one that Morley will never forget, as Waterford came from two goals down to defeat Cork Hibs 3–2 and clinch the title.

Morley passed away in November 2013 at 79 years of age. Few would argue that he was a true sportsman throughout his career, and his skills will never be forgotten by those fortunate enough to see him play.

TOMMY MORONEY — SOCCER

Tommy Moroney, the boy from Evergreen, won the hearts of thousands of rugby and soccer supporters in his native county.

Born in 1923, Moroney played rugby on Saturdays and soccer on Sundays, and showed promise at an early age in rugby when playing for the Presentation Brothers College. On leaving school, he joined the junior ranks at Highfield before switching to Cork Constitution. By 1943 he was regarded as the most promising out-half in the province, and in December of that year he was selected to play for Munster.

In 1946 he played against Leinster at Lansdowne Road on Saturday and turned out for Cork United against Shamrock Rovers at the Mardyke the following day. A month later, he played with the Rest of Ireland on a Saturday and the following day travelled to Milltown in Dublin to play against Shamrock Rovers. Moroney's greatest achievement with Cork Constitution came in 1946, when he scored the winning try against Garryowen in the Munster Senior Cup final just 24 hours after playing for Cork United against Shamrock Rovers in Dublin.

The role of a dual star can be very demanding, but when you combine two codes the demands on time, commitment and skill are even more intense. The punishing schedule began to take its toll on the youngster, and he decided on a career in professional football.

Although he was a late bloomer in soccer, only being introduced in 1943 with the Cork United reserves, he was a spectacular talent. In 1947 Cork United won the FAI Cup final. Following the win, Moroney joined West Ham United and spent six seasons at Upton Park. He returned to Cork in 1953 and was appointed player/coach of Evergreen United, later to be renamed Cork Celtic. Moroney relished the thought of lining out with his former colleagues, namely Seánie McCarthy, Liam O'Neill, Billy Venner and Florrie Burke.

Moroney marked his international début for Ireland with a goal in the 2–1 loss to Spain in Barcelona before a crowd of 65,000. The highlight of his international career was undoubtedly the starring role he played in the defeat of England at Goodison Park in 1949. In 1953 he was the only League of Ireland player on the Irish team that lost to France at the World Cup. He won a total of twelve caps for Ireland at senior level.

Discussion still rages among soccer fans as to who were the greatest Irish players of all time. Moroney must surely rank as one of them.

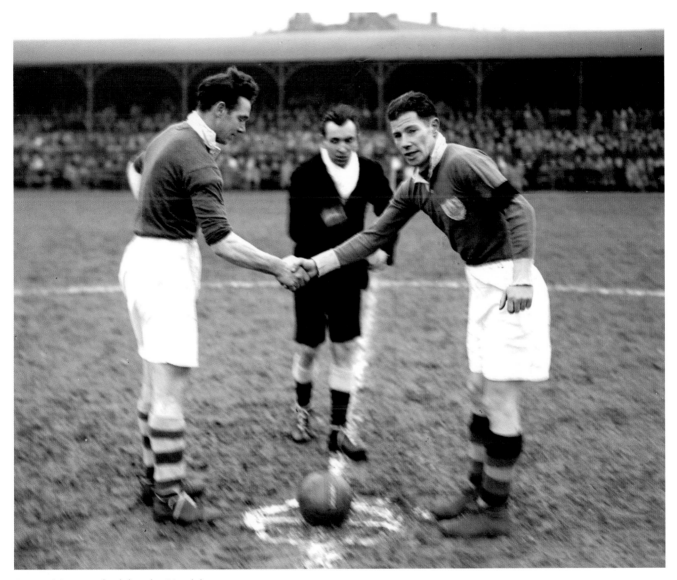

Tommy Moroney (right) at the Mardyke prior to a game.

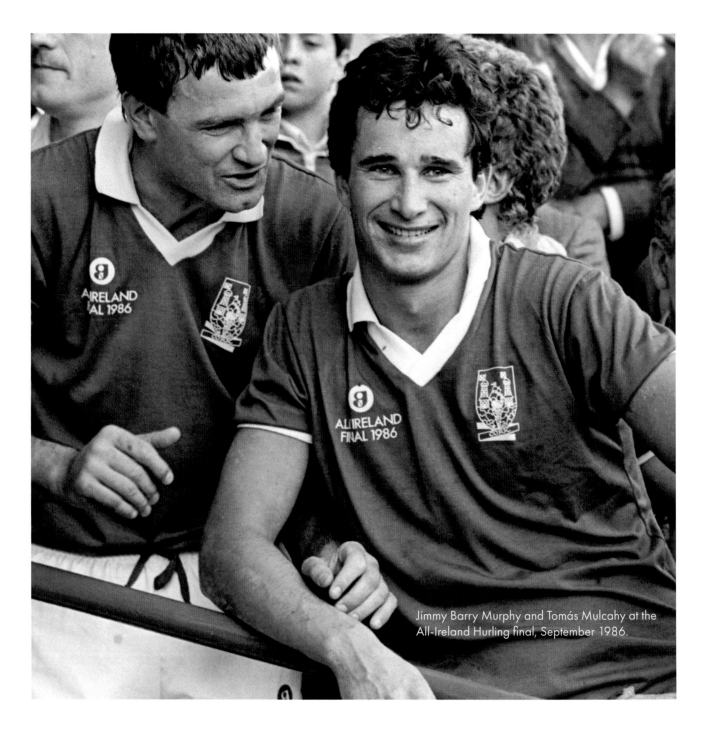

Jimmy Barry Murphy and Tomás Mulcahy at the All-Ireland Hurling final, September 1986.

TOMÁS MULCAHY — HURLING

Glen Rovers hurling club in Cork is renowned for producing quality hurlers, and in Tomás Mulcahy, captain of the Cork senior hurling team of 1990, they have a leader of men. Mulcahy grew up on Boyce's Street and has great memories of his youth. He attended the Northern Monastery AG for secondary school, an institution which was known for producing great hurlers.

'Brother Burke drove the GAA and I played a lot of hurling and football in my youth at the school and with the Glen,' he said. 'The combination of secondary, technical and AG made the Mon a serious hurling academy and, with little to no schools around Cork city, it was the place to get educated, and I am sad to see how it's deteriorated in recent years.'

In Mulcahy's time at the Mon, he won the Dean Ryan Cup, the Dr Harty Cup, the Frewen Cup and the All-Ireland Colleges in hurling.

'We had an exceptional team in both codes, and when you mention the late Paul O'Connor, Tony O'Sullivan in hurling, and in football we had Temple United players Denis Keane (brother of Roy) and Austin Ricken, and to be honest they were the days I look back on with pride.'

His father Gerald, a 'staunch' Glen Rovers man, passed his love for his club to his son. In 1989 Mulcahy was part of the Glen side that won the Cork Senior Hurling Championship for the first time since 1976.

'The Christy Ring Bridge had just opened and when we got there we were met by Jack Lynch, and to me that was a very special day, and to see grown men crying really showed me the character of our club.'

Mulcahy made his senior début for Cork in 1993 and won All-Irelands in 1984, 1986 and 1990 before his retirement after the 1994 campaign. He also won five Munster medals, one National Hurling League medal and two All-Stars. He worked for RTÉ as an analyst from 1995 until 2021, regularly appearing on The Sunday Game.

There is little doubt that Mulcahy brought a lot of skill and character to GAA in this county, and he summed up his days playing for club and county:

'There is a responsibility on us to make sure that Glen Rovers never dies and our Rebel County maintains a stronghold for hurling, because at the end of the day there will be a time when we cannot offer any more, but for now we will do everything to keep us alive.'

NOEL MURPHY — RUGBY

Noel Murphy will go down as one of the greatest rugby players and sports ambassadors that this country has produced. Born near the Lough on Cork's south side, he moved to Mulgrave Road on the north side as a young boy. He attended the Christian Brothers College, Cork, and played a leading role for them when they won the Munster Schools Junior Cup of 1951/2. In his youth he played hurling with Grenagh and soccer with Victoria Rangers.

He began his rugby career playing underage with Connettes, and in 1955 he took his first tentative steps towards the big time at Cork Constitution with the club's junior team. He moved to the senior squad in 1956 and his fifteen-year tenure in this grade saw him win five Munster Senior Cups and a record-breaking eight consecutive Munster Senior League titles. It wasn't long before his displays with Cork Con caught the attention of the Munster senior selectors, and he began playing for the province in 1956. Longevity is a key word in his career and he saw fourteen seasons of action with the famous Reds, playing against Australia, New Zealand and South Africa.

Murphy earned the first of his 41 international senior caps in 1958, and he was always proud to represent his country.

'I have had many pleasures and thrills out of rugby in my time, but to me there is nothing better than wearing the green jersey. It is hard to explain how I felt every time I was capped, but to be playing for your country is the ultimate honour for any player.'

Murphy's outstanding displays for Ireland were rewarded when he was selected for two Lions tours. In 1959 he went to New Zealand, Australia and Canada. He found it difficult to be away from home for so long, as tours would last up to five months. In 1966 he toured the same route, and once again it was a tough schedule that included nine test tours.

When Murphy brought the curtain down on his international career in 1969, he had achieved everything possible out of the game. After taking a break for a few years, he took over as coach for Munster. After a successful spell there, he took over the Irish senior team between 1976 and 1979, leading Ireland to two test wins over Australia in their own backyard.

In 1980 he coached the British Lions tour of South Africa. It wasn't the best tour for the Lions as, despite winning fifteen of their eighteen games, they crucially lost all three tests to South Africa. He also served as president of the Irish Rugby Football Union and was a member of the Six Nations Committee.

Rugby has been simply a way of life for Murphy, and the city of Cork is proud to have produced a man who has served them both on and off the field with honour and dignity.

Noel Murphy (right) in Irish training with Mike Gibson.

Juliet Murphy, captain of the Cork team that defeated Kerry in the Munster Senior Football final at Killarney in 2005

JULIET MURPHY — FOOTBALL

When it comes to the legends of ladies football, Juliet Murphy is up there with the best of them. When the late Eamonn Ryan took over as coach of the side he named Murphy as captain, knowing that in so doing he had picked a leader on and off the field. Her relationship with Ryan was unique and very similar to the one that Roy Keane had with Alex Ferguson in their early days. Keane was Fergie's on-field leader and often acted out the role of manager on the pitch with Fergie's blessing. Murphy did the same for Ryan, but in a different, more subtle manner.

Ryan's shrewd decision was one of the reasons why Cork went on to enjoy the success they did, as Murphy captained the team to three All-Ireland titles and overall was part of the winning side eight times. Add in ten Munster titles and nine National League titles and you get some idea of the calibre of the player that Murphy was. Since she first made her début in 1996 against Kerry, the primary school teacher has been one of the team's most important players, leaders and characters.

'I was just very fortunate to be part of such a unique bunch of girls and I will remember that feeling forever. You think of the enjoyment you get from winning. There is nothing that I can do in my life in the future that can compare to that feeling.

'The sheer euphoria, the buzz, the excitement—you are with your friends and you are part of a great team. You are honoured to be in that situation for that moment in time and you never really want to lose that feeling. We have a never-say-die attitude and that's why the team is where it is today.'

With seven All-Ireland titles to her name, Murphy decided that it was time to retire and made the heart-wrenching decision to hang up her boots at the end of the 2012 season. Her first retirement didn't last too long, however, and she soon returned to the pitch.

'It was an accumulation of things, really. I suppose our club situation wasn't great. A couple of the girls were injured and we were facing into the championship short a few senior players. I felt that I was physically able to play and I never would have let my club down if they were short, so I got involved with them and then I met Nollaig (Cleary) and we just started talking.

'I had it in my head that if I was going to go back and help my club Donoughmore, then I would go back and help Cork also.'

That decision proved fruitful, as Murphy played her part in winning three-in-a-row All-Ireland titles for Cork, the second such run under Ryan. That game was her last in the red shirt, as Murphy decided that it was time to go, but her status within the game as one of the all-time greats is well and truly secured.

BRIAN MURPHY — FOOTBALL AND HURLING

In all sports there are unsung heroes, and the former Nemo Rangers star of the seventies, Brian Murphy, was most certainly in that category. The holder of ten All-Ireland medals, including three in senior football and hurling, found a love for the sport at Coláiste Chríost Rí. Under the coaching of Dick Toban, he helped the school win the Dr Harty Cup in 1968. That year they won the All-Ireland Colleges football final when they defeated Belcamp OMI from Dublin. The greatest moment for Brian at colleges football was in 1970, when he captained the team to another All-Ireland crown, beating St Malachy's of Belfast 1–13 to 4–5.

Murphy made his first appearance for the Cork senior hurlers in the 1971/2 National Hurling League against Tipperary. Having won minor All-Ireland hurling medals in 1969 and 1970, an All-Ireland minor football medal in 1970, All-Ireland U21 hurling medals in 1971 and 1973, and an All-Ireland U21 football medal in 1971, the word was out that Murphy was a senior star in the making.

Murphy played a major role in 1973 against Galway, as the Cork footballers lifted their first senior All-Ireland title in 28 years. The biggest disappointment for Murphy was the 1976 Munster football final defeat by Kerry, with the Kingdom proving to be master of football in the following years. In 1977 Cork were well beaten by Kerry in the Munster final and hence followed the 'Three Stripes Affair', with the Cork team being suspended. Before that final the Cork team were offered a set of Adidas jerseys, but they didn't get approval from the county board and the trefoil logo had to be covered up. The ban didn't extend to dual players, who continued to play hurling for Cork.

Murphy was part of the Cork senior hurling team that won the three in a row between 1976 and 1978. In the 1976 final against Wexford, Tony Doran was running them ragged, but once Murphy was moved to full back he completely nullified his threat. Disappointingly, Galway denied the Rebels the magical four in a row with a 2–14 to 1–13 semi-final defeat.

Murphy was very successful in club football, as he won seven Cork senior football titles plus All-Ireland club titles in 1973, 1978, 1982 and 1984. He looks back on the 1978 final, when he captained Nemo in their defeat of Scotstown, with pride. On that day, the snow was falling so heavily that it was almost impossible to see the players on the field. More disappointment followed in 1982 and 1983 with All-Ireland final losses to Kilkenny.

Murphy, who operated mainly at right back, was the type of player that goalkeepers and defenders dream of, as his style was quiet and professional. He did what every corner back should do—marked his man, covered well, read the game and left no gaps to goal.

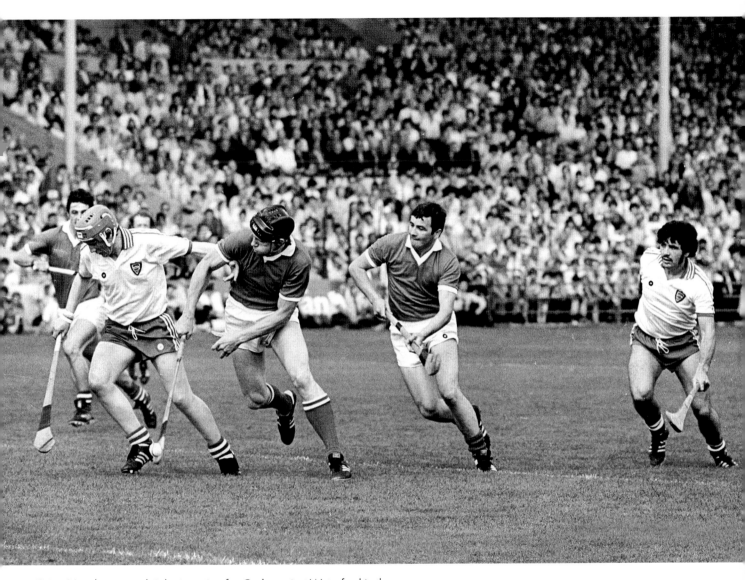

Brian Murphy, second right, in action for Cork against Waterford in the
1982 Munster hurling championship.

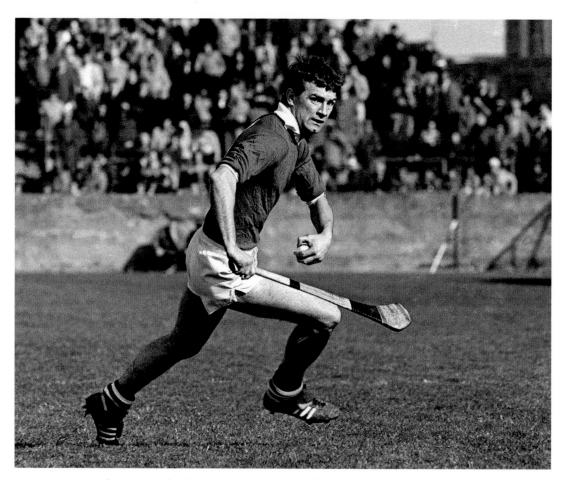

Jimmy Barry Murphy in action for the Cork senior hurlers in 1984.
(© Ray McManus/Sportsfile)

JIMMY BARRY MURPHY — HURLING AND FOOTBALL

The initials 'JBM' are well known in sporting circles all over Ireland, as Jimmy Barry Murphy has an honoured place as one of the greatest dual stars ever to grace a GAA pitch. Born in 1954, it was playing in the street leagues with St Finbarr's that really set the ball rolling for Barry Murphy.

Few in the game will equal his haul. He won his first and only Cork County Minor Championship medal with the Barrs in 1971. At senior level he excelled with the southside club, winning Senior Championships in 1974, 1977, 1980, 1981, 1982 and 1984. He was simply awesome in their All-Ireland club hurling successes of 1975 and 1978.

He won his first senior All-Ireland medal at the age of nineteen, producing a devastating performance when Cork won their first All-Ireland senior title for 28 years with a 3–17 to 2–13 victory over Galway in 1973. In that memorable final Barry Murphy scored 2–1, as the Cork fans celebrated the end of their long drought. He looks back on that day with pride.

'After so many years trying, it was great for our city and also for Donie O'Donovan, who was a tremendous person and coach to work with, to finally land the title.'

Barry Murphy has an incredible record on the hurling scene, including ten Munster Championship titles, five All-Ireland titles and five All-Star awards. Of all the honours he won in hurling, the three in a row that Cork won between 1976 and 1978 meant the most to him. He played a pivotal role in the 1978 final, scoring a goal that gave Cork a five-point lead in the final quarter. The game finished 1–15 to 2–8, and the fact that the win was against Kilkenny made it all the sweeter for the Barrs man, as the Cats had often got the better of them over the years.

Barry Murphy's final achievement with Cork was managing the 1999 All-Ireland-winning team. He returned from 2011 to 2015 but is now enjoying his retirement from the sport.

Despite Barry Murphy's full trophy cabinet, he missed out on one honour. He would have loved to captain the Rebels to an All-Ireland win, but he puts it into perspective.

'What about all the great players that never won one All-Ireland or even played in Croke Park, as I count myself one of the lucky ones, and now, when I look back on my career, I just thank God I was part of that great era.

'I never put emphasis on medals, as instead I always emphasised that it does not matter how many medals you won, it is how you presented yourself on the field and how you played on the day. To me, that's what matters and how you are really rated in sport.'

Small ball or big ball, it made no difference to JBM—he was a class act in both codes.

AOIFE MURRAY — CAMOGIE

Arguably the best goalkeeper in the history of camogie, Aoife Murray had done it all before bowing out of the sport in 2020. For someone so prominent and such a stalwart in Cork camogie, she hung up her boots very quietly.

As the youngest of eleven children, Murray was often put in goal. 'I think that being put in goal, using me as target practice, certainly toughened me up physically and mentally,' she said. 'I grew up seeing my sisters and brothers playing underage hurling and football. I had good role models.'

Murray had the honour of captaining Cork in 2018, with her three brothers on the sideline.

'I had one job really, to pick heads or tails. If we won the game, I'd have to say a few words. I wanted to be in the background,' she said. 'My greatest joy was that so many other leaders really came to the fore.'

Despite winning nine All-Irelands with Cork (2002, 2005–6, 2008–9, 2014–15, 2017–18), she still feels a little disappointed in her contribution. 'Every time you put on the Cork jersey, it's an honour. To be able to win in that jersey is an expectation. I let down Cork camogie in a certain way; I would be disappointed in that sense.'

To play for your county isn't an easy feat. 'I don't think that people understand the commitment, even for our counterparts on the hurling team.'

At club level, she has won three County Senior Championship medals with Cloughduv, captaining the side for their third title in 2005.

Murray is a transitional executive board member of the Gaelic Players Association, which merged with the Women's Gaelic Players Association in 2020. Throughout her playing career, she'd always enjoyed giving her opinions and listening to those of others.

'I think it was a natural progression and all I ever had was a passion and an opinion. It helped me to transition, giving me an avenue to get into the administration side.'

Murray acknowledges that camogie and ladies' football started 'a lot later' than hurling and men's football, but now more players are taking on leadership roles, for example as regards funding.

The transition from player to supporter was made easier for Murray owing to the fact that supporters couldn't attend matches in 2020. This year, however, she loved supporting her team.

'I really enjoyed supporting them; I thought it would be harder. I didn't want them to win just because I played in it,' she said. 'It's less stress playing than watching!'

Murray's contribution to Cork camogie speaks volumes about her skill and loyalty and rightly puts her among the élite Leeside Legends.

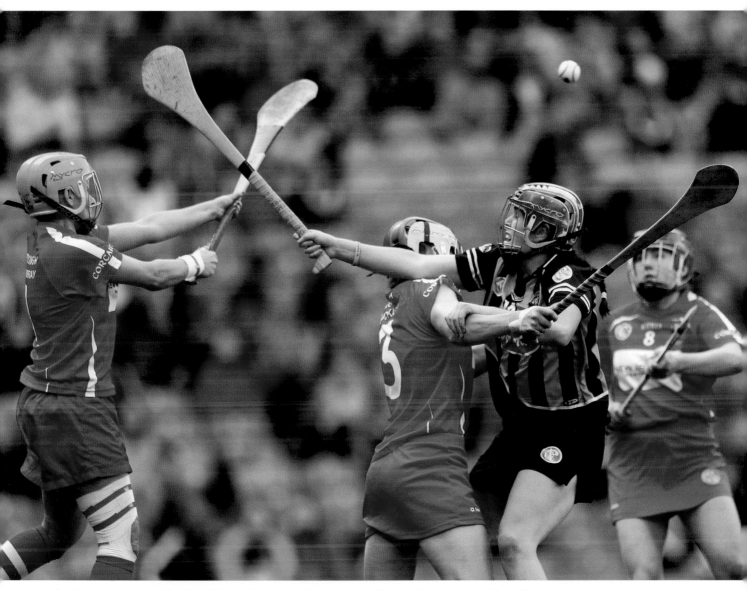

In the Liberty Insurance All-Ireland Senior Camogie Championship final at Croke Park, Cork goalkeeper Aoife Murray clears the sliotar in spite of the efforts of Kilkenny's Miriam Walsh.

Stephen O'Brien playing for the Cork senior football side in 1995.
(© James Meehan/INPHO)

STEPHEN O'BRIEN — FOOTBALL

When Nemo Rangers won the All-Ireland Club football title in 2003, it brought to an end the playing career of one of Cork's finest footballers, as Stephen O'Brien bowed out of the sport that he had served for 28 years.

O'Brien, from Father Mathew Street in Turners Cross, began playing with Nemo at five years old as he attended Coláiste Chríost Rí. His first success with the school came in 1985, when they defeated Spioraid Naoimh in the Corn Uí Mhuirí Munster Senior Colleges final, and in a sensational All-Ireland Colleges decider they got the better of Summerhill College, Sligo.

'I really enjoyed my time playing football at school and I must say that Brother Colm of Coláiste Chríost Rí had a huge influence on my career.'

During his glittering career, O'Brien helped Nemo win six Cork County Senior Football Championships and three All-Ireland Club titles. In 1989 O'Brien won an All-Ireland U21 medal, an All-Ireland Senior Championship, a National Football League and an All-Ireland Club Championship, making it a very special year for him.

'To win that many championships in one year was absolutely brilliant and I certainly look back on that year with a lot of pride, as it's a record that won't be achieved by too many players,' he said.

The following year was also kind to him, as Cork completed an All-Ireland hurling and football double that had the Rebel County buzzing. The hurlers were 5–15 to 2–21 winners against Galway, while the footballers triumphed over Meath by 0–11 to 0–9.

'There was a lot of talk in the press about our clash with Meath because of previous games against them, and with the Cork hurlers' great win, the build-up and the tension gripped Cork for weeks …We knew that we needed a top-class display to win that final.'

In 2002 O'Brien's father, Michael, died suddenly; this affected him deeply, as they had had a very close relationship.

In March 2003, on the back of losing their previous two All-Ireland Club finals, Nemo emerged victorious against Crossmolina of Mayo with a score of 0–14 to 1–9. After the game, a famous photograph of O'Brien appeared in the national newspapers, showing him in floods of tears, as the emotion of winning got to the Cork star.

'I knew for weeks that, win or lose, my body could not go on playing at this level for much longer and I was determined to go out in glory. I think the tears I shed were for my father, who would have been so proud if he was alive to witness this great day.'

Few in Cork would doubt that Stephen O'Brien rates as one of the finest footballers produced in the last 50 years. O'Brien is a genuine man whose determined style of play won him many admirers, and he was always proud to serve his club and county.

VINCENT O'BRIEN — HORSE-RACING

The late Vincent O'Brien was one of the greatest racehorse trainers of the last century. Born in April 1917 in Clashganniv, Churchtown, he almost singlehandedly put Ireland into the first division of world racing. His achievements include three Grand Nationals, four Cheltenham Gold Cups, three Champion Hurdles, six Derbys and three Arcs de Triomphe.

The list of the champion flat racers that O'Brien sent out from his Baldoyle stables in Cashel to conquer Europe includes Ballymoss and Gladness in the 1950s, Sir Ivor in the 1960s, Triple Crown hero Nijinsky, Roberto, Thatch, dual Arc-winner Alleged and Monteverdi in the 1970s, and Storm Bird Golden Fleece and El Gran Señor in the 1980s.

Even if O'Brien had never trained a flat winner he would still rank amongst the greatest of his profession. His stable dominated the National Hunt scene in the late 1940s and throughout the 1950s. Cottage Rake scored a hat-trick of victories for him in the Cheltenham Gold Cup, and Hatton's Grace did the same in the Champion Hurdle. He won a fourth Gold Cup with Knock Hard, while Early Mist, Royal Tan and Quare Times gave him a unique Grand National treble.

The week after Hatton's Grace's third Champion Hurdle win in 1951, O'Brien moved from his late father's yard at Churchtown, Co. Cork, to a yard of his own at Baldoyle, where he built up one of the finest training establishments in the world—a stable that has become synonymous with excellence in the thoroughbred world.

O'Brien won his first classic with Chamier in the 1953 Irish Derby, but Ballymoss was his first flat champion. It was one of O'Brien's new breed of American owners, Raymond Guest, who provided him with his first Derby winner at Epsom in the form of Larkspur. The first O'Brien/Lester Piggott champion was another of Guest's colts, Sir Ivor, who came off the pace to score a spectacular win in 1968. That year, O'Brien bought a yearling that became perhaps the best, and certainly the most famous, that he ever trained—Nijinsky. American businessman Charles Englehard asked O'Brien to visit Windfield's farm in Canada to inspect a colt by the stallion Ribot. O'Brien advised Englehard to buy instead a son of the untried stallion Northern Dancer. This inspired choice of the yearling Nijinsky had a dramatic effect on the fortunes of both trainer and stallion and helped change the state of the international bloodstock market.

Nijinsky won the Epsom Derby in 1970 and sired great horses like Kingslake, Golden Fleece and Royal Academy. Having won the Derby again with Roberto in 1972, O'Brien achieved the remarkable feat of saddling six winners from seven runners at Royal Ascot in 1975. With his son-in-law John Magnier, he established the highly influential Coolmore Stud. He won his final Epsom Derby in 1982 with Golden Fleece and just failed narrowly with El Gran Señor in 1984.

Vincent retired from training at the age of 77 in 1994. His brother Phonsie summed him up: 'He was a brilliant man, single-minded, and didn't care what people thought of him'. He died on 1 June 2009, aged 92. In this case, we can safely say that there will never be another like him.

Vincent O'Brien at home at Baldoyle.

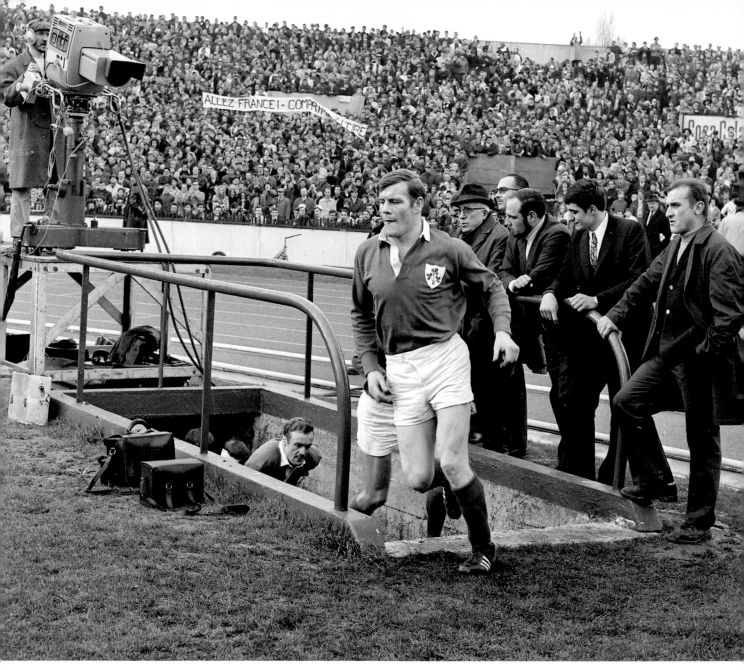

Phil O'Callaghan running onto the pitch for the Ireland–France game in 1970.

PHIL O'CALLAGHAN — RUGBY

Phil O'Callaghan was a remarkable rugby player who, although he had none of the traditional school coaching, played for Ireland 21 times at tighthead prop in an international career spanning ten years. There are many yarns about 'Philo', as he was affectionately known, but the story of his introduction to rugby is quite true.

He was a sixteen-year-old soccer player with Blue United in Ballyphehane when he dropped into Musgrave Park on a Sunday morning to see Dolphin's third XV, captained by his pal Dick O'Meara, in an end-of-season game. Dolphin were short a player and invited young Phil to line out. Before he could think twice, he was out on the pitch, ready for action. Phil knew a little about the game from watching it and, although he had absolutely no idea about the rules of rugby, his natural enthusiasm got him through. Powerful and mobile, he played well in the second row and was played again in the final match of the 1960/1961 season in Skibbereen.

The following season he played with the thirds, and after a few outings he was called up to the seniors. Jim Kiernan captained the team which got to the Munster Senior Cup semi-final, where they were defeated by Young Munster. Such was O'Callaghan's contribution that he played in every Munster Senior Cup up to 1980. Phil had beefed up since he started playing and had been in the Dolphin front row for a few years when he was selected for Munster in 1967.

That season he went straight into the Irish team, playing against the touring Australians at Lansdowne Road, where Ireland won 15–8. Ireland's tour of Australia was very successful, as they completed the double over the Aussies when they won 11–8 in Sydney, the first northern hemisphere nation to defeat a southern hemisphere side away from home. This victory was very special for Cork, with all five city clubs having a representative on the winning side. O'Callaghan played right through the international championship for the following three seasons and was part of the side that drew 8–8 against South Africa in Dublin.

That seemed to be the end of O'Callaghan's international career; he was omitted from 1972 until 1976, when he received the call for Ireland's 26–3 loss in Paris and was retained for the remainder of the championship. The icing on the cake for O'Callaghan was when he was selected for the test game against the All-Blacks in Wellington, as he re-established his reputation as a fine all-round forward.

The most popular of the O'Callaghan stories in rugby folklore is the one where, during an international game, the referee tapped him on the shoulder and admonished him.

'O'Callaghan, you are boring,' he said, referring to the way he was lining up against his opponent in a scrum.

O'Callaghan's reply was classic: 'You're not so entertaining yourself.'

Great memories of a player whose courage will always be respected far beyond his native country.

DR PAT O'CALLAGHAN — ATHLETICS

Dr Pat O'Callaghan was arguably one of Ireland's finest male athletes. He had the honour of winning his country's first Olympic gold medal at the Amsterdam games in 1932, and he repeated the feat four years later in Los Angeles. He was born into a farming family at Derrugallon in 1905. As a student at the College of Surgeons, he would ramble out to the UCD sports grounds, and it was there that he became interested in hammer-throwing.

In 1927 he made his Dublin début, winning the big Garda meeting with a throw of just over 136ft. Over the following weeks he made huge strides in his technique and won the Irish championship with a throw of 143ft, which ironically was the worst winning throw in the event for ten years. The following year he retained the Irish title with a throw of 162½ft, which ensured his qualification for the Olympics in Amsterdam. He showed his Herculean strength in the Dutch city at those championships. The Corkman was trailing Oissan Skoeld of Sweden by 13ft, but O'Callaghan produced a second throw that saw him pip the Swede by four inches, ultimately winning the gold medal. On his return, the Olympic hero beat 170ft in the Tailteann Games to set a new Irish record.

A look at the results of the Irish championships in 1930 gives an idea of O'Callaghan's versatility: he won the hammer, shot put, high jump and discus. At the Cork cricket ground he cleared 6ft 4in., when the world record at the time was 6ft 7in. for the high jump. After arriving in Los Angeles for the Olympics in 1932 with three pairs of spiked shoes, he discovered that the ground in the circle was as hard as concrete. He could only perform two turns in the circle and, facing his last throw, he was inches short of the effort of Ville Porhola of Finland.

After winning the 400 metres, Ireland team-mate Bob Tisdall went to see how O'Callaghan was getting on. He learned that the spikes on O'Callaghan's shoes were unsuitable to the hard cinder surface of the circle and went about trying to correct the problem. They found two metal files and shortened the spikes on the shoes. By the time O'Callaghan stepped into the circle for the final throw he was able to fling perfectly, and he flung the hammer 176ft 11in. to win a second gold medal for Ireland at the games. Ireland's double Olympic gold medallist had a busy year in 1938, as he took up wrestling in the USA, met the king of Sweden and turned down an offer to make a Hollywood version of Tarzan. He built up a busy general medical practice in his adopted town of Clonmel, where he practised for nearly 60 years.

Looking back on his career, he once said, 'Nobody learned us or taught us; we learned by our own mistakes and by our own endeavours. The people who knew about hammer-throwing had their secrets and wanted to keep them, and it's actually hard to realise how we were left on our own.'

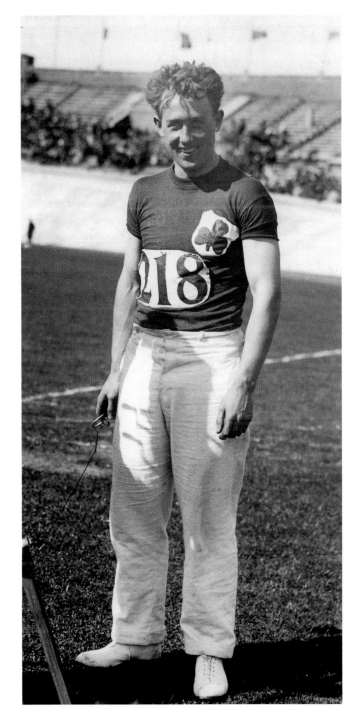

Dr Pat O'Callaghan, winner of two Olympic gold medals in 1928 and 1930.

At the Irish Laurels Final at Cork Track: Christy O'Callaghan (left), Liam O'Callaghan with the winning dog, The Stranger, and Michael Kelly, the winning owner.

CHRISTY O'CALLAGHAN — GREYHOUND RACING

The sport of greyhound racing is particularly outstanding in this country, with state-of-the-art facilities at Curraheen Park in Cork and Shelbourne Park helping to take it to new heights. It's people like the legendary trainer Christy O'Callaghan who deserve the most credit for its popularity, with his years of dedication to training at a high level. Born in Macroom in 1945, he became interested in greyhounds through his uncle, Jimmy Masters. It wasn't until 1964 that O'Callaghan trained his first winner, when a dog called Don's Darling won at the old track on Cork's Western Road. His skills were noticed and in 1966 he was chosen by Bord na gCon to travel to Sweden to promote the Irish greyhound industry.

O'Callaghan trained four winners of the Irish Laurels, beginning in 1975 with a stunning run by the talented Moonshine Bandit. The other winners were Standard Image, Knockeen Master and The Stranger, who completed his winners in the event in 1992. The Stranger also won the St Leger in Limerick, and his supreme talent surfaced when he became the first greyhound in the history of the sport to break the 29-second barrier for 525 yards at the Western Road track. Outside of his six classic winners, O'Callaghan also trained two winners of the Guinness 600 at Shelbourne Park. When you've trained greyhounds for over four decades, you're bound to have a soft spot for one, and for O'Callaghan Cable King is tops. Cable King was born in 1995 and over his great career he raced 83 times and won on 44 occasions.

This writer's late brother Paudie purchased Mountleader Peer, a quality greyhound, in 1996, and it was O'Callaghan whom he asked to train him. After winning the Champion Stakes, Mountleader Peer almost won the Irish Derby, only to be pipped in the shadow of the post. In the months before he died in 2018, my brother spoke about how close this greyhound came to winning the biggest prize in Irish greyhound racing.

'Mountleader Peer was an outstanding hound, but Christy O'Callaghan's handling was meticulous and was a huge part of the success story,' he said.

When Curraheen Park opened in 2000, attendances improved beyond all recognition in Cork, and O'Callaghan was adamant that it was a great addition to the sport.

'The facilities at the Cork track are second to none but I must say that to be successful as a trainer you've got to have a class dog with plenty of pace.'

The increased prize money was a welcome boost to all owners and trainers.

'The cost of feeding supplements and the increase in fuel—it was getting harder all the time and the burden was eased a bit.'

O'Callaghan had taken the rough with the smooth, but for upcoming trainers he had only one tip.

'If you are good to your dogs, your dogs will be good to you.'

Sound advice indeed from a greyhound racing legend.

GEMMA O'CONNOR — CAMOGIE

With nine All-Irelands and eleven All-Stars, Gemma O'Connor was a force to be reckoned with in Cork camogie. Her mother, Geraldine, who died in 2015, got her involved in the sport as a child. 'My mother had a massive love for GAA. She was a staunch Glen Rovers supporter.'

Her allegiance may have expanded to include St Finbarr's when her son and daughter joined the club. O'Connor's brother Glenn plays senior hurling with the Barrs, and they are each other's 'biggest fan and biggest critic', which benefits both of them.

O'Connor's first All-Ireland with Cork was in 2002 when she was just seventeen and, although the years tend to roll into one, she says that it's something she'll never forget. At that age, although you might be a bit nervous, you're more excited because you've got nothing to lose. She actually started off as a forward when she was sixteen, but the Cork management tried her at wing-back. 'That position was made for me since then,' she said.

She feels 'very fortunate to be from Cork', and to have won All-Irelands with the Rebels in 2002, 2005, 2006, 2008, 2009, 2014, 2015, 2017 and 2018. 'The county has been really successful and produced players.' When you're wearing the Cork jersey, there's an expectation that you're going to win. One thing she regrets is that they lost many opportunities to do three in a row.

O'Connor's highlights are the two consecutive All-Ireland final victories over rivals Kilkenny in 2017 and 2018. Cork and Kilkenny are 'two counties that have a massive proud sporting tradition of hurling,' she said. 'Each county thinks they're the best.'

It's not easy to be a GAA player. In the men's game, they often receive benefits like kit, funding and expenses, which 'makes the task a bit sweeter', while women 'play for the love of the game'. She believes that the LGPA and GPA merging is 'massive' and, looking ahead, that the next few years will be 'very exciting' for women in GAA.

After retiring in February 2021, she found it tough not to be involved this year. 'It was hard to accept that I wasn't going to be part of the panel,' she said. 'But, look, it is what it is. I've had a massive run at it, and I'm very fortunate, and I just think the time was right to retire.'

Although she wishes that she could have ended her career on a higher note than a semi-final defeat in 2019, which was 'very hard to take', she feels incredibly lucky to have had so many ups. 'I've had so many great runs and I'm very fortunate to get so many wins,' she said. 'There's no definites and you don't deserve anything.'

St Finbarr's have suffered a couple of camogie semi-final defeats in the last few years, with the most recent coming in mid-October, when they lost to Iniscarra 1–11 to 1–6. They won their first and only County Championship in 2006. 'We probably should have won more than one, if I'm being honest,' O'Connor said. 'There'll be some players out there who'll never get an opportunity to win a county medal, so I have to accept that I have one, and I'm very grateful for that.'

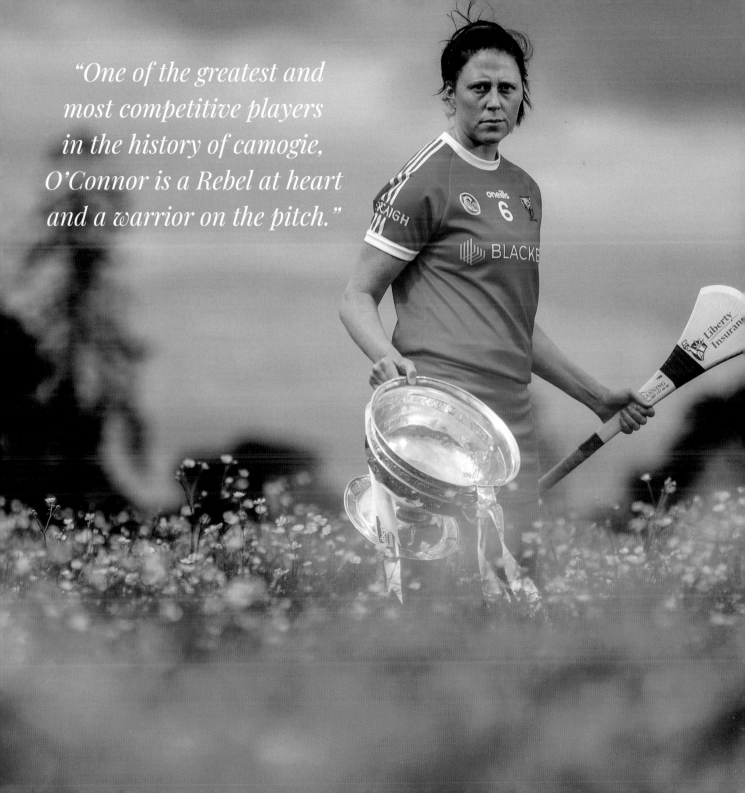

"One of the greatest and most competitive players in the history of camogie, O'Connor is a Rebel at heart and a warrior on the pitch."

Frank O'Farrell (right) is welcomed to Manchester United by the legendary Sir Matt Busby.

FRANK O'FARRELL — SOCCER

Frank O'Farrell is well known in soccer circles as the Corkman who once managed Manchester United. His rise in the soccer world from playing on a patch of ground in Douglas to managing the Iranian national team is incredible. The fact that he became involved in professional football was quite remarkable, as from the outset he wanted to follow in his father's footsteps and become a train-driver. He began working on a railway at the age of sixteen, but that dream was soon derailed as he set out into the football world.

In his young days he played with Clapton Celtic, Western Rovers, St Joseph's (Waterford), CIE 90 (Inter-house) and Cork United. His stay at Cork United was a short one, as he was soon signed by West Ham United and appointed captain. He made over 200 appearances at West Ham before being transferred to Preston North End. His outstanding leadership qualities were also spotted at Deepdale, where he once again wore the captain's armband. He then joined Weymouth, and the Southern League side made a history-making FA Cup fourth-round appearance and later their first-ever championship.

From 1952 to 1959 O'Farrell made nine appearances for Ireland and was very popular among the Irish faithful. He earned his first cap in the 6–0 thrashing by Austria in Vienna, but was there on the return leg and scored one of the goals in a tremendous 4–0 victory.

Clubs all over England were monitoring O'Farrell, and in his first season at Torquay he took them from the Fourth to the Third Division at his first attempt. In December 1968 he replaced Mat Gillies as manager of Leicester and took the side to an FA Cup final, where they lost to Manchester City 1–0. He brought Leicester back to the First Division in 1971, a feat that landed him the biggest job in British football when he took over as manager of Manchester United. He had the unenviable task of replacing Sir Matt Busby and, despite having the likes of Bobby Charlton, Denis Law and occasionally George Best at his disposal, the task of replacing Busby proved daunting. O'Farrell gave it his best shot but was never far away from Busby's lingering shadow, as he found it hard to work with the senior players who'd grown up under their former boss. The Reds' eleventh defeat of the season was the catalyst for O'Farrell's departure in December 1971, and a year later he took over the reins at Cardiff City before moving to manage Iran on the international stage.

He guided Iran to the Asian Games championship final, where they defeated Israel 1–0 before 120,000 spectators in Tehran. They qualified for the Olympic Games in 1976 and two years later qualified for the World Cup in Argentina. O'Farrell later joined Torquay as a football consultant and general manager before retiring five years later.

RONAN O'GARA — RUGBY

From a very young age Ronan O'Gara was a household name in rugby, as his all-round skills were evident throughout his illustrious career. O'Gara was born in San Diego in 1977 and his family moved to Cork when he was young. He attended the Presentation Brothers' College in Cork, where his rugby career began in earnest as he helped them to win the Munster Schools Junior Cup in the 1992/3 season. The following season he went one better, winning the senior equivalent.

After a season with UCC in 1995, the out-half joined Cork Constitution. When he looks back on his club career, 1999 will be the year that stands out for him. Cork Con won the All-Ireland Club title in tremendous style after defeating Garryowen at Lansdowne Road.

In 1996 Ronan began his Munster career when he sat on the bench against Connacht, but his outstanding kicking ability meant that he was not going to pick up too many splinters and he soon became the first choice. The success of Munster during the O'Gara era is well documented, as they went head to head with the élite sides in Europe. Nevertheless, Munster suffered some bitter defeats, particularly in the Heineken Cup, where they lost in 2000 to Northampton.

Munster looked dead and buried in the 2001 Heineken Cup, as the only way they could make it through to the quarter-finals was to beat English champions-elect Gloucester by 27 points, while also making sure that their opponents didn't score a try. The rest is history, as Munster won 33–6 on another famous Thomond Park day that had the Limerick venue rocking.

'I think that Mick Galwey and Peter Clohessy deserve a lot of credit for the Munster revolution, as they started the ball rolling years ago, and it was always an honour to put on that Munster jersey.'

After many close shaves, Munster clashed with French side Biarritz in May 2006 and ran out 23–19 winners after a pulsating final at the Millennium Stadium in Cardiff. At the same venue in 2008 Munster were up against another crack French side in Toulouse and again they turned up trumps when running out 16–13 winners.

O'Gara is Ireland's second most-capped player, with 128 appearances. He's Ireland's top scorer, with a points tally of 1,083. He won the Grand Slam and Six Nations Championship with Ireland in 2009 and four Triple Crowns in 2004, 2006, 2007 and 2009. He played for the British and Irish Lions on their 2001, 2005 and 2009 tours.

When he finally retired from rugby in May 2013, he moved to French club Racing 92, where he worked as assistant coach for four years. After being appointed assistant coach with Crusaders in New Zealand for one season (2018–19), he is presently director of rugby at La Rochelle in France. Awarded the Freedom of Cork in 2017, O'Gara's achievements in rugby put him high on the list of Leeside legends.

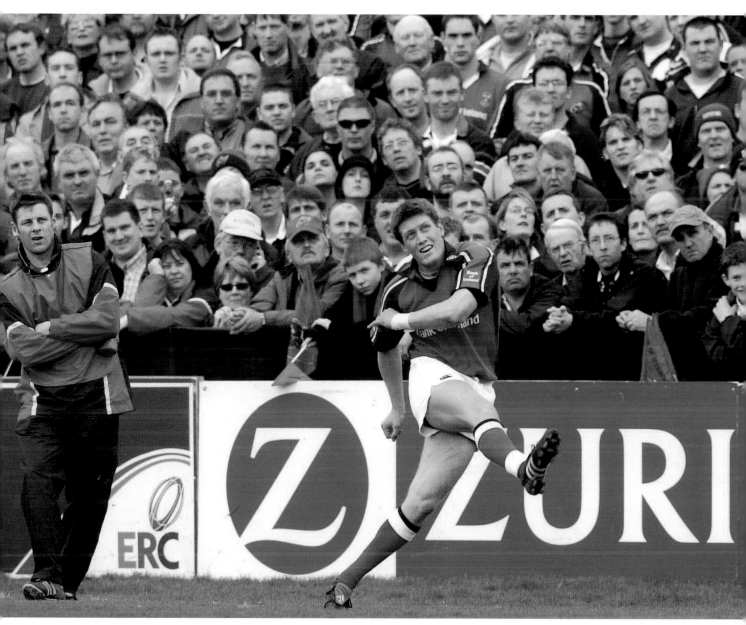

Ronan O'Gara showing his kicking skills for Munster.

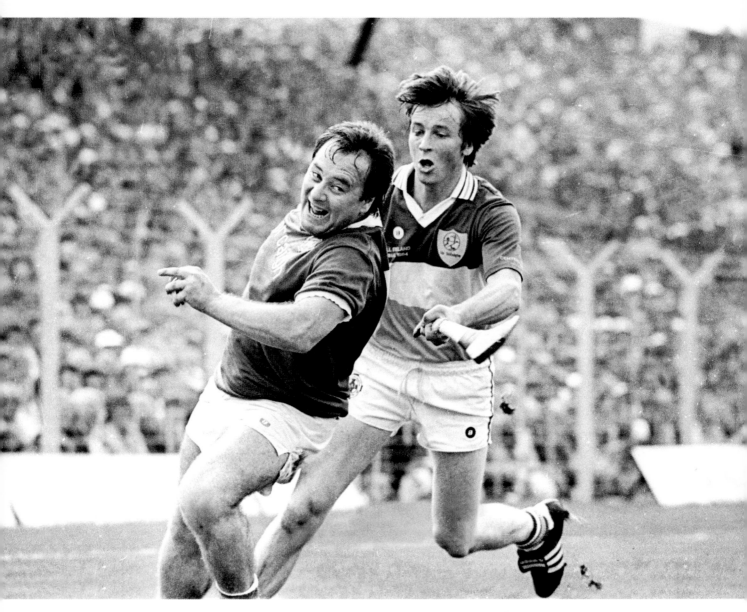

Seánie O'Leary shows his battling qualities in the 1984 Senior All-Ireland final against Offaly.

SEÁNIE O'LEARY — HURLING

Youghal is a town that will always be associated with hurling legend Seánie O'Leary, who is still very much appreciated in the East Cork town. O'Leary began his hurling education at St Colman's College, Fermoy, but his early days in hurling weren't a bed of roses, with honours few and far between. In the Harty Cup, St Colman's lost both finals to the North Monastery in 1969 and 1970.

The year 1969 was good to O'Leary at club level, as Youghal were crowned Intermediate Hurling Champions. That year he won a Minor All-Ireland with Cork, and another in 1970 when the Rebels defeated Galway. In 1972 Youghal reached the Cork Senior County Hurling Championship, but lost out to Glen Rovers.

O'Leary was part of the Cork U21 side that won back-to-back All-Ireland titles in 1970 and 1971. He didn't have the best start to his senior county career, as Cork were beaten by Limerick in the first round of the Munster Senior Hurling Championship in 1971, and lost out again to Kilkenny in the All-Ireland final the following year. His first senior All-Ireland medal came in 1976, when Cork beat Wexford 2–21 to 4–11. They went on to win two successive All-Irelands in 1977 and 1978.

Cork almost had to line out without O'Leary in the 1977 decider, when he received a belt of a sliotar in a puck-around before the game. 'I had to go back into the dressing room to be treated by our team doctor, Con Murphy, and we were in there longer than anticipated. Out of the blue, in walked the legendary Christy Ring, who looked a little uneasy with the minutes counting down to the throw-in.'

Ring looked at O'Leary and said, 'Come on, it's time to go out. It isn't your bloody nose you are playing with.'

The next five years were topsy-turvy for Cork hurling, as they lost the 1982 and 1983 All-Ireland finals but had some consolation with two National League wins in 1980 and 1981.

The Centenary Final of 1984 was very special to O'Leary, not least because he was conscious that he was coming to the end of his hurling career.

'I was very disappointed that we had lost the previous two finals and I knew I couldn't handle losing another one,' he recalled. 'We played well on the day and lifted the McCarthy Cup and that was my swansong, as I decided to quit at the top.'

O'Leary took his total of All-Stars to three in 1984, having won them previously in 1976 and 1977. He believes that there is far more pressure on the hurlers of today to perform.

'We never had to go through what the players of today have to put up with, as some media people seem to pick out a player or two and dissect their performances.'

The Youghal man was a gifted opportunist with superb close control, and his instinct for scoring goals made him a vital cog in many Cork teams between 1971 and 1984. His power and match-winning skills made him a Braveheart on Leeside.

MARY O'LEARY — CAMOGIE

When people debate the most prolific scoring machine in camogie, the name of Mary O'Leary will immediately come into the conversation. Sister of the former Cork hurling star Seánie O'Leary, she was born in 1955 and began playing with Glanworth. She moved to Watergrasshill and, although honours weren't plentiful with either club, she looked back fondly on her years with them.

'We did not win a lot, but I had a great time at both clubs and, as we all know, it's great to win trophies but my attitude to any sport is to enjoy it, because in my book competing is the most important issue,' said O'Leary.

She began playing for her county in 1971, when Cork won the Munster U18 title. Two years later it was All-Ireland number two, this time with the Cork junior team that defeated Galway in the final. She was called up to the senior panel in 1975 but it was a tough baptism, as Cork were defeated by Wexford in the final. In 1978 Cork produced a sterling performance to beat Dublin in the Senior Camogie final 6–4 to 1–2, earning O'Leary her first senior All-Ireland medal. In 1980 the Rebels beat Limerick with a score of 1–8 to 2–2.

The 1981 final against Kilkenny was rated as one of the best in years. With Cork looking destined for glory, they were denied in the closing seconds as Kilkenny levelled a point. Extra time proved fatal for Cork, as they lost 1–9 to 0–7.

'It was hugely disappointing, as we went so close to winning in normal time, but dropping our concentration cost us dearly and to get pipped in extra time was hugely disappointing.'

That year O'Leary was named Camogie Player of the Year, an award that will always be cherished by the former Cork star. The Rebels beat Dublin 2–7 to 2–6 and 2–5 to 1–6 in the 1982 and 1983 finals. O'Leary also has another notable achievement, as she played in the 1981 All-Ireland Ladies' Club Football Championship with Watergrasshill, when they defeated Galway Gaels by a point.

O'Leary looks back on her career with pride, but firmly believes that the game has changed quite a bit from the era in which she played.

'The one negative thing about the sport of camogie is that counties like Dublin and Wexford are no longer a force, and that is sad. At the moment Cork, Kilkenny and Galway seem to be in a league of their own, and that cannot be good for the game.'

O'Leary is still a huge camogie and GAA fan and gets a lot of satisfaction from watching the modern-day games. She will always be remembered as an incredibly gifted scorer.

Cork forward Mary O'Leary (centre) beating Dublin defenders Shiela Wallace and Catherine Doherty during the All-Ireland Senior Camogie final at Croke Park, Dublin. (*Cork Sporting Heroes*, Vol. 1)

Dan O'Mahony in action, wrestling Tim Stack in 1936.

DANNO O'MAHONY — WRESTLING

Apart from the TV exposure that wrestling gets in this country, Cork people see very little of it. If you told the present generation that Cork had a world champion in the 1930s, they'd find it very strange. Enter Dan O'Mahony, affectionately known as 'Danno', born in Ballydehob in 1912. He was a big man, so much so that Fr James O'Donovan, who baptised him, said that he was the strongest baby he had ever seen. At twelve years of age, O'Mahony displayed great strength when he helped to heave a car out of a drain near his home.

In 1933 he joined the army and within months had shattered the majority of the army weight-throwing records. At that time professional wrestling in America was in a bad state. Boston promoter Paul Bowser figured that what wrestling needed was an Irishman along the lines of famous world heavyweight boxing champion John L. Sullivan, 'the Boston Strong Boy'. He delegated Irish-American Jack McGrath to go to Ireland and find a strong all-round athlete who could fit the bill. After Dr Pat O'Callaghan turned down the role and recommended O'Mahony, McGrath bought him out of his army contract and brought him to London for training.

O'Mahony made his début in December 1934 against 'Stranger' Lewis, which resulted in a draw. He later moved to New York, where he was taught all the basics of wrestling by Freddy Moran, the coach of world champion Ed Don George. In his American début at the Boston Garden in January 1935, more than 14,000 Irishmen saw their new hero exploit his specialty, the 'Irish Whip', and pin Ernie Dusk from Nebraska for a straight fall within fifteen minutes and 50 seconds. Within seven months O'Mahony had won 54 consecutive contests, and he was crowned world champion when he threw George, the reigning champion, out of the ring before the count of twenty before 60,000 fans in Braves Field, Boston. It's estimated that the gate receipts totalled over $70,000.

The Irish public were stunned by the news of O'Mahony's sudden death in 1950. He was in Ireland on holiday when his car crashed into the back of a parked lorry in Portlaoise. At the time of his death he was the owner of a nightclub in the Santa Monica area of the United States. After his funeral Mass at Ballydehob church, his coffin was shouldered five miles to Schull cemetery, as hundreds of people converged on west Cork to pay homage to the great man. Today in Ballydehob he is honoured with a bronze statue.

NOEL O'MAHONY — SOCCER

Noel O'Mahony will be remembered as a soccer superstar, both as a player and as a manager. He began his soccer career with Ballyphenane before moving to Tramore Athletic, where he played a major part in the club's success when they clinched the U16 National Youth Cup. Two years later, he was one of the stars on the team that were crowned Leinster Champions. Three seasons later, he joined Cork Hibernians in 1960. Amby Fogarty took over the reins at the Cork club in 1967 and soon the fortunes of the Leeside club changed.

'Amby brought a lot of professionalism to the club and also got the ball rolling by bringing top-class cross-channel players to Cork,' said O'Mahony. 'Luckily, of all the players that Amby inherited I was the only one he kept on, so I was always grateful to him for showing me loyalty.'

The story took another twist in the 1969/70 season when, under new boss Austin Noonan, they won the Shield, which gave them a place in European competition for the first time in the club's history. In 1970 Dave Bacuzzi took over the hot seat and won a league crown with them after a play-off against Shamrock Rovers for the title.

'It was a tremendous game, with Miah Dennehy scoring both goals, and playing in front of 35,000 people at Dalymount Park is something I will never forget,' recalled O'Mahony.

The rest of the glory years of Hibs are now well documented, especially the 1972 FAI Cup final win over Waterford, as they won five trophies in that season. Unfortunately, Cork Hibs folded in 1974.

'I felt that the decline started in 1974 when Dave Bacuzzi left the club in controversial circumstances, as it never recovered where crucial mistakes were made within the club.'

The role of the manager soon beckoned for Noel, as he took over the newly formed Cork Alberts in 1979, but it was a rough baptism for him. The collapse of both Hibs and Cork Celtic left Cork football fans with a bad taste in the mouth; as a result, any team that was going to try to take their place was going to find it difficult. Alberts dropped out of the league after a few years.

O'Mahony took over at Cork City in 1986 and yet again had to pick up the pieces, as the majority of the players had been released. He left the club after one season but returned for the 1989/1990 season, in which the club lost the FAI Cup final to Derry City but managed to qualify for Europe for the first time. The icing on the cake for O'Mahony came in the 1992/3 season, when he led City to the League of Ireland crown.

This was to be O'Mahony's swansong, as he bowed out of soccer at the very top. He died in 2013 and left behind an incredible record by an incredible man, as nobody could doubt the honour that O'Mahony brought the city both on and off the pitch.

Cork Hibs, winners of the 1972 FAI Cup, pictured prior to defeating St Pat's in the semi-final.
Back: Noel O'Mahony, Tony Marsden, Joe O'Grady, Martin Sheehan, John Lawson and Donie Wallace. Front: Miah Dennehy, John Herrick, Dave Bacuzzi, Dave Wigginton, Gerry Finnegan and Sonny Sweeney.

Jonjo O'Neill after winning the 1985 Cheltenham Gold Cup with Dawn Run.

JONJO O'NEILL — HORSE-RACING

On the walls of the reconstructed schoolhouse that is now an office at his home, endless photographs are interrupted just once. A scroll hangs in its simple frame, its script the type of rhyme that could seem out of place elsewhere. Here it is an appropriate parable for the life and turbulent times of Jonjo O'Neill. O'Neill has always been public property, with that rare sporting status of being known everywhere by his Christian name. The masses are sometimes misguided when it comes to such figures, but in O'Neill they have somebody as authentic as his reputation for courage in adversity.

Born in 1952, the grocer's son from Castletownroche had a boyhood ambition to become a jockey. He first worked with a private trainer, Don Reid, before completing an apprenticeship with Michael Connolly on the Curragh after leaving school. He packed his bag and emigrated to England in 1973. That year changed the affable Corkman's life; he based himself at Gordon Richard's stables, where he befriended Limerick-born Ron Barry. Barry had ridden a record 125 winners that season, but in 1977 O'Neill broke his record with 149 winners in a season that included a five-timer at Perth. In October 1980 he suffered his worst fall at Bangor, when he broke his right leg for the second time. The broken bone was plated, but had to be replated a few months later after O'Neill tried to make a recovery too early. He suffered injuries that would have broken lesser men, but showed typical resolve to make a comeback each time.

Of his 901 winners, O'Neill's fondest memories are of winning the 1979 Cheltenham Gold Cup on Alverton. He also won the Champion Hurdle on Night Nurse, Sea Pidgeon and Dawn Run, with the latter also winning the 1985 Cheltenham Gold Cup—the only horse to win both. The popular mare looked well and truly beaten on rising to the final fence but, characteristically, the rider did not give up and neither did Dawn Run. The scenes after the race were amazing, as the Irish punters went absolutely wild with excitement, having just witnessed one of the bravest performances ever from a horse and rider at the famous Cotswolds track.

When he was 33 and had recently started his training career at Penrith in Cumbria, O'Neill had to undergo treatment for cancer and suspended his training activities for a time. The character of the man was vividly illuminated once again.

The legendary Fred Winter once told O'Neill: 'You will never go out and buy a star, it will just come into your yard with a bit of luck'. O'Neill trained Wichita Lineman, winner of the 2009 William Hill trophy, Don't Push It, winner of the 2010 Aintree Grand National, and Synchronised, winner of the 2012 Cheltenham Gold Cup. There's another O'Neill jockey presently making great strides in England, as Jonjo Junior is highly rated by many pundits.

Nowadays O'Neill's once main owner J.P. McManus has only fifteen horses in training at his Jackdaws Castle base, but that will not deter him in his battle to mix it with the best—but then O'Neill is an eternal optimist.

DERVAL O'ROURKE — ATHLETICS

The career of Derval O'Rourke in athletics is something of which all Leesiders are very proud, as her astonishing feats made her a household name in her beloved city and beyond. Born in Cork in 1981, O'Rourke graduated from University College Dublin with a degree in sociology and geography in 2003, later receiving a master's in business management from the college in 2010.

She is a three-time Olympian, having represented Ireland in Athens in 2004, in Beijing in 2008 and in London in 2012. In 2005 she earned a bronze medal in the 100m hurdles at the World University Games in Izmir. She won the 60m hurdles at the World Indoor Championships in Moscow with a time of 7.84 in 2006, becoming the first Irish woman to win an indoor world athletics championship. That year she was awarded a silver medal in the 100m hurdles at the European Championships in Gothenburg, with a time of 12.72. She earned another silver in the same event at the Europeans in Barcelona in 2010. In August 2009 she came fourth in the 100m hurdles at the World Championships in Berlin. She represented Europe in the 2010 IAFF Continental Cup, making her the fifth Irish person and second woman to be selected. She finished in fifth place in the 100m race with a time of 12.99. She competed at three European Indoor Championships in the 60m hurdles in 2009 (3rd), 2011 (4th) and 2013 (3rd). She's also an eight-time national champion in the 100m hurdles (2001, 2002, 2004, 2005, 2006, 2007, 2008 and 2010), as well as an eleven-time national indoor champion in the 60m hurdles (1999, 2000, 2001, 2002, 2003, 2004, 2005, 2006, 2009, 2010 and 2012). She's an Irish record-holder in the 60m and 100m hurdles. She retired from the sport in June 2014.

From September 2014 to October 2016 O'Rourke was a player development manager for Munster Rugby. In 2018 she founded Derval.ie, an online health and fitness community. She's also a best-selling author, a regular commentator on RTÉ and a coach on the popular television show *Ireland's Fittest Family*. Without a doubt, the determined record-breaker is a true Leeside Legend.

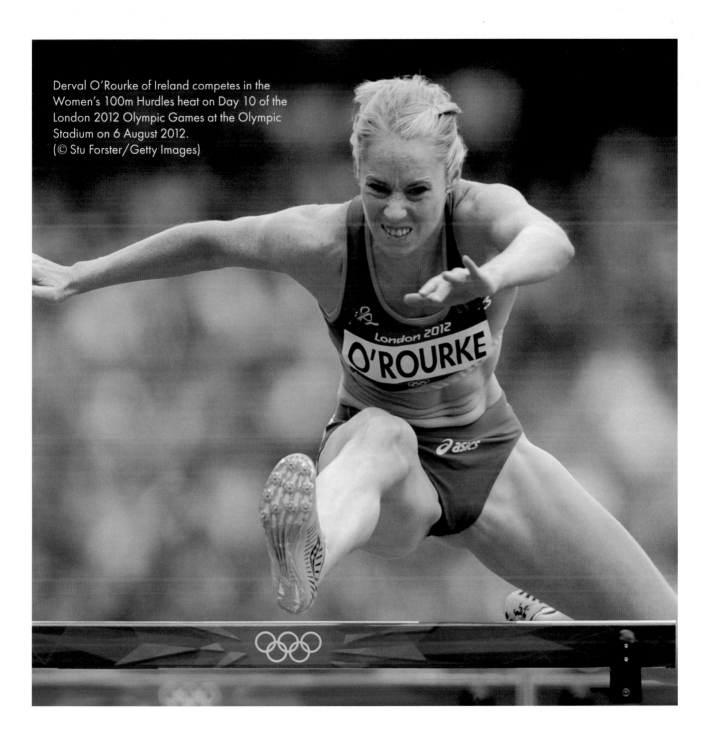

Derval O'Rourke of Ireland competes in the Women's 100m Hurdles heat on Day 10 of the London 2012 Olympic Games at the Olympic Stadium on 6 August 2012.
(© Stu Forster/Getty Images)

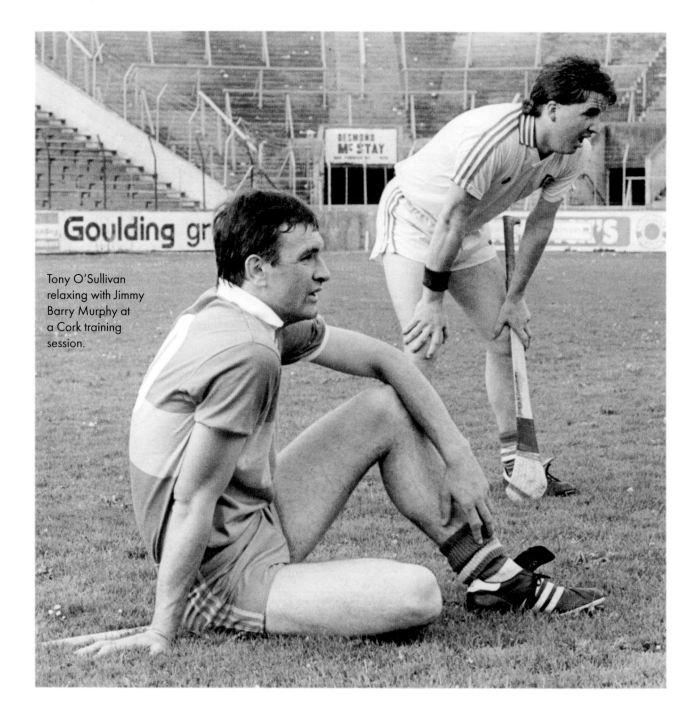

Tony O'Sullivan
relaxing with Jimmy
Barry Murphy at
a Cork training
session.

TONY O'SULLIVAN — HURLING

Cork has produced a series of stylish hurlers down the decades, and Tony O'Sullivan of Na Piarsaigh proved a real gem in the Cork colours in the 1980s and '90s.

Born in 1963, Tony was a student at Scoil Íosagáin in Farranree before moving to the North Monastery, where his hurling and football career began in earnest. Like many great hurlers and footballers in the city, Tony began playing in the Na Piarsaigh Street Leagues, where he developed his skills and, with great encouragement from his father Denis, went on to make his name at the top level.

O'Sullivan was on the Cork minor hurling team that defeated Kilkenny in the 1979 All-Ireland final, and in 1980 was a member of the North Monastery team that won the Harty Cup and the All-Ireland Colleges double.

He joined the Cork senior hurling panel in 1982 and soon experienced the highs and lows of the game. They were Munster champions that year, but lost 3–18 to 1–13 to Kilkenny in the All-Ireland final.

'We flew through the Munster Championship, but were given a serious lesson in the All-Ireland final by Kilkenny,' he said. 'I can clearly remember being shattered after the game, as I had been substituted, but I took it on the chin and worked harder on my game.'

Cork lost out to Kilkenny again in the 1983 final, but the good times came back in 1984 when they beat Offaly 3–16 to 1–12 in the Centenary Final. O'Sullivan completed his hat-trick of senior medals when Cork defeated Galway in the 1986 and 1990 finals.

Na Piarsaigh won their first Cork Senior Hurling Championship in 1990, beating St Finbarr's 2–7 to 1–8 in a replay. O'Sullivan looked back on that famous day with a great deal of pride, as he has a special affection for the club.

'People in our club cried after our victory over the Barrs, and it was a memorable day for me to help my club and its members achieve a lifelong ambition.'

O'Sullivan earned All-Stars in 1982, 1986, 1988, 1990 and 1992, as well as the Texaco All-Star in 1990. He retired from inter-county hurling in 1995, as he felt that he could no longer commit to the hectic schedule.

'I honestly think a lot of people do not understand the level of commitment that is needed to play when you play with county and club,' he said. 'To be successful at hurling, you have got to practise very hard at your skills, and that is my advice to the many aspiring stars that want to make it to the top of the tree.'

A gentleman off the field, O'Sullivan was a master on it.

FRANK O'SULLIVAN — CYCLING

Cycle racing may not be what it once was in Fermoy but the north Cork town will always hold a special place in the sport in this country. The first record of the sport in Fermoy dates back to about 1890, when the Vagabond Cycling Club was founded. People will remember the deeds of Harry O'Sullivan in the years before, during and after World War One, and especially the achievements of his son Frank, who dominated Irish cycling throughout the 1950s and '60s.

Growing up as he did in a cycle-mad house, it was inevitable that O'Sullivan would follow in his father's footsteps, even though hurling and football absorbed much of his time as a student. He took up competitive cycling at the age of sixteen in 1949 and, having worked his way through the novice and junior ranks, he grabbed the headlines with his first major victory in the Matt Linehan Shield in 1953. Ironically, Linehan was O'Sullivan's first cousin.

O'Sullivan won his first championship in 1954 at Banteer, a venue for which the O'Sullivans always had a soft spot. This was the first of his 55 Irish titles. He trained from January to May, a regime that saw him cycle 100 miles on weekends and 50–60 miles midweek. He got great pleasure from travelling up and down the country and meeting people at the various sports events. O'Sullivan used road racing in early March as a means of getting ready for the track but rarely mixed the two.

He recalled his appearance in the RAS Tailteann of 1965.

'It was my one and only stage race and I enjoyed it immensely, as it was a great experience. The Cork team were short and I think they only brought me in to fill the gap.

'The first stage from Dublin to Monaghan was my last, as I got violently sick, but the second stage from Monaghan to Birr was grand. I finished fifth in that stage and never looked back after that, finishing 19th overall.'

In 1956 it was decided to award a medal to the best cyclist overall in the various championships, with three points for the winner, two points for runner-up and one for third in each event. In the spirit that epitomised O'Sullivan, he went all out to land this prize. Eventually it came to the last race in Drogheda, where he had a one-point lead over Dublin's Seamus O'Reilly. After O'Sullivan mistook the finishing line for another ten yards short of the actual finish, O'Reilly flashed by him and they ended up sharing the spoils. O'Sullivan can reflect on a truly great cycling career, and when he received his Caltex award he joined illustrious sportsmen like Freddie Gilroy and Ronnie Delaney as symbols of the very best in Irish sport.

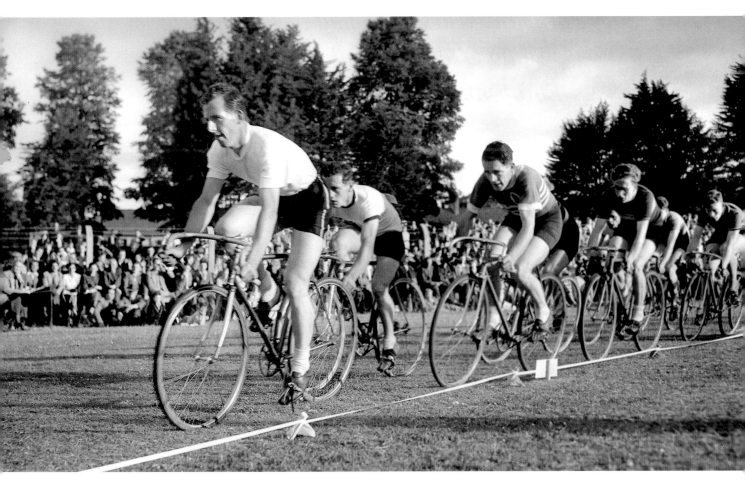

Frank O'Sullivan, winner of 55 Irish titles.

*For many years Cobh had its own queen,
as Sonia O'Sullivan ruled the world of
European middle-distance running
with regal charm.*

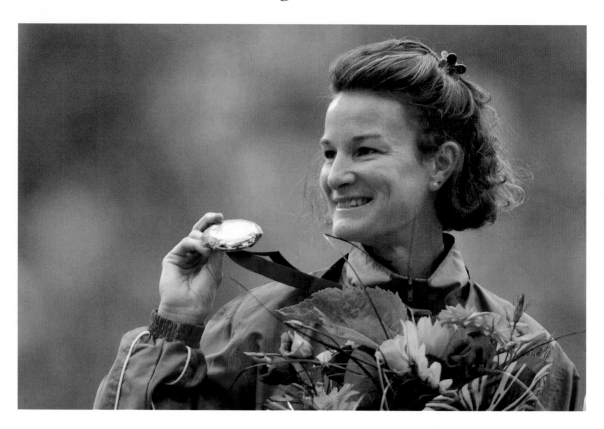

Sonia O'Sullivan celebrating her silver medal at the Sydney Olympics.
(© Brendan Moran/Sportsfile)

SONIA O'SULLIVAN — ATHLETICS

The town of Cobh stands resplendent, overlooking Cork Harbour, and its strategic position and deep water made it one of the most important seaports in western Europe. Queen Victoria's visit in 1849 resulted in its being renamed Queenstown in her honour. That changed again in 1938, when the British troops marched through Cork city for the last time, and it was Queenstown no more. For many years Cobh had its own queen, as Sonia O'Sullivan ruled the world of European middle-distance running with regal charm.

O'Sullivan attended St Mary's School in Cobh and ran with her school and her club, Ballymore. In 1987 she earned herself a place in the history books by winning the national junior and senior cross-country championships, as well as the Irish Schools title in Mallusk. She then went to Villanova University in Pennsylvania. Her breakthrough came at the 1991 World Student Games, as she hit the headlines by winning gold in the 1,500m and silver in the 3,000m.

The 1992 Olympics in Barcelona taught her a tough lesson: she had been left in the lead on the back straight, as the plan to track Yvonne Murray proved the wrong one. The Russians stalked her throughout, with Yelena Romanova winning the gold medal from Tatyana Dorovskikh. O'Sullivan had the bronze medal in her grasp until she was overtaken in the final strides by Angela Chalmers. In 1993 she finished runner-up in the final of the 1,500m at the World Championships in Stuttgart. The following year she gave her legions of fans something to cheer about when she won gold in the 3,000m European Championships in Helsinki following a gutsy run. Her rich vein of form continued in 1995 at the World Championships in Gothenburg, as Ireland saluted her great win in the 5,000m final.

The 1996 Olympics in Atlanta still haunts O'Sullivan when she reflects on her career, as she was ill before the race but still decided to run. In 1998 she was crowned World Cross-Country Champion and that year she completed a double in the European Championships, with victories in the 5,000m and 10,000m. The 2000 Sydney Olympics was another case of so close and yet so far, as she finished runner-up to Gabrielle Szabo in the 5,000m final. In the 2002 European Championships in Munich she had to be content with silver medals in the 5,000m and 10,000m finals. Her career came to an end in 2007 at the age of 37 after she completed in the Great BUPA Run in Dublin.

Returning to Cork has always been special to O'Sullivan and she has supported the Cork City Sports event on numerous occasions.

'I always loved coming back to Cork to compete in the Cork City Sports because I have wonderful memories, and with the sports going for 67 years, long may it continue.'

These days O'Sullivan, based in the US, no longer pounds the pavements around Cobh, but her home town has a special place in her heart and she is an icon for up-and-coming athletes in all corners of this country.

MARCUS O'SULLIVAN — ATHLETICS

Marcus O'Sullivan is one of just three people to have recorded at least 100 sub-four-minute miles, with 101 throughout his career. Born in December 1961, O'Sullivan took up athletics in secondary school. He got an athletics scholarship at Villanova University in Pennsylvania, and moved there when he was nineteen. At university he was a two-time NCAA champion, was part of six Penn Relays titles and also captured ten BIG EAST crowns. He won championships at the Penn Relays in the 4x1500m relay on three occasions (1981, 1982 and 1984), won the 4x800m relay twice (1982 and 1984), and won a DMR title in 1981. In BIG EAST competition, he won individual titles in the indoor 1500m three times and the outdoor 5000m on one occasion. With the team, he won two relay titles each in the DMR, two-mile relay and 4x800m relay. He graduated from the college with a degree in accounting in 1989. In 2004 he was inducted onto the Wall of Fame in Villanova Stadium.

O'Sullivan qualified for four Olympic Games for Ireland in 1984, 1988, 1992 and 1996, at both 800m and 1500m. At the 1988 Olympics in Seoul, he finished in eighth place in the 1500m with a time of 3.38.39. He won three World Indoor Championships in the 1500m in 1987, 1989 and 1993, as well as earning fourth place in 1991. He set championship records in his 1987 and 1989 wins. He won a silver medal at the European Indoor Championships in the 1500m in 1985 with a time of 3.39.75. At the European Championships in Stuttgart in 1986 he finished in sixth place.

He won the Wanamaker Mile in Madison Square Garden's Millrose Games five times (1986, 1988, 1989, 1990 and 1992) and set an indoor 1500m record of 3.35.04 in February 1989. In addition, he was one of four Irish runners, along with Ray Flynn, Eamonn Coughlan and Frank O'Mara, who set the world record in the four by one mile relay in August 1985 with a time of 15.49.08, which still stands today.

O'Sullivan is currently the head coach of men's track and field and cross-country at Villanova, also directing the programme. He has coached fifteen national champions, 103 All-Americans and 203 BIG EAST champions. He has had a brilliant career, first as an athlete himself and now as a coach, duly earning his spot in the list of Leeside Legends.

Marcus O'Sullivan wins the Men's 1500m race
at the World Indoor Championships, 1993.
(© Allsport/INPHO)

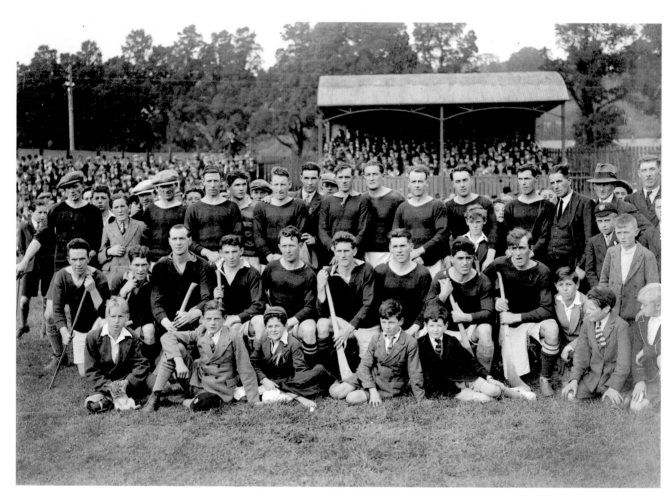

The Blackrock Cork Senior champions of 1932 after defeating Glen Rovers.
John Quirke is seated second from right in the front row.

JOHN QUIRKE — HURLING

A swashbuckling performer from a golden era of hurling, John Quirke will be best remembered for his huge contribution to Cork's historic four in a row from 1941 to 1944. On more than one occasion when their bid for glory looked doomed, Quirke popped up to land vital scores to turn the tide. It all began for him in the Kerry town of Milltown in 1911, where he was born into a farming family, but his father moved as steward to the Ursuline Convent in Blackrock when Quirke was just ten months old. All the youngsters in the area played hurling and Quirke began practising his hurling skills on the local roads and fields in Blackrock.

His hurling career began through his friendship with Ireland and Shamrock Rovers keeper Mick McCarthy. McCarthy introduced Quirke to some Blackrock mentors in 1929, and he made his début as a sub against Carrigtwohill in the Cork Senior Hurling Championship later that year. He proved an instant hit with the Rockies selectors and was on the team that defeated St Finbarr's in the county final. He won the Cork Senior Championship with Blackrock in 1930 and 1931, which was to be their last championship win for 25 years.

In 1941 Quirke was a seasoned inter-county player, having played with the Rebels for almost ten years. He was centre-forward in a truly superb Cork team that swept to Munster and All-Ireland glory as they demolished Dublin 5–11 to 0–6, earning him his first All-Ireland senior medal. Cork met Dublin again in the 1941 All-Ireland final and, with the Dubs looking to be getting the upper hand, Quirke got two quick points from the 40 and placed Beckett in for a goal, as the Rebels ran out 2–14 to 3–4 winners. Antrim were the surprise package in the 1943 final, as the northern county had surprisingly and sensationally claimed the scalp of Kilkenny en route to this decider. There was no fairytale ending to the Antrim challenge, as in the final Cork turned on the style to easily account for the northerners 5–16 to 0–4.

After the final, Quirke remarked to the media, 'We did the bulk of the scoring in the first half and rightly eased off as the second half progressed, as I have never believed in humiliating the opposition.'

Cork completed their historic four in a row in 1944 after a couple of close encounters with Limerick. The Rebels looked to be coasting in the first game, but Limerick rallied in style and it took a late goal from Quirke to ensure that the Rebels would get a second bite of the cherry.

In the replay Limerick again looked to be in pole position, five points ahead in the closing minutes. A couple of Quirke points began the Cork revival, and the legendary Christy Ring billowed the back of the net with the winning goal. It is well documented that Quirke's display rescued Cork on 16 July 1944 with another stunning display that inspired the Rebels to a memorable win, as he proved the doubters who had believed that he was past his best totally wrong.

John Quirke passed away unexpectedly in August 1983 at the age of 72, but his memory will live on among hurling fans.

CHRISTY RING — HURLING

Christy Ring's immense talent and indomitable spirit are the stuff of legend. Nobody would doubt that he was Cork's greatest hurler, and very few would dispute the claim that he was the greatest ever. Not only did he land eight All-Ireland senior medals but he was a colossus in the Railway Cup when it was a hugely prestigious competition, a force of nature for Glen Rovers in the Cork Championship, and served as a selector to Cork's three-in-a-row winning team until his untimely death. He replaced Limerick's Mick Mackey as the king of hurling and his reign lasted a lot longer.

From his début in Killarney in the All-Ireland Minor final of 1937, he was destined to wear the red and white jersey of Cork for many years, as he became Cork's free-taker from a very young age. The following year he won the All-Ireland Minor Hurling Championship with Cork. He made his senior début for Cork in a league match against Kilkenny in 1939, and his senior championship début in the drawn and replayed Munster final against Limerick.

Ring was the first hurler to win eight senior All-Ireland medals (1941–4, 1946, 1952–4). There are so many stories still told about the maestro, such as the time when Limerick were two goals up in the final quarter of the Munster final of 1956. Ring was shackled by Donal Broderick for most of the game, but late in the second half he unleashed three classy goals and a point that put the Rebels firmly back in the driving seat. On another famous day in November 1951, Ring scored six goals and four points against Wexford in what was one of his finest displays in the red and white jersey. He joined Glen Rovers in 1941, winning fourteen senior county hurling championships with the side, the last in 1967. Besides his club and county successes, he amassed a total of eighteen Railway Cup medals between 1942 and 1963.

Tipperary's John Doyle once said that such was Ring's strength and courage around the square that three men couldn't contain him, and at crucial stages of a game he could whip himself up into a hurling frenzy.

Off the pitch, Ring was an introvert who shied away from publicity. Once you were classed as his friend, his loyalty and generosity knew no limits. Before any big game he would never practice taking a free, as he felt that it only mattered once the ball was thrown in.

Ring retired from inter-county hurling in 1964 at 43 years of age when the Cork selectors omitted him. Three years later he played his last game for Glen Rovers. His name lives in hurling history, with the city of Cork honouring him by naming a bridge across the River Lee the Christy Ring Bridge. In his native Cloyne there is a bronze statue that honours him in an especially fitting manner—striding into battle with a hurley in his hand.

His biographer Val Dorgan said it best: 'In my experience Ring was so good I cannot imagine anyone will ever compare to him, as there were no flaws in his game'.

Fitting words of tribute for an incredible hurling artist!

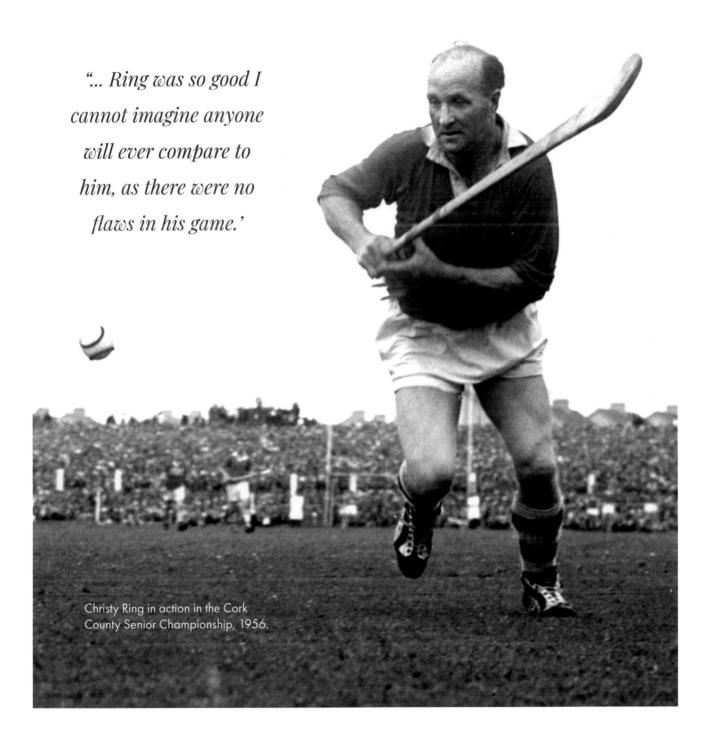

"... Ring was so good I cannot imagine anyone will ever compare to him, as there were no flaws in his game.'

Christy Ring in action in the Cork County Senior Championship, 1956.

Michael Roche, Ireland's only representative at the Sydney Olympic Games in 2000. (© Tom Honan/INPHO)

MICHAEL ROCHE — BOXING

Boxing is one of the toughest sports in the world, but for Michael Roche it meant fun and enjoyment for the 22 years of a successful career. Born in 1971, his passion for boxing became evident when he was ten years old. He joined the Sunnyside Boxing Club and began in the 39-kilo weight division. By the time Roche reached the U16 age group, he'd won six county, six Munster and four national titles.

With the encouragement of Albie Murphy, he moved into the senior ranks in the 1991/2 season. His first fight was against Michael Carruth, which gave him a good idea of the calibre of fighter he would meet if he wanted to make it to the top.

'He beat me fairly handily, but when I look back on that fight I think I gave him too much respect, but it was all a learning experience for me,' said Roche.

It was a measure of Roche's talent that he had gone punch for punch with the man who made history by winning the gold medal at the 1992 Barcelona Olympics.

His breakthrough came in 1997 when he won his first National Senior title at lightweight, beating fellow Corkman Tomás Fitzgerald at the Glen Boxing Club. He made it two in a row the following year and completed the treble in 1999 with a win over Frank O'Brien from Drimnagh Boxing Club in Dublin.

Roche succeeded on his third attempt to qualify for the 2000 Sydney Olympics, becoming the only Irish boxing representative at the games. Unfortunately, he didn't get very far, as he was defeated in the first round by a Turkish fighter in his first bout.

'I was very disappointed with the way I fought, and looking back I will never forget the Irish support I had in Sydney, but the pressure got to me when I came to get in the fight, it was like something from a Rocky film.

'Sadly, I got caught up with the hype and it changed how I normally fought and, no excuses, I was well beaten, and to be honest the experience shattered me, as I waited all my life for this opportunity and I blew it.'

When he reflected on where it all went wrong, lack of preparation for the Games became the number one factor.

'There was no such thing as a training camp, and maybe if there was it could have been a different outcome because, speaking to other people from different countries, my preparation for the games was miles apart.'

Following the Olympics, Roche was defeated in the last sixteen of the World Boxing Championships by a Russian. A shoulder injury forced him to hang up his gloves in 2003.

He names Albie Murphy and Kieran Joyce as the biggest influences on his career.

'They were great coaches and great friends to me, and that's crucial when you are competing at the top level of any sport.'

Anyone who has ever met Roche will say that he is a gentleman. The sport of boxing produced a man who always gave his best throughout an impressive career.

PADDY SHORTT — SOCCER

The city of Cork has produced many fine soccer players over the last century, but the story of the late Paddy Shortt, whose footballing skills made him one of the finest players in the 1970s and '80s, is quite remarkable.

Born in 1949, Shortt began his footballing career with the Middle Parish team Wembley. He helped them win the Evans Cup (U15 National) in the 1963/4 season, and was chosen as Cork Schoolboy of the Year the following season. A year later, Wembley won the FAI Minor Cup, and Shortt's natural talent was spotted in 1969 when he got a call-up to the Irish amateur team. In his début, he scored a goal at Dalymount in the 1–1 draw against England.

In 1971 Shortt won the FAI Senior Cup with Limerick after a replay against Drogheda United at Dalymount. He earned an U23 cap for Ireland against France in 1972 and in the same season he was on the Waterford team that won the League of Ireland Championship. It was back to Leeside for Shortt when he became an integral part of the Cork Celtic team that won the League of Ireland.

In the 1980s Shortt played a leading role in the fortunes of Cobh Ramblers. From 1980 to 1985 he won Munster Senior League medals with the club. This was coupled with an Intermediate Cup Medal in the 1982/3 season, a fantastic record by any standard.

In 1995 Shortt was diagnosed with a tumour in his right leg that resulted in amputation. The unbelievable courage that he showed during those dark days was a testament to the man, and even his closest friends were stunned by his reaction. With the help of his wife Catherine, his family and friends, he got through this horrible time. Notable names like the legendary George Best and his former team-mate at Waterford, Shay Brennan, visited him in hospital.

'My whole world was turned upside down when I was given the bad news, but I shook myself and my attitude was simple, as I knew there were people far worse than me.'

During that period Shortt was assistant manager at College Corinthians, and such was the respect in which they held him that they organised a dinner which drew an attendance of 600 people. At the time, Roy Keane and Denis Irwin made contributions that were very much appreciated by Shortt.

'First of all, what Roy and Denis have done for football over the years was incredible and I am in full admiration for them both,' he said. 'When I was ill, Roy donated a free weekend in Manchester plus tickets for a draw, and that really touched my heart.'

Sadly, Shortt passed away in 2007, and Cork lost a man who had graced the sport of soccer with style and panache over many years.

Paddy Shortt at Turners Cross, captaining Wembley to the FAI Minor Cup in 1969.

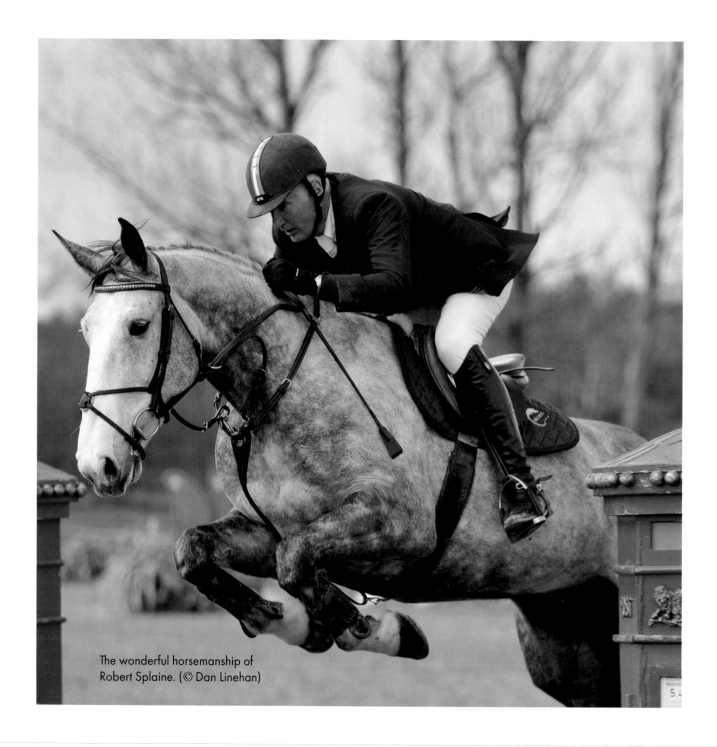

The wonderful horsemanship of
Robert Splaine. (© Dan Linehan)

ROBERT SPLAINE — SHOWJUMPING

What makes a great showjumping combination? Nerves of steel, a good horse and a cool head. Robert Splaine has all of these and more. It was inevitable that he would get involved in some form of equestrian sport, as his father owned thoroughbred racehorses.

'I sort of drifted into it when my father gave me the opportunity and I never looked back,' said Splaine.

In the mid-1970s, Splaine became the brightest young star on the Irish showjumping circuit. He represented Ireland in several Nations Cup events between 1976 and 1978, and performed so well that he was selected to represent his country in the world championships of 1978. There he teamed up with Capt. Con Power, Eddie Macken and Paul Darragh.

'I was very fortunate to be in a team with some of Ireland's greatest-ever riders and I had a brilliant horse called Carrigroe,' he said. 'I was still very young and gained invaluable experience and insight into what was needed to survive in this business.'

Splaine made a lot of contacts that helped him develop the main part of his business, which is the buying and selling of horses. His business is a tough one, in which he is constantly assessing whether an animal has the potential to be a winner. Once in a while, however, a real quality animal that is too good to pass comes along, and this was the case with Heather Blaze, owned by his friend Jimmy Flynn.

'Heather Blaze was a tremendous horse and my outstanding memory was the fantastic round he jumped to win the 1990 Tripoli Grand Prix.' That year Splaine and Heather Blaze won a record seven Grand Prix events and his performances earned him the Showjumper of the Year title. Splaine won his first Millstreet Derby in 1992 on You Can Tell, and Heather Blaze won the Canadian Airlines Challenge, two outstanding wins of his career.

Even the best riders need quality horses to remain at the top of the international showjumping circuit. After Heather Blaze retired, Spaine faded out of top-class competition and concentrated on developing his business at Belgooly. In the early 'noughties', Splaine returned to the top of international showjumping with Coolcorran Cool Diamond, a superb horse. Splaine and Coolcorran Cool Diamond's success began with Grand Prix wins at Millstreet in November 1999 and at Windsor in May 2000, with notable performances at Deauville, Barcelona, New York and Geneva.

In 2002 Coolcorran Cool Diamond started his international career and earned first place at the Glenamaddy Indoor Show. In 2003 he maintained his outstanding form with two victories in Spain and Switzerland, as well as helping Ireland to the Nations Cup in Achen. Coolcorran Cool Diamond was a top stallion in world breeding rankings before his death in 2013. Sheer hard work and commitment made Splaine a successful businessman and an international star. His achievements include serving as Chef d'Équipe of the Irish showjumping team from 2002 to 2016. His triumphs in the world of equestrian sports have brought honour and glory to this county.

PETER STRINGER — RUGBY

They called him the 'Pocket Rocket' in rugby circles, and the old saying that 'the best of goods come in small parcels' is certainly a fitting tribute to Peter Stringer. Born in 1977, Stringer is a former Irish scrum-half and had an incredible rise to fame when he broke into the international team in 2000.

Like many Cork youngsters, Stringer's first introduction to team games was in the Ballinlough hurling and football leagues. When he attended the Presentation Brothers College for secondary school, he switched his focus to rugby. In 1995 he couldn't get into the Presentation Brothers team that won the Munster Schools Senior Cup, but the following year they repeated their win and he played a major part in that victory. In the semi-final of the 1996 Senior Cup, they had a superb 8–6 win over the Christian Brothers' College. That year Stringer was picked for the Irish Schools team that toured Australia.

After three years playing at UCC, he was called up to the Munster panel at the start of the 1998 season and was named as a substitute against Edinburgh. He was a revelation in his first season with Munster, helping them to a quarter-final place, where they lost to French side Colomiers.

It wasn't long before Stringer's crisp, accurate passing was noticed by the Irish selectors. In 2000 he won his first cap for Ireland against Scotland in the Six Nations Championship. That year Munster lost out to Northampton in an epic European Cup final in Twickenham. There was more disappointment for Stringer the following season, as Munster failed again, this time to Stade Français at the semi-final stage.

The incident in the 2002 Heineken Cup final against Leicester in the Millennium Stadium is still talked about. With the clock running down, Munster were awarded a scrum near the Leicester line. Just as Stringer was about to put the ball into the scrum, the Leicester flanker, Neil Back, knocked it out of his hand.

'I was furious at the time, but sport is about incidents and he got away with it, which probably incensed the whole of Ireland,' Stringer said. Munster got their revenge in style twelve months later when they defeated Leicester away in the Heineken Cup quarter-final.

In 2003 Ireland suffered a humiliating defeat by England, a game that decided the Grand Slam. Stringer looked back on that day with sheer disappointment.

'We were given a mighty chance to defeat England, but in a nutshell they ran us ragged on the day.'

Stringer finished his international career in 2011 against the same opposition, but it was on a winning note, as they defeated England 24–8.

Stringer played a key role for Munster when they won the 2006 Heineken Cup, scoring their second try in the 23–19 win over Biarritz. In the closing years, he had spells at Saracens, Newcastle, Bath, Sale and Worcester before retiring in 2018. Stringer tackled and mixed with the best, and Cork is proud to have produced such a lion-hearted player.

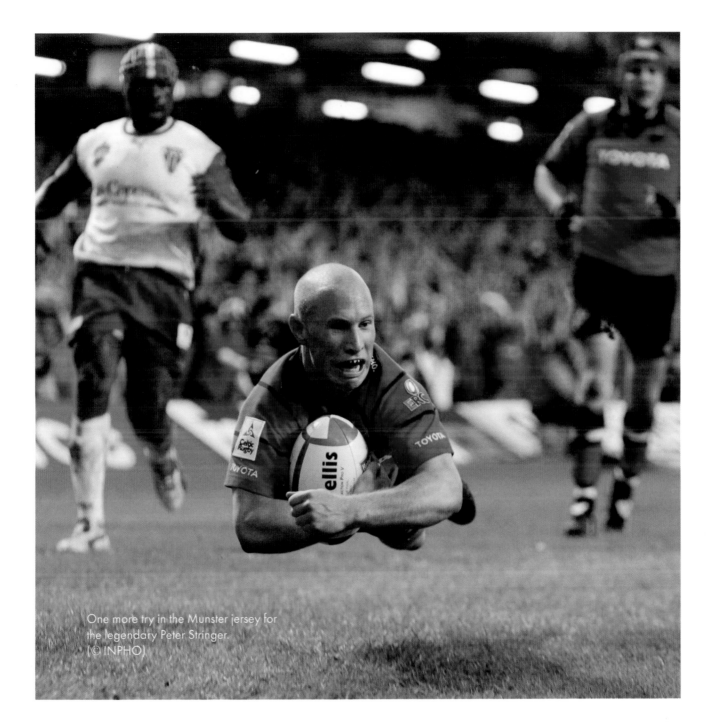

One more try in the Munster jersey for
the legendary Peter Stringer.
(© INPHO)

Fergie Sutherland chatting to racing personality Ted Walsh.

FERGIE SUTHERLAND — HORSE-RACING

Fergie Sutherland's life is the stuff of legend, from the Korean War of the 1950s to training the winner of the Cheltenham Gold Cup in 1996, when Imperial Call helped his trainer to become the Lion of Cheltenham. Imperial Call brought a lot of joy to Irish punters and those involved in Irish horse-racing, as he gave them their first win in the race in over ten years.

Born in 1931, Sutherland came from a wealthy background in Scotland and took the classic route from Eton and Sandhurst into the British Army before fighting under the flag of the United Nations. He was a brave man as he faced the North Korean troops on the battlefield in 1950, and a shrewd one against the Canadians in poker sessions, where no pity was shown to the uninitiated. He was in action as a lieutenant when the lower part of his leg was blown off by a land-mine; when he returned to duty he found himself in the thick of things in the Suez crisis, but a bout of malaria brought an early end to that tour.

He returned to England and worked with horse-trainer Geoffrey Brooke, and later helped Joe Lawson, who had trained Never Say Die, to win the Epsom Derby. When Lawson retired, Sutherland's father bought Lawson's Newmarket yard for his son. Sutherland's training career began to blossom and he didn't have to wait long for his first major success, as he had a winner at Royal Ascot in his first season.

He first met one of his owners, bookmaker Jack Wolfe, at Manchester races in 1958. Sutherland was placing £20 on one of his horses when Wolfe spotted them.

'You should be betting with me and, anyway, will your horse win?'

'Not bloody half, and for spite I am going to have a tenner on you.'

The horse won and that was the start of a great friendship. The first horse that Sutherland trained for Wolfe was Boston Girl, who won her first race at odds of 8/1 in a two-horse race against a 1/20 favourite called Conwyn.

In 1963 Sutherland moved to Carrigadrohid in Cork, and five years later he trained his first winner in Ireland as Primrose Rosy won at Limerick. In March 1996, Imperial Call won the prestigious Cheltenham Gold Cup as 'The Banks of My Own Lovely Lee' sounded around the Cotswolds. Whatever the experts thought, Sutherland had made up his mind that Imperial Call and jockey Conor O'Dwyer would win the £225,000 first prize. Celebrations went on for days at his local pub, the Angler's Rest.

Sutherland retired in 1998, and his ready wit, delightful one-liners and, above all, his courage were sadly missed in the winner's enclosure. Following a long illness, he passed away at the age of 81 in 2012. The adopted Irishman will always be remembered by his many friends in Cork's Lee Valley.

GEARÓID TOWEY — ROWING

Fermoy's Gearóid Towey put rowing firmly on the map for many years with some incredible performances. He once said, 'I do not want to walk on water, I just want to be the fastest in it', and he has provided Irish sports fans with a moment to cherish in Irish sporting history.

Anyone who witnessed the scenes from Lucerne, Switzerland, in August 2001 will recall the sheer delight on the faces of Towey and his partner Tony O'Connor at the end of a gruelling World Championship final.

'I think the thing that stands out most for me was that we were really nervous the day before, and that continued to the morning of the race and at the start as well; all we wanted to hear was the gun and get on with it,' Towey said.

The race saw the Dutch pairing take the lead but, displaying true Irish grit, Towey and O'Connor wore down their opponents with 150m to go to claim a tremendous win.

'We breathed a collective sigh of relief that the months of hard work and training had been worth it.'

It takes extreme commitment to reach the top of your sport, and at times Towey questioned whether it was worth it. In 1996 he trained three times a day: he spent 90 minutes on the River Blackwater covering twenty kilometres; after a short break he was back doing gym work, and after another break he would run or go on a machine. He then went to a training camp in freezing Sweden with the national squad, and that memory sticks with Towey.

'That was hell and at one stage I thought they wanted to break us, and I went to bed telling myself that this wasn't for me, and the worst part of it was that the selection process had just started,' he said. 'Six of us were going for two places on the Lightweight Sculls team, and despite living together we were all competing hard against each other and you couldn't get emotionally close to anybody.'

Towey was downhearted but determined, and he survived as three were cut and three stayed on. For the next five months Towey, Niall O'Toole and Brendan Dolan rotated as pairs in international competition. Three weeks before the games, Towey was informed that he was the man to miss out. Although he was a natural lightweight and had the best volume of oxygen intake, the coach, Thor Nilsson, opted for experience. Instead, Towey rowed in the Amsterdam Regatta and the World U23 Lightweight Sculls, where he won both events and set the world's fastest time of the year in the U23 races. A season later he teamed up with O'Connor and the pair wrote a page in sporting history.

Towey competed at three Olympics—Sydney 2000, Athens 2004 and Beijing 2008, where he retired. He was certainly an ambassador for rowing; while always enjoying his successes, he was equally gracious in defeat. Towey now resides in Sydney and is a founder of Crossing the Line in Sport, which is dedicated to mental health and transition out of sport.

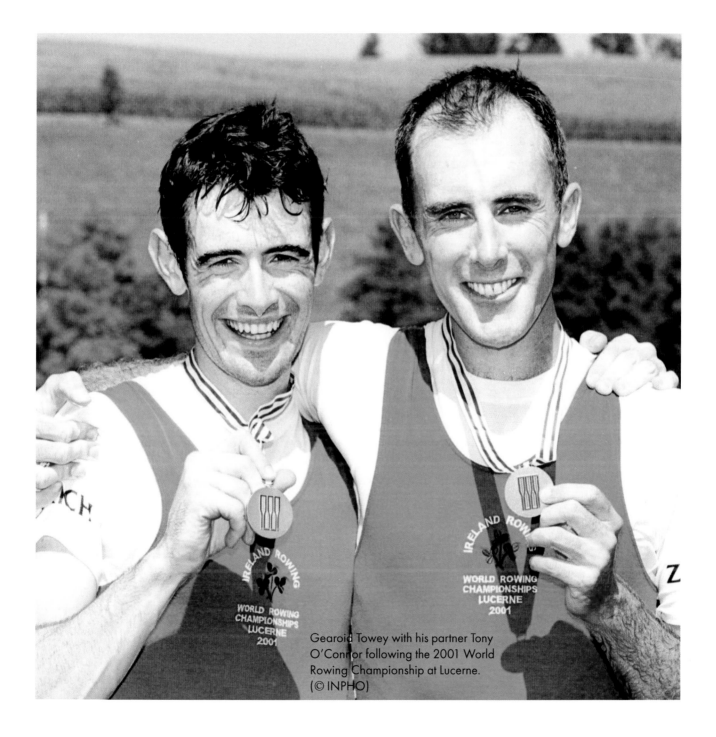

Gearoid Towey with his partner Tony O'Connor following the 2001 World Rowing Championship at Lucerne. (© INPHO)

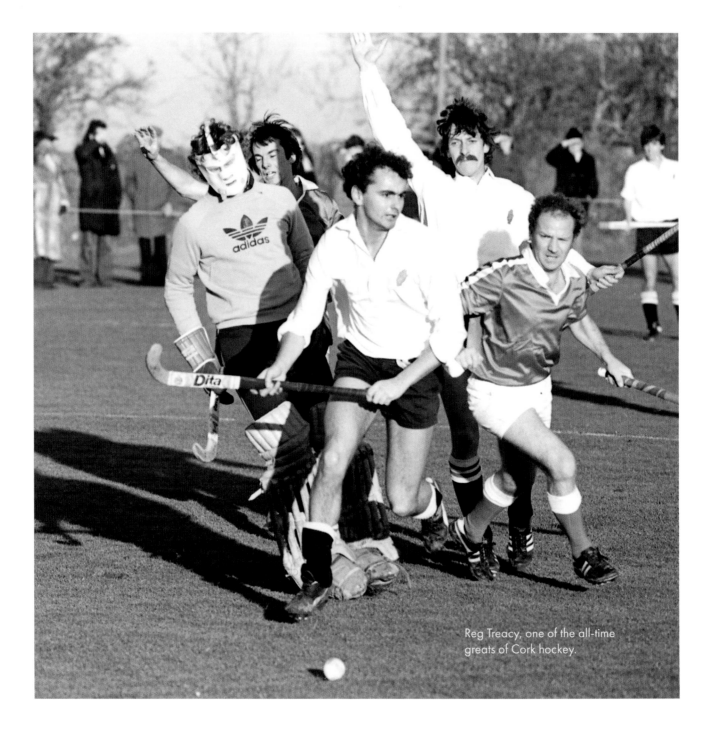

Reg Treacy, one of the all-time greats of Cork hockey.

REG TREACY — HOCKEY

Few have helped to propel the game of men's hockey to such new heights as Reg Treacy, who played at the top level for three decades, his brilliant technique making him a master at his sport.

Born in 1940, he began to play hockey while attending the Cork Grammar School and took an immediate liking to the sport. When he was fourteen he was chosen to play for the 1954 Munster Schools team. Later that year he gained Schools international recognition and scored two goals when Ireland defeated Scotland 4–1.

Treacy played for just two clubs in his long career. After spending one season with Cork Harlequins, he transferred to Cork Church of Ireland. He won his first Munster senior hockey cap in 1955 and went on to represent the province for 27 consecutive seasons before finally bowing out of inter-provincial hockey in 1982.

Known as an attacking player with a sharp eye for goal, Treacy earned his first senior international cap in 1959 and five years later toured India with the British and Irish hockey team. He was eligible for selection on the Great Britain Olympic teams of 1964 and 1968 and, although he managed to make the pre-tournament squads of 24, he was cut from the final squad on both occasions. Despite the setbacks, he continued to enjoy playing hockey.

The Irish Senior Cup is the blue ribbon of hockey in Ireland. In 1967, when Church of Ireland met Pembroke Wanderers in the final, the talented Treacy was the star of the game, crowning his man-of-the-match performance by scoring the winning goal. Three years later he was part of the Irish team that competed in the first European Championship. One of the many highlights of Treacy's illustrious international career was an eight-nation 1972 tournament in Spain, as his brilliance was the principal reason for Ireland's success. When the curtain finally came down on his international career in 1984, he had amassed a total of 54 caps and hockey had lost one of its greatest players. He was the first hockey player to earn 54 caps for Ireland.

Some sports stars leave their chosen sport after retirement and never give anything back to the sport that made them. That certainly wasn't the case with Treacy.

'I always get great pleasure in coaching young kids at Garryduff, as I would like to think that I could pass on some good positive knowledge and understanding of the game.'

On a parting note, Treacy looked back on his career with pride. 'I think the good side of any sport is that if you are successful you have some wonderful memories to look back on, and even if you are not fortunate to be successful, whether you play hockey or football and enjoy it, the happy memories will stay with you always, as participation is key.'

Treacy died in June 2015. Although small in stature, the soft-spoken man will always be remembered as a giant in his beloved sport.

DAVE WIGGINTON — SOCCER

It's difficult to explain the excitement and drama in the Cork soccer scene of the early 1970s to the present generation. It goes back to when the late Dave Wigginton was in his prime. Those were heady days for club soccer, and it was a time when Waterford and Cork were setting the pace on the national scene, as the removal of the GAA ban in 1971 contributed to a growth of huge interest in the sport.

Wigginton was introduced to League of Ireland supporters in 1968 by the then manager of Cork Hibernians, Amby Fogarty. He had been an apprentice at Derby County under Brian Clough, who was such a close friend of Fogarty's that the Irish international was best man at Clough's wedding. A story that was popular at the time of Wigginton's arrival on Leeside was that he had outpaced his Derby County team-mates in a cross-country run and arrived back in the stadium so far in front of everybody else that Clough accused him of cheating. The row that followed caused a rift between player and manager, resulting in Wigginton's coming to Cork Hibs—and what an inspired move it turned out to be for Fogarty and Wigginton.

The coming together of Wigginton and Cork Hibs was a partnership made in heaven. His swashbuckling, fiery football and blinding pace produced a steady flow of goals. In 1972 he played a starring role when Hibs defeated Waterford United in the FAI Cup final in front of 25,000 fans, thanks to a Miah Dennehy hat-trick. The following year saw another cup triumph for Hibs, when they defeated Shelbourne after a replay at Flower Lodge. On top of these successes, he won a league title with Hibs in 1971, as well as the Blaxnit All-Ireland Cup and Dublin City and Munster Cup medals. His overall tally of 130 goals with Hibs was remarkable, considering that he spent lengthy periods on the sidelines with cartilage injuries and announced his retirement on numerous occasions. There's no doubt that he could have returned to England to play at a decent level, but he was happy in Cork. After the collapse of Cork Hibs, he played with Cork Celtic, Cork Alberts and Galway United.

When Wigginton died at the age of 51 on 18 October 2001, the sporting and Cork soccer fraternity were stunned. His former team-mate Dennehy paid tribute to him.

'What a character Wiggy was when Hibs and Cork Celtic were the top teams, as many soccer fans in our city appreciated his undoubted talent and, for me, he was the best player to ever grace the League of Ireland,' he said.

Wigginton represents all that was good and vibrant and exciting at a memorable time for club soccer in this country. We will always be in his debt for the wonderful memories he gave us.

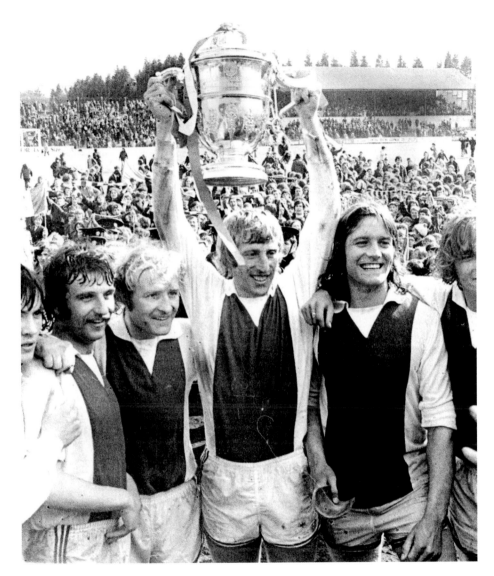

Cork Hibs players Carl Humphries, John Lawson, Sonny Sweeney, Dave Bacuzzi (capt.), Gerry Coyne and Dave Wigginton celebrate winning the FAI Cup for the second year in a row following the 1–0 replay win over Shelbourne at Flower Lodge, Cork, on Sunday 29 April 1973. (Courtesy of the *Cork Examiner*.)

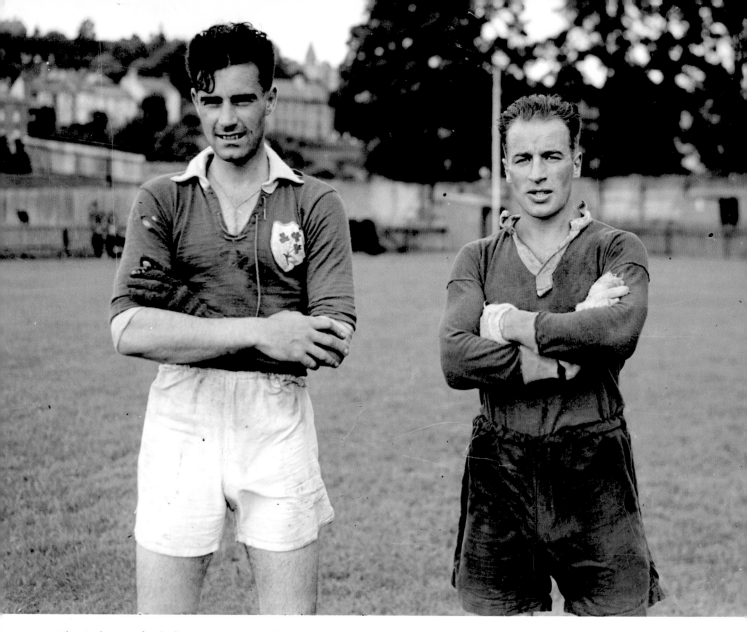

The Cork senior football team in training at the Mardyke in 1945, with Tadgh Crowley (left) and Eamonn Young. (*100 Cork Sporting Heroes, Vol 1.*)

EAMONN YOUNG — FOOTBALL

Skilful and courageous, Eamonn Young was arguably one of Cork's greatest footballers of the twentieth century. He grew up in Dunmanway, where football was like a religion and the street leagues were played with all the intensity and determination of an All-Ireland final. Young's father, Jack, who was the local schoolmaster and had won an All-Ireland senior medal with Cork in 1911, ensured that all the children were proud of their club, Dohenys.

Young attended the Good Counsel School in New Ross, where his natural skill, ability and determination were seen at their best as he continued to progress as a quality player. He made his senior début for Dohenys in 1939, when he lined out against a Bantry side that included such notable names as Tim Harrington, Tim Cotter and Danny McCarthy. He rose to the challenge and helped Dohenys to a famous win, with the side beating Beara in the next round, but disappointment came their way when they lost the game following an objection.

Young transferred to the city-based Army club Collins in 1943 and was at the peak of his football powers during those years. During the war years and into the 1950s the Army side were one of the top five clubs in Cork. The games against Garda, UCC, St Nick's and Clonakilty drew attendances of 10,000+ spectators, as they won county titles in 1949, 1950 and 1953. Young returned to Dohenys in 1961, with a new position as corner forward and a new role as free-taker. At 40 years of age he was still playing champagne football, and helped Dohenys to clinch the Cork County Junior Football Championship in 1966 before finally hanging up his boots at the age of 45.

He won his first inter-county football medal with Cork in 1939, when he played on the first Cork minor team to win the Munster crown. In 1940 he won another Munster medal, this time with the Cork juniors, and a year later he was brought into the senior panel. In 1943 Young, along with his brother Jim, won the Munster Senior Championship. He crowned his inter-county career by winning a senior All-Ireland medal in 1945 when Cork defeated Cavan. He won two more Munster medals in 1949 and 1952, as well as a National Football League medal in 1952.

Young was also a skilled hurler, winning All-Ireland minor medals in 1938 and 1939, a National Hurling League medal and a county championship with Glen Rovers. He was a very innovative Gaelic football coach, deploying skill-training and strategies that helped develop the game. He was a trainer and selector with the Cork football teams that won Munster titles in 1956, 1957, 1966 and 1967. His only regret was that Cork failed to win an All-Ireland under his charge. The name of Young will always be a part of Dohenys and Cork football history.